## IMAGES
### *of America*

# AFRICAN AMERICANS
## OF
# CHESTERFIELD COUNTY

IMAGES
*of America*

# AFRICAN AMERICANS
## OF
# CHESTERFIELD COUNTY

Felicia Flemming-McCall

ARCADIA
PUBLISHING

Published by Arcadia Publishing
Charleston SC, Chicago IL, Portsmouth NH, San Francisco CA

Library of Congress Catalog Card Number: 2008923568

For all general information contact Arcadia Publishing at:
Telephone 843-853-2070
Fax 843-853-0044
E-mail sales@arcadiapublishing.com
For customer service and orders:
Toll-Free 1-888-313-2665

Visit us on the Internet at www.arcadiapublishing.com

*This labor of love is dedicated to those who continue to preserve African American history in Chesterfield County.*

# CONTENTS

# ACKNOWLEDGMENTS

I am deeply grateful to the families who welcomed me into their homes and allowed their histories to be shared. I am indebted to these families for supporting me and for trusting me with their precious heirlooms. To the pioneers who are still with us, I thank you for paving the way for those who came after you. To the pioneers who are no longer with us, may we continue to remember your contributions and leave our own legacy for future generations.

I am grateful for the valuable photographs, information, and permissions granted from the following individuals and institutions: Lynne Walsh of the Cheraw Matheson Memorial Library, the *Cheraw Chronicle*, the South Caroliniana Library at the University of South Carolina, Thomas L. French Jr., Dr. William T. Dargan and the Stories About Us Project, the South Carolina Department of Archives and History, and the Historical American Buildings Survey. I especially thank the following: Thelma Rivers, Dr. Margaret Ann Reid, Louise Nichols, Zelaker McNair, Vera Swann, Ernest Gillespie, Lucille Sellers, and the African American Cultural Society of McBee, South Carolina. These people provided images of their own families but also collected photographs and gathered information from other families on my behalf. I am truly touched by your generosity. I would also like to thank my colleagues on the South Carolina African American Heritage Commission for their encouragement and support. Photographs without an accompanying credit are from my personal collection.

To my family members who live near and far away, I thank you all for your prayers. And now to my supporting cast: my parents, Loretta and James, who have supported my every endeavor, and my stepmother Laura, for her prayers and encouragement; my brother J. T., who has always been there for me; my grandmother Lorraine, who taught me how to appreciate the past; my grandmother Blanch, who taught me how to trust in God; and my children, Narrie, Sydney, and Jordan, who are truly the joys of my life. To my devoted husband, Norris, I thank you for your love, patience, encouragement, and support. I love you all and appreciate you being so understanding.

Finally, to the Heavenly Father, who bestowed this calling on my life, I thank you for the strength, grace, and mercy to fulfill my purpose.

# INTRODUCTION

African Americans have made an impact on Chesterfield County since its beginning. They persevered from slavery to freedom, becoming farmers, civic leaders, entrepreneurs, educators, and musicians. The faces and stories within these pages reveal individuals who were living ordinary lives but doing so under extraordinary circumstances. This volume celebrates all African Americans in Chesterfield County, because regardless of living situation, pedigree, or educational status, each made his own contribution. Some African Americans were fortunate to be emancipated prior to the Civil War, but freedom still had its challenges. These select few remained determined to carve out a better life for themselves and their families.

After the Civil War, blacks were reconstructing their lives by means of land ownership and education. Those who were fortunate enough to acquire property knew that real freedom relied on land ownership, which for African Americans was based on the African principle of subsistence farming. This principle implied that one could build a house for his family, grow his own food for nourishment, and then eventually begin his own cash crop business. Research into the county's African American history revealed that many families producing leaders, educators, and entrepreneurs owned land. Thus these farmers not only provided food but also paved the way for the black community.

The ownership of land was a catalyst for change in many venues and afforded blacks the opportunity to build schools. When schools were established, some teachers traveled all over Chesterfield County, while some students walked miles to receive their education. The church served as the core of the black community—as it remains today—and many schools were derived from local churches. Other educational institutions were begun by missionaries from the North, as was the case with Coulter Memorial Academy. The first high school for African Americans in the county, Coulter later became a coeducational boarding school with a high school and junior college. Some children could not attend school because of their obligations to the family farm. Parents each had their own priorities, but one commonalty was insuring a better life for their children.

Numerous African American businesses flourished in the county's various towns. Segregation was a system used to impede the progress of blacks, but in actuality, it assisted in producing thriving black-owned businesses that helped to initiate African American communities such as Petersburg in Pageland, the Back Lot in Chesterfield, and the Hangout in McBee. At the time, African American commercial enterprises included grocery stores, funeral homes, barbershops, restaurants, gas stations, and dry cleaners.

Chesterfield County also has a rich history in the performing arts. Music has always been sentimental to African Americans as the vehicle of ingenious and artistic expression. Some music pioneers from the county are known nationally, such as John Birks "Dizzy" Gillespie of Cheraw.

Throughout each chapter of this book, a town is showcased, and along with it, the African Americans who excelled at making their communities better places to live. Within these pages are

leaders who defied the odds and proved instrumental to the civil rights movement, challenging the status quo. The courage of these individuals created inroads for a transition to equality, which many take for granted today. In the midst of these complex times was the belief of a better tomorrow.

African Americans have been blessed with a creative spirit that has allowed their communities to overcome adversity and persevere during the hardships of everyday life. This pictorial history would not have been possible without the individuals who held on to photographs, written and oral records, and precious memories. This rare glimpse of the late 1800s to the mid-1900s will hopefully be a pleasant walk down memory lane for some and an introduction to others of the contributions of African Americans from Chesterfield County.

# One

# CHERAW

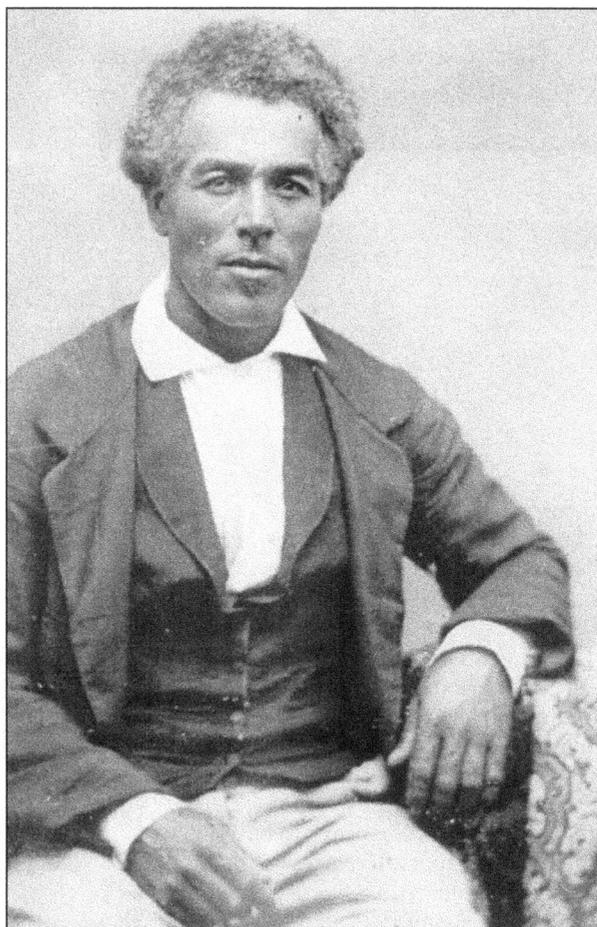

Horace King was born in the Chesterfield District on September 8, 1807, and became the slave of John and Ann Godwin in 1830. Both King and his master were well versed in bridge building, and King held something like a junior partner position in Godwin's company. Godwin developed the proposals, while King supervised construction of the bridges. Eventually, the Godwins and William C. Wright, Ann Godwin's uncle, successfully petitioned for King's emancipation by the Alabama Senate and House of Representatives on February 3, 1843. This daguerreotype of a handsome King was taken around 1855. (Courtesy of Thomas L. French Jr.)

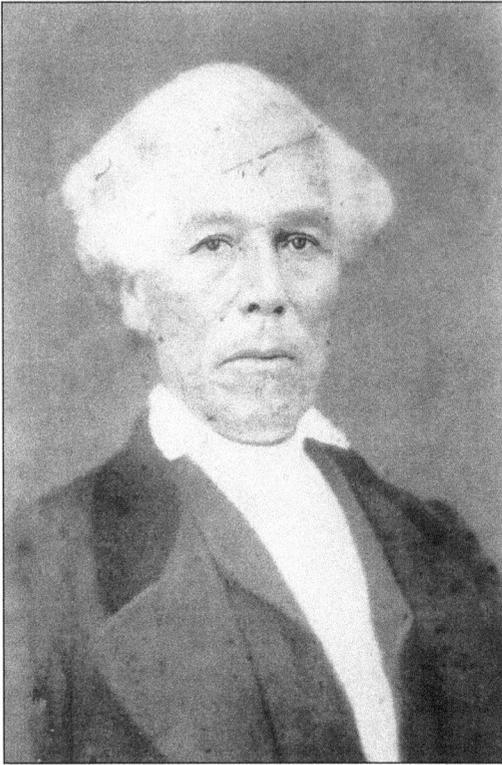

King's four sons and daughter joined him in the family business, which involved building courthouses, warehouses, factories, houses, and bridges in numerous southeastern states. Horace King was married twice—first to Frances Gould Thomas on April 28, 1839, and after her death to Sarah Jones McManus on June 6, 1866. During Reconstruction, he became a magistrate for Russell County and served in the Alabama legislature from 1869 to 1872; in 1870, he served as a registrar in Girard and as a census compiler. This photograph was taken sometime in the 1870s. (Courtesy of Thomas L. French Jr.)

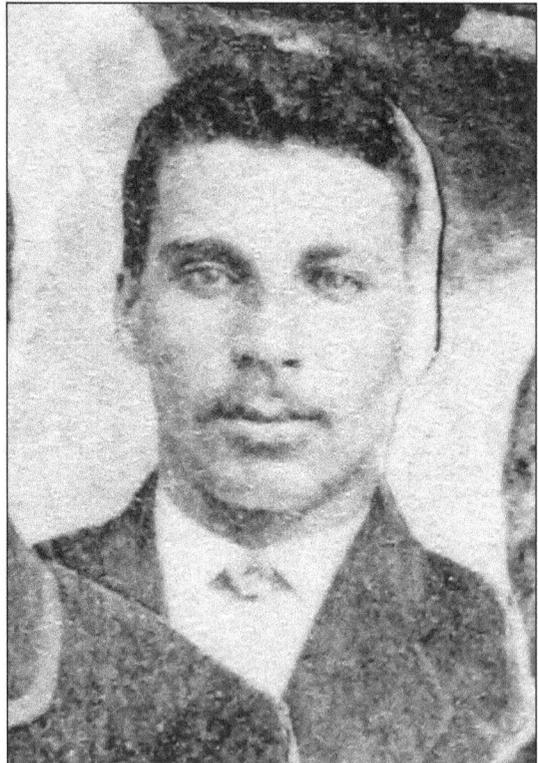

Henry J. Shrewsbury was the Chesterfield County representative of the South Carolina legislature in 1868 as a Radical Republican. A free mulatto, Shrewsbury was born in Charleston in the late 1840s and attended school in the North before moving to Cheraw. He was employed with the Freedmen's Bureau and served on the board of registration for Chesterfield County. Shrewsbury and D. I. J. Johnson were the first two African Americans to hold an office in the county. (Courtesy of South Caroliniana Library, University of South Carolina, Columbia.)

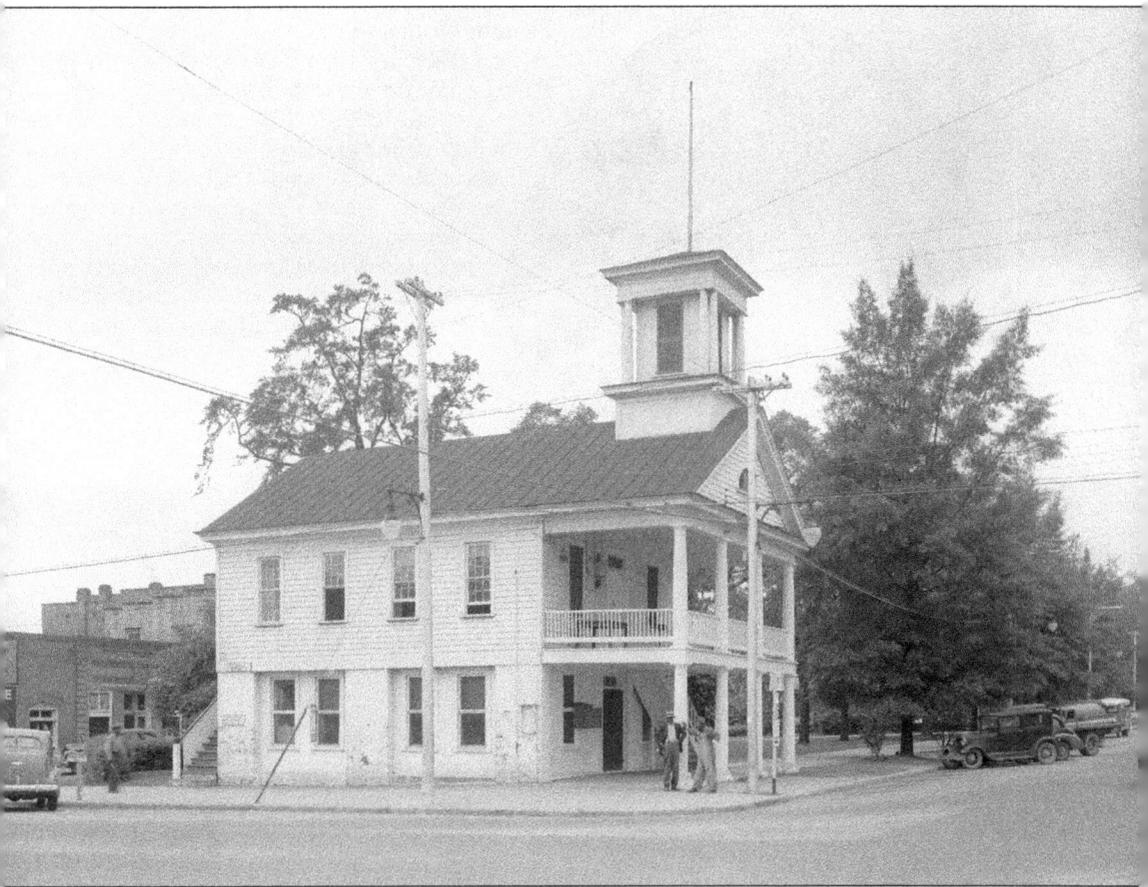

The Market Hall, built in 1837 by Peter Conlaw Lynch, once served as a slave market. The lower portion of the structure was originally an open area where slaves were auctioned. At the time of this 1940 photograph, however, the upstairs was occupied by a police station, and the former open area, now closed in, was used by the Civic League. On the right, a gentleman walks up Second Street with a stick in his hand. On the right corner, two men engage in conversation. (Courtesy of Historical American Buildings Survey, C. O. Greene.)

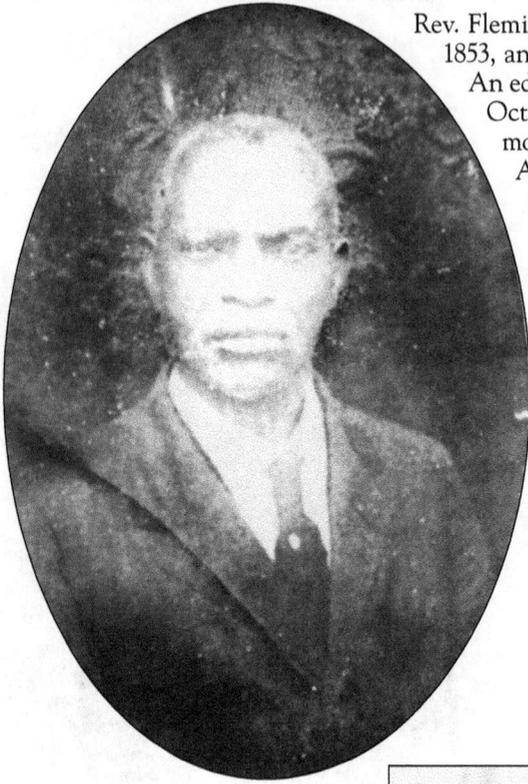

Rev. Fleming William Prince was born on August 29, 1853, and graduated from Benedict College in 1878. An educator, he was ordained into the ministry on October 30, 1880. In 1908, Prince was elected moderator and president of the Pee Dee Baptist Association and Sunday School Convention, serving for over 40 years. He was also the pastor of several churches. Prince retired from the pulpit of Pee Dee Union Baptist Church after 24 years. He was married to Charity Smith Prince. (Courtesy of Lovye Oesterlin.)

Born on August 14, 1905, Lucille Reese Davis McIver became valedictorian of her class and graduated from Benedict College with a bachelor of science degree. After earning her master of arts degree from New York University, she engaged in a teaching career spanning 43 years. Her first husband was John Eliot Davis, a minister and principal. Following his demise, she married Alphonso McIver, also a minister. Recognizing the importance of education, Lucille began an evening school where she taught about 50 adults how to read. She served in many civic organizations and as the secretary for the NAACP for 15 years. A pianist, she played for several churches in the surrounding towns and communities. (Courtesy of Lovye Oesterlin.)

Major D. McFarlan graduated from the Avery Institute in Charleston, South Carolina, and relocated to Cheraw in the late 1880s. He became the first black postmaster in Cheraw when he was appointed to the position in 1892 and again in 1897. Major lived with his wife, Fanny, and their daughter, Dorothy, who taught at the Robert Smalls School. (Courtesy of the *Cheraw Chronicle*.)

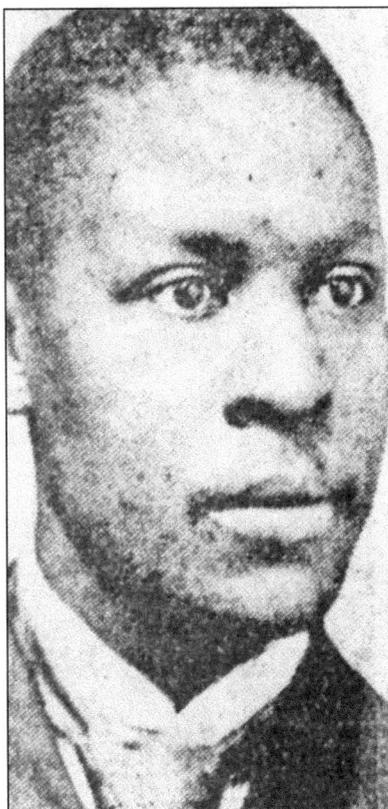

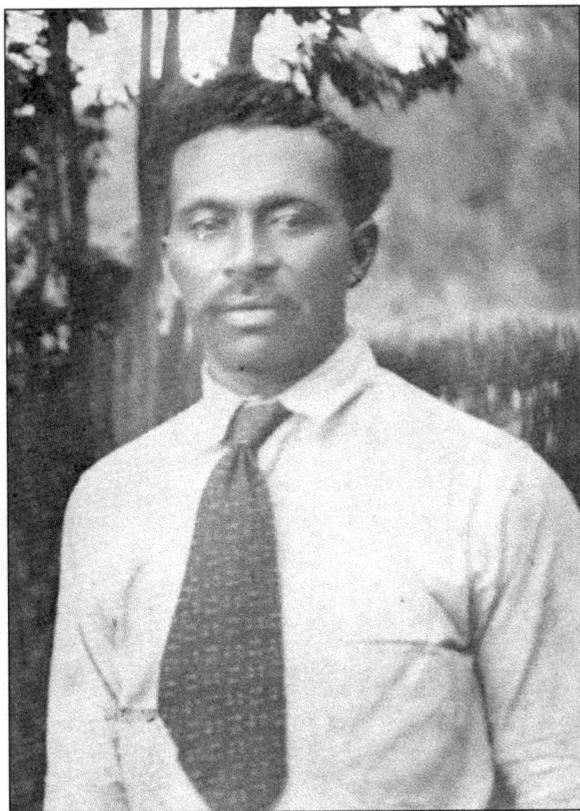

During the late 1800s and early 1900s, Prentis Godfrey sold ice and coal all over town from the old Reid Ice plant. He traveled with his wagon and a horse named Raymond. Godfrey was so skillful and accurate that he could give the correct amount of ice or coal without using a scale. (Courtesy of Walter Godfrey.)

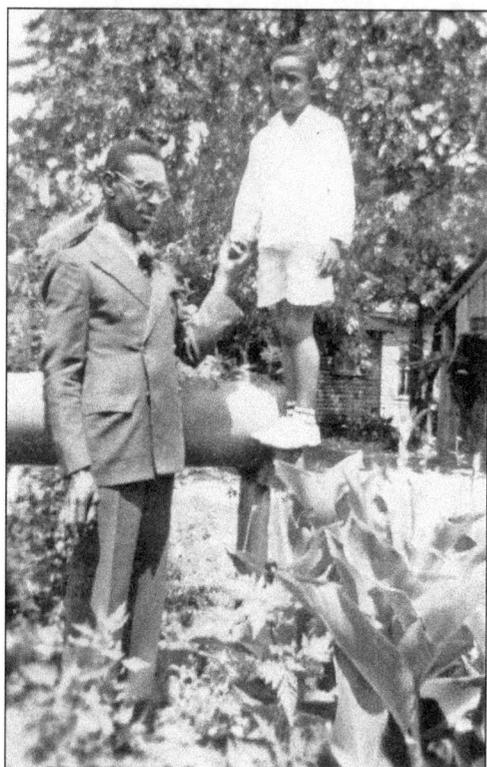

Dr. John V. Hanna Sr. was the first African American dentist to set up office in Cheraw. He also practiced dentistry in various towns for the South Carolina school system. Dr. Hanna is pictured with his son John V. Hanna Jr. in 1938. (Courtesy of Dr. Margaret Ann Reid.)

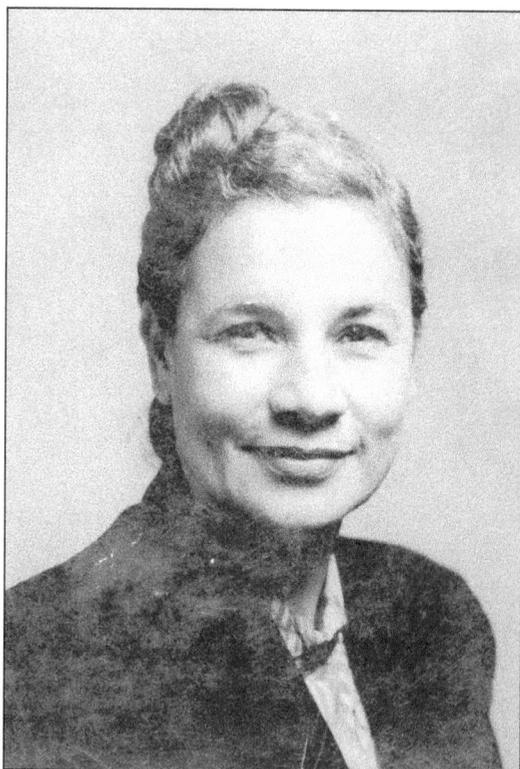

Gladys Wilson Hanna, seen in the 1950s, was the wife of Dr. John V. Hanna Sr. and the mother of John V. Hanna Jr. She attended Coulter Memorial Academy and Mary Holmes Seminary in Mississippi before teaching for 43 years at the academy and Long High School. (Courtesy of Dr. Margaret Ann Reid.)

Atty. John E. McCall served the entire county through his law practice and civic leadership. Graduating from Coulter Memorial Academy, he received a bachelor of science degree in structural and architectural engineering in 1943 and a law degree from the South Carolina State School of Law 10 years later. He was admitted to the South Carolina Bar in 1954. McCall held various positions on boards and committees, including vice president of the Southeastern Lawyers Association, a member of the Chesterfield County Bar Association, cofounder of the Chesterfield County Citizens Committee, and legal advisor to the Cheraw Branch of the NAACP. (Courtesy of Wayne McCall.)

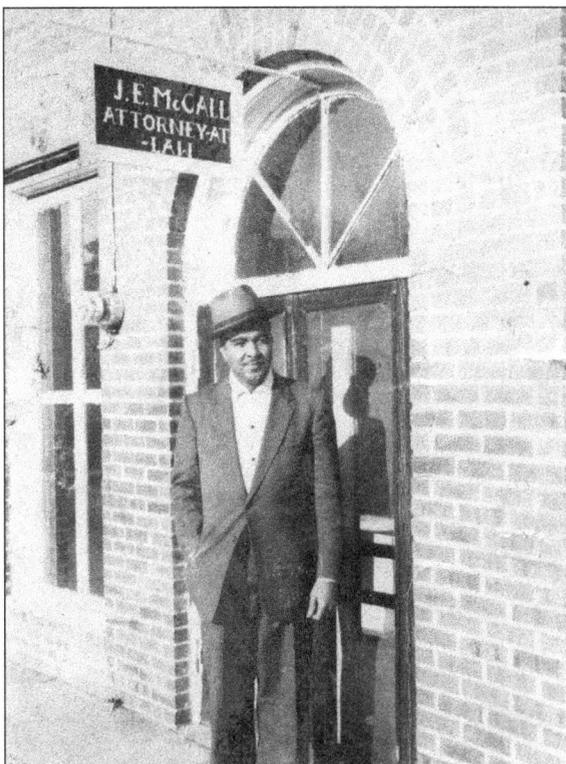

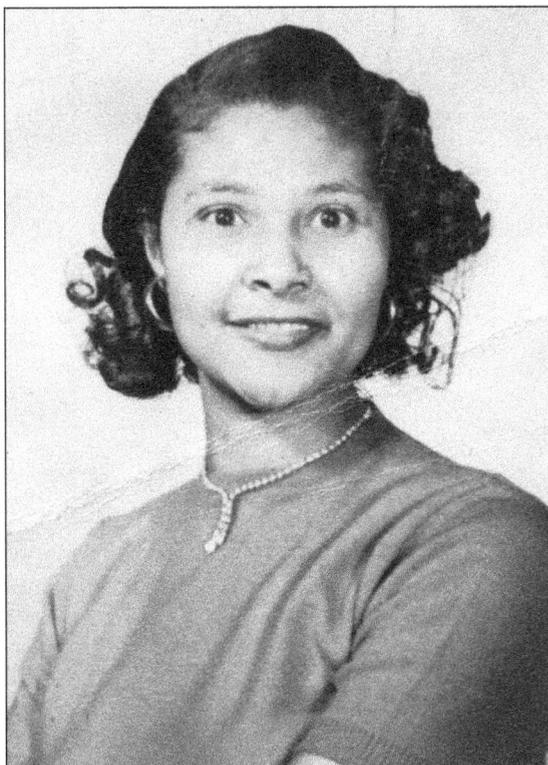

After studying at Coulter Memorial Academy, Nellie Talley McCall earned a bachelor of science degree in business administration from South Carolina State University in 1947. She was a member of the Beta Sigma chapter of the Alpha Kappa Alpha sorority. Nellie was married to Atty. John McCall. (Courtesy of Wayne McCall.)

15

Levi G. Byrd, a licensed plumber, was instrumental in establishing the South Carolina State NAACP in 1939 and was a member of the Cheraw chapter. He served the organization as treasurer on both state and local levels from its inception until May 1979. As cofounder of the Chesterfield County Citizens Council, he advocated for human rights and racial equality. Well known for selling black weekly newspapers, Byrd often sent Cheraw's black news to the *Pittsburgh Courier*. In 1971, the Town of Cheraw honored him by designating December 19 as Levi G. Byrd Day. (Courtesy of Alfred D. Byrd.)

Franklin E. Johnson was a stalwart force in the civil rights movement. In 1964, the Ku Klux Klan burned a cross 100 yards from his house because he had petitioned for his children to be transferred to the white schools. (Courtesy of Betty Dorsey.)

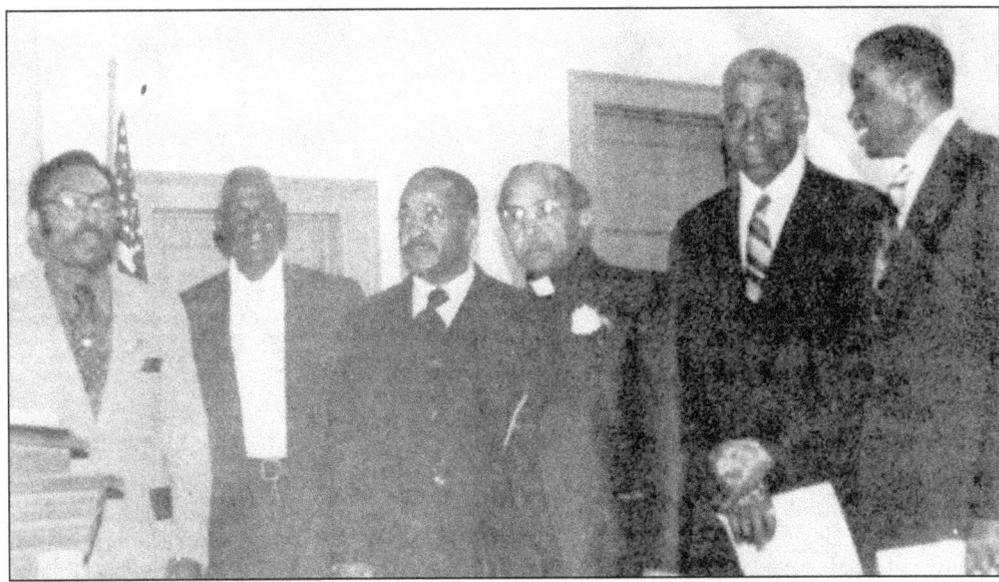

This photograph was taken when the NAACP held its Jubilee Day program at the Pee Dee Union Baptist Church. Participants included, from left to right, Rev. Thomas Dawkins, Frank Johnson, Dr. C. L. Bowens, Rev. Alphonso McIver, Van Buren Long, and James E. Crawford. (Courtesy of the *Cheraw Chronicle*.)

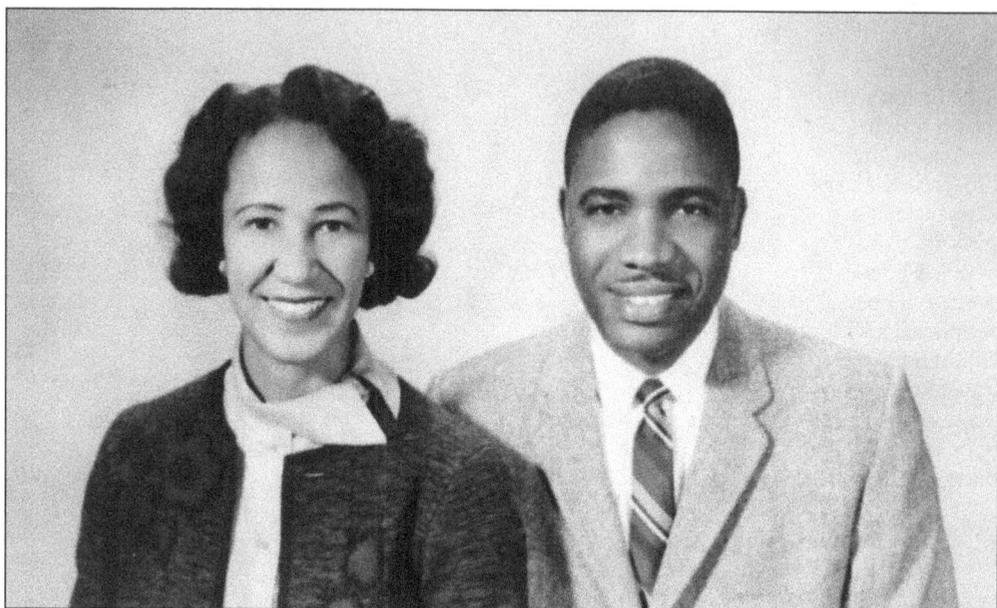

*Swann v. Charlotte–Mecklenburg County Board of Education*, decided on April 20, 1971, was a U.S. Supreme Court case that became known nationally. It has been used in determining the basis for desegregation and to promote equality and integration in public schools. (Courtesy of Dr. Darius and Vera Swann.)

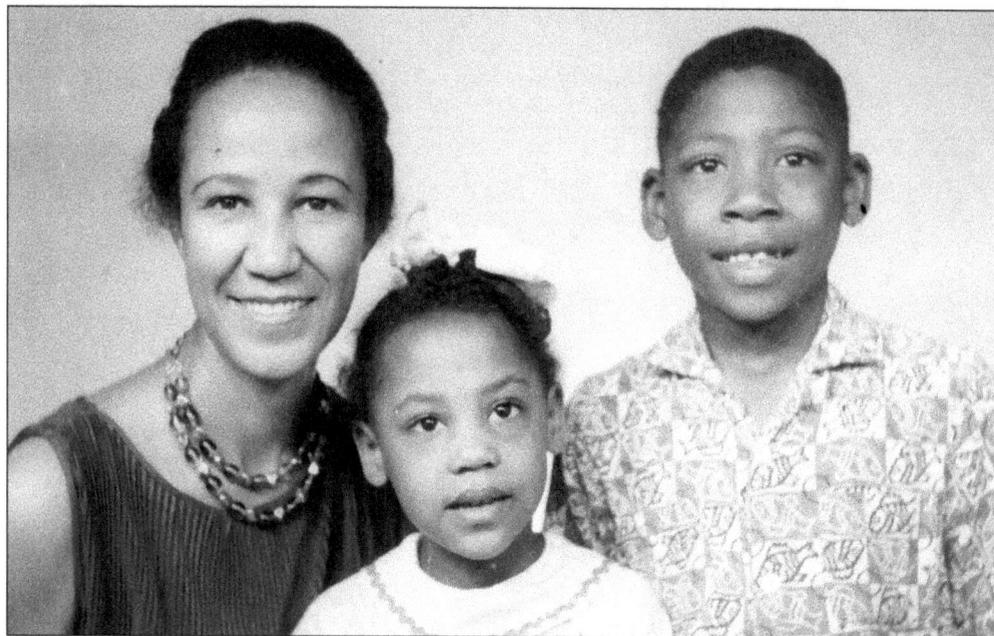

Vera Poe Swann is shown with her children, Edith Marionette Swann and James Everett Swann. A native of Cheraw and a graduate of Coulter Memorial Academy, Vera earned her bachelor of arts in religion from Johnson C. Smith University in Charlotte, North Carolina, and her master of arts in social science from Columbia University. She and her husband are civil right activists, authors, educators, and missionaries who served in China and India. (Courtesy of Dr. Darius and Vera Swann.)

A tireless advocate for civic and social justice, James E. Crawford Sr. was active in many organizations, most notably the NAACP. He also served as chairman of the fifth congressional black caucus. In 1990, he was presented with the first Harry Briggs Achievement Award, sponsored by the South Carolina Conferences of the NAACP. Having learned the printing trade at Jenkins Orphanage in Charleston, South Carolina, and the Tuskegee Institute, Crawford became the first African American employed by the *Cheraw Chronicle* when he was hired as a linotype operator in 1957. (Courtesy of Margaret Ann Reid.)

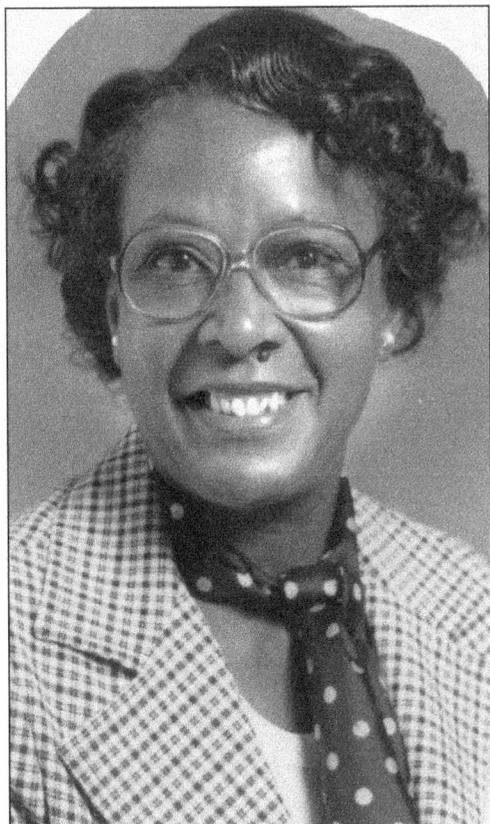

Lois Reid Crawford, the wife of James E. Crawford Sr., is a retired educator who began her teaching career as a "suitcase teacher" for the Colleton County school system in Cottageville, South Carolina. A graduate of Coulter Memorial Academy, she left the classroom upon her marriage but later returned, first as a teaching assistant at a day care school in Chesterfield and then as a staff member of the Barbara Lawrence School. She is a third-generation member of the G. W. Long Presbyterian Church. (Courtesy of Margaret Ann Reid.)

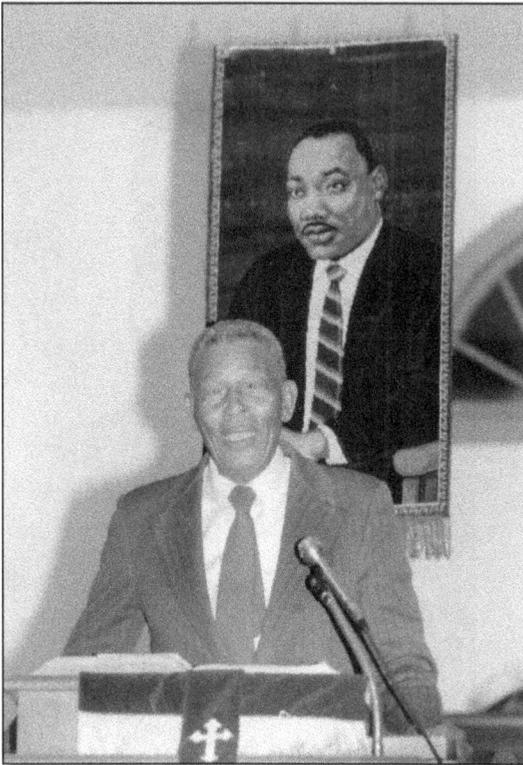

Robert McCall received his early education at Coulter Memorial Academy. He later attended Benedict College in Columbia and Morris College in Sumter, earning a degree in elementary education. He has taught in several counties and served as principal of the Patrick Colored School. As the first African American radio personality in the Cheraw area, McCall had two broadcasts: a daily show, *The Bob McCall Variety Show*, and a Sunday broadcast, *Chariot Wheels Time*. An organist and pianist, he played for his church, Pee Dee Union Baptist. This photograph was likely taken at the Martin Luther King Jr. Day celebration McCall founded after King's death in 1968. (Courtesy of Karen Wilkerson.)

William J. Reid graduated from Coulter Memorial Academy, Coulter Junior College, and Eckels College of Mortuary Science in Philadelphia. He is a licensed, practicing mortician and the owner of Reid's Funeral Home, established in 1949. Reid is a 33rd degree Mason and a member of Sanctorum Lodge No. 25 Prince Hall Affiliation (PHA). He also participates in Booker T. Washington Consistory No. 225, Al Bahr Temple No. 178 Prince Hall Shriners of Camden, South Carolina, and the Grand Lodge of South Carolina. Reid is well respected for his knowledge and experience in both the funeral industry and the Masonic organization. (Courtesy of Dr. Margaret Ann Reid.)

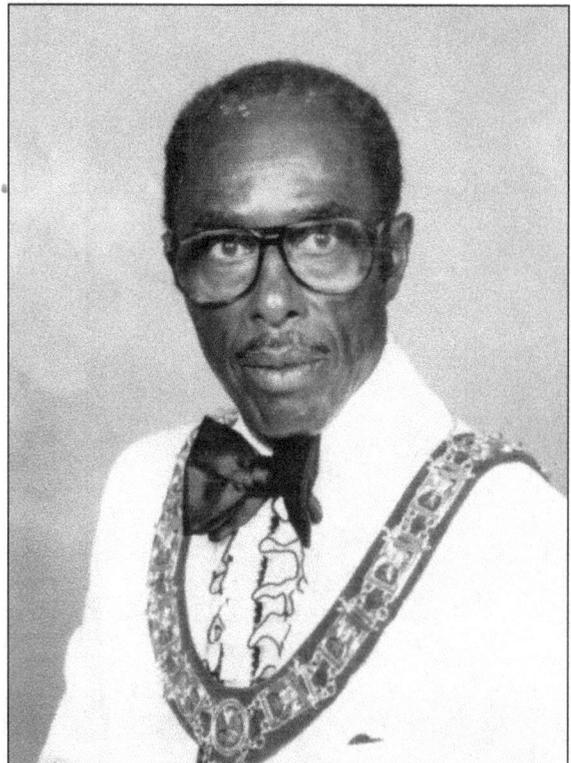

Joseph H. W. Morris Jr. was a successful businessman who founded the Morris Funeral Cottage. Upon receiving his bachelor of arts degree from Johnson C. Smith University in 1936, he moved to Cheraw and operated his establishment on Second Street. When Morris opened his funeral home, licensure was not required by law; however, he had received training during a three-year apprenticeship with his father. He decided to attend the Gupton-Jones School of Mortuary Science in Nashville, graduating in 1938. (Courtesy of Jacquelyn M. Brooks.)

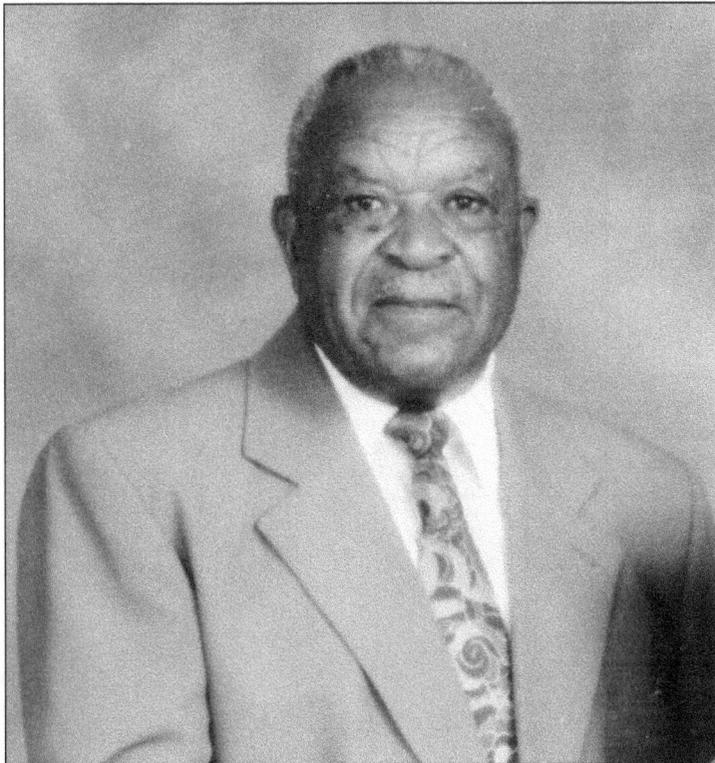

For 48 years, Legrand Bridges Sr. was employed by the Morris Funeral Cottage as funeral director. He was a member of the Sanctorum Lodge No. 25 PHA and a second-generation member of Wesley United Methodist Church, where he served on the Wesley Men Organization. In his early years, Bridges played left field with the Cheraw Red Sox. He married Lorraine Robinson. (Courtesy of Lorraine Bridges.)

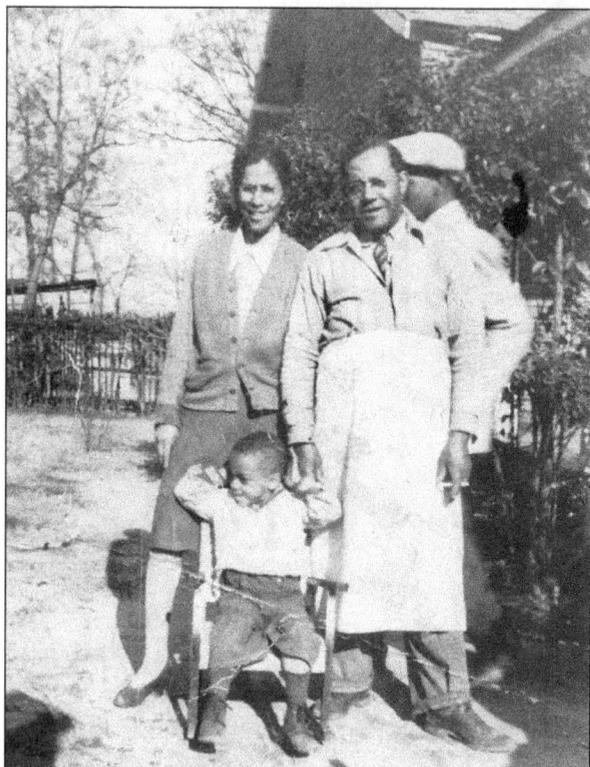

Charles McClellan, better known as "Chitlin' Charles," operated a store and restaurant on Huger and Maynard Streets. People traveled from all parts of the Carolinas to sample his famous chitlins. The store provided snacks such as ice cream and penny candy and everyday items like bread, milk, flour, and sugar. Here McClellan wears an apron and stands with his wife, Bertie Godfrey McClellan, and son Johnnie. (Courtesy of Karen Wilkerson.)

In the 1940s, Carrie Dorsey Lashley opened Carrie's Beauty Rest. She attended the Apex School of Beauty Culture in New York, graduating with the class of 1941. Her column in the *Cheraw Chronicle*, "Carrie's Social Notes," shared the news in the black community. Carrie's husband, Livingston Lashley, taught music at Coulter Memorial Academy and played the organ at Pee Dee Union Baptist Church. He was the Scoutmaster and she a den mother with Cub Pack 175. (Courtesy of Karen Wilkerson.)

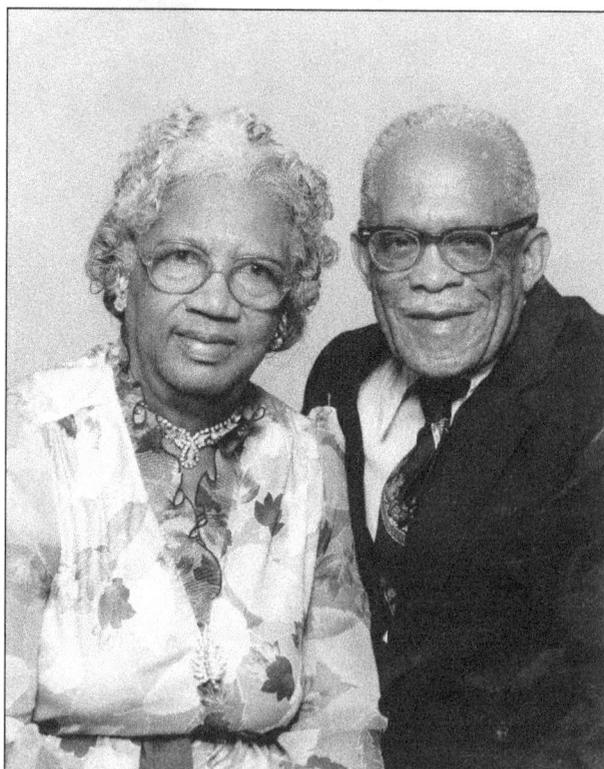

Charles Alford and Isabell Talley McDonnell were a prominent family and the proprietors of several businesses. Reared in Waynesville, North Carolina, Charles attended A&T Normal and Industrial School in Greensboro. In 1940, he opened Arrow Dry Cleaners on Second Street and, in 1948, Superior Dry Cleaners on Kershaw Street. A tailor, Charles actually made the suit he is wearing in this photograph of his grandson's wedding. Isabell operated Sonnie's Grill and Lounge, a popular gathering place on Kershaw. Civically oriented, she worked with the Girl Scouts, served in Venus Chapter No. 51 in the Order of the Eastern Star and in the Addie Pickens Federated Club, and volunteered at the Barbara Lawrence School. (Courtesy Alfred McDonnell.)

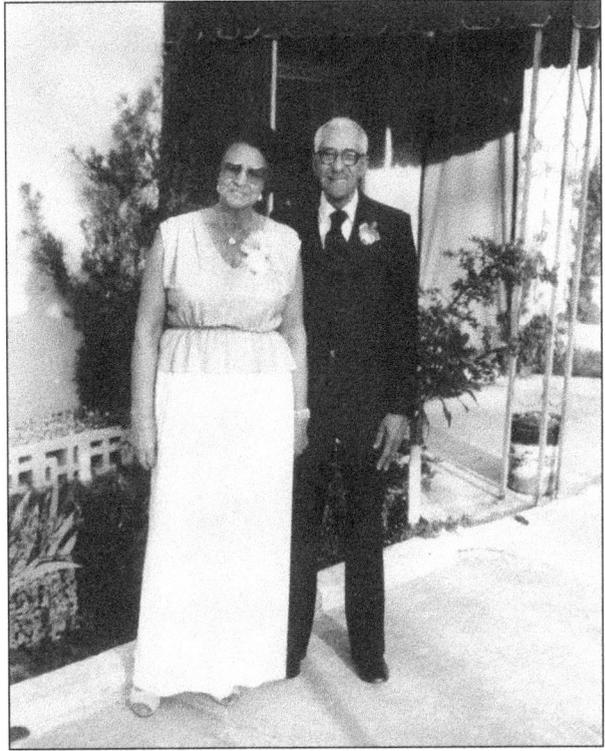

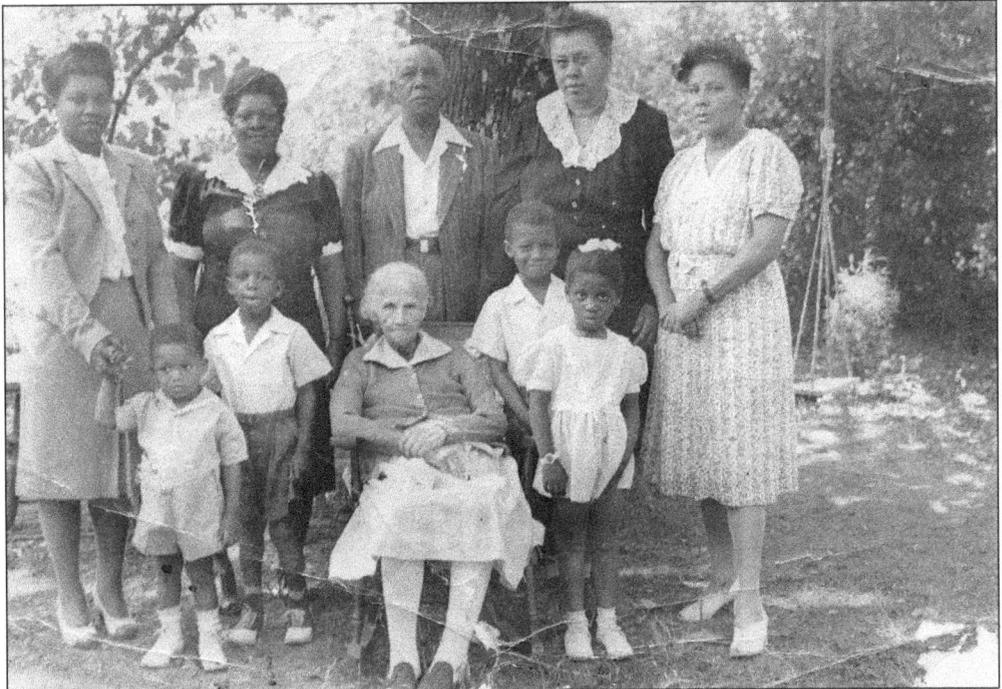

Matriarch Edith Munnerlyn poses with her family; from left to right behind her are Kate Smith, Roxie Munnerlyn, Willie Munnerlyn, Lot Munnerlyn, and Lem M. Ellerbe. (Courtesy of Karen Wilkerson.)

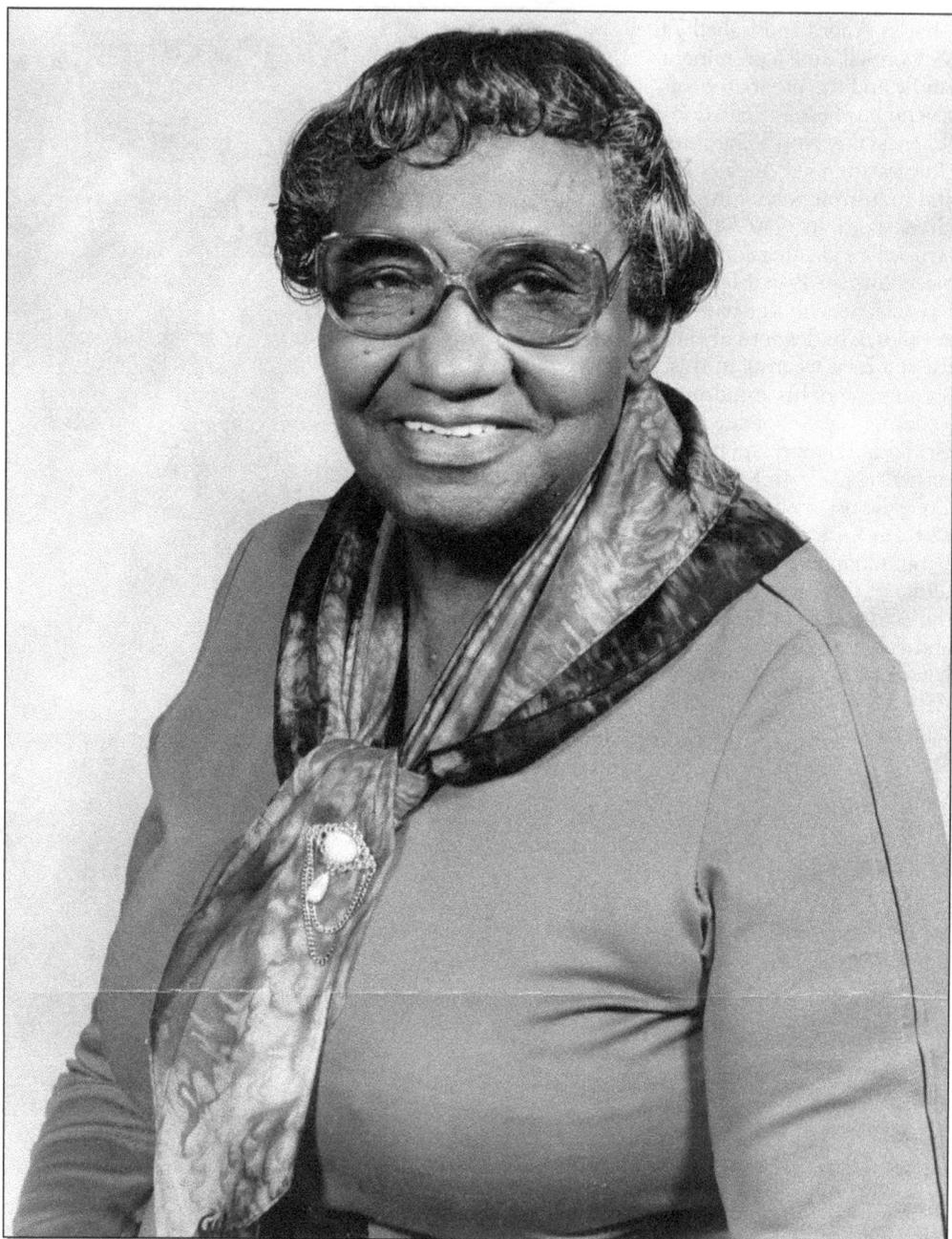

Bernice Stokes Robinson graduated as valedictorian of the Coulter Memorial Academy class of 1932 and continued her education through correspondence courses at several colleges. In 1950, she graduated summa cum laude from Barber Scotia College in Concord, North Carolina. She taught for 41 years in the Chesterfield County school system and volunteered for 15 years as director of the Barbara Lawrence School. Bernice wrote a column for the *Cheraw Chronicle*, "Cheraw United News," which shared information and events pertaining to the black community. She was married to Major Robinson. (Courtesy of Marjorie Streater Lynch.)

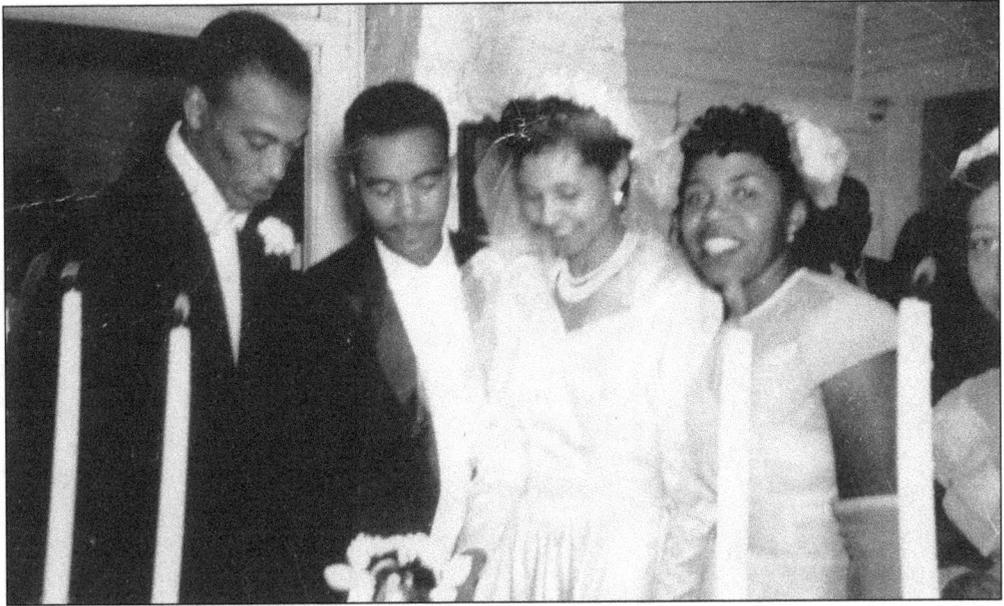

On June 25, 1949, John Evans McCall and Nellie Mae Talley were united in marriage at Wesley United Methodist Church in Cheraw. The reception was held at the home of the bride's parents, Mr. and Mrs. Martin Luther Talley (Tina Wilson). John and Nellie are pictured in the center looking at their wedding cake. (Courtesy of Wayne McCall.)

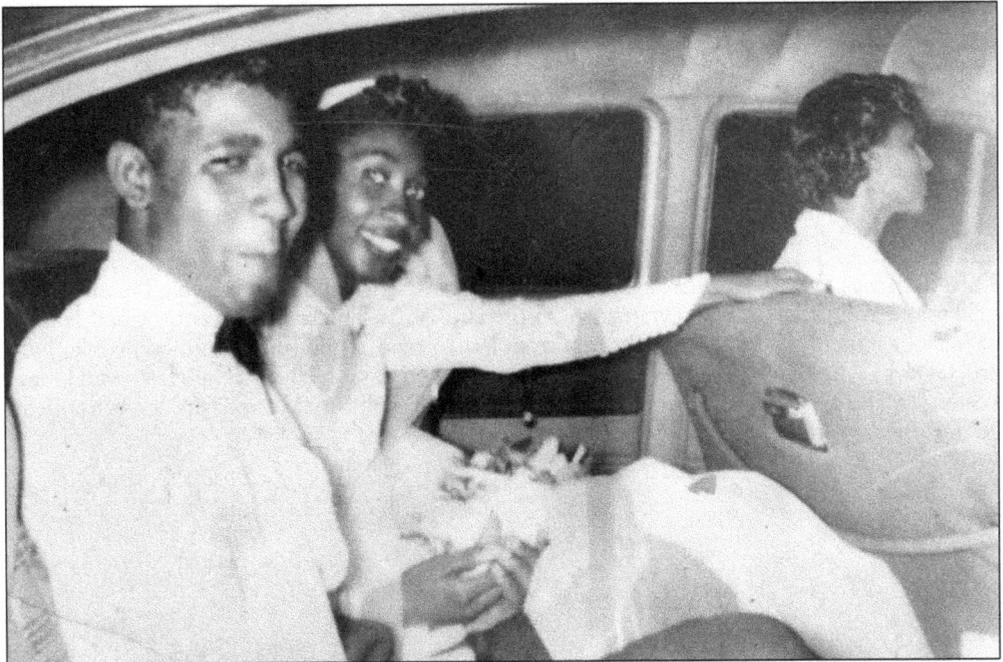

Paul Stewart Streater and Marjorie Robinson Streater are shown on their wedding day, July 19, 1952. The ceremony was held at G. W. Long Presbyterian Church in Cheraw. In 1955, Paul became one of the first black boom operators in the U.S. Air Force. Marjorie taught at Long High School, worked for the Department of Social Service, and taught kindergarten at the Barbara Lawrence School. (Courtesy of Marjorie Streater Lynch.)

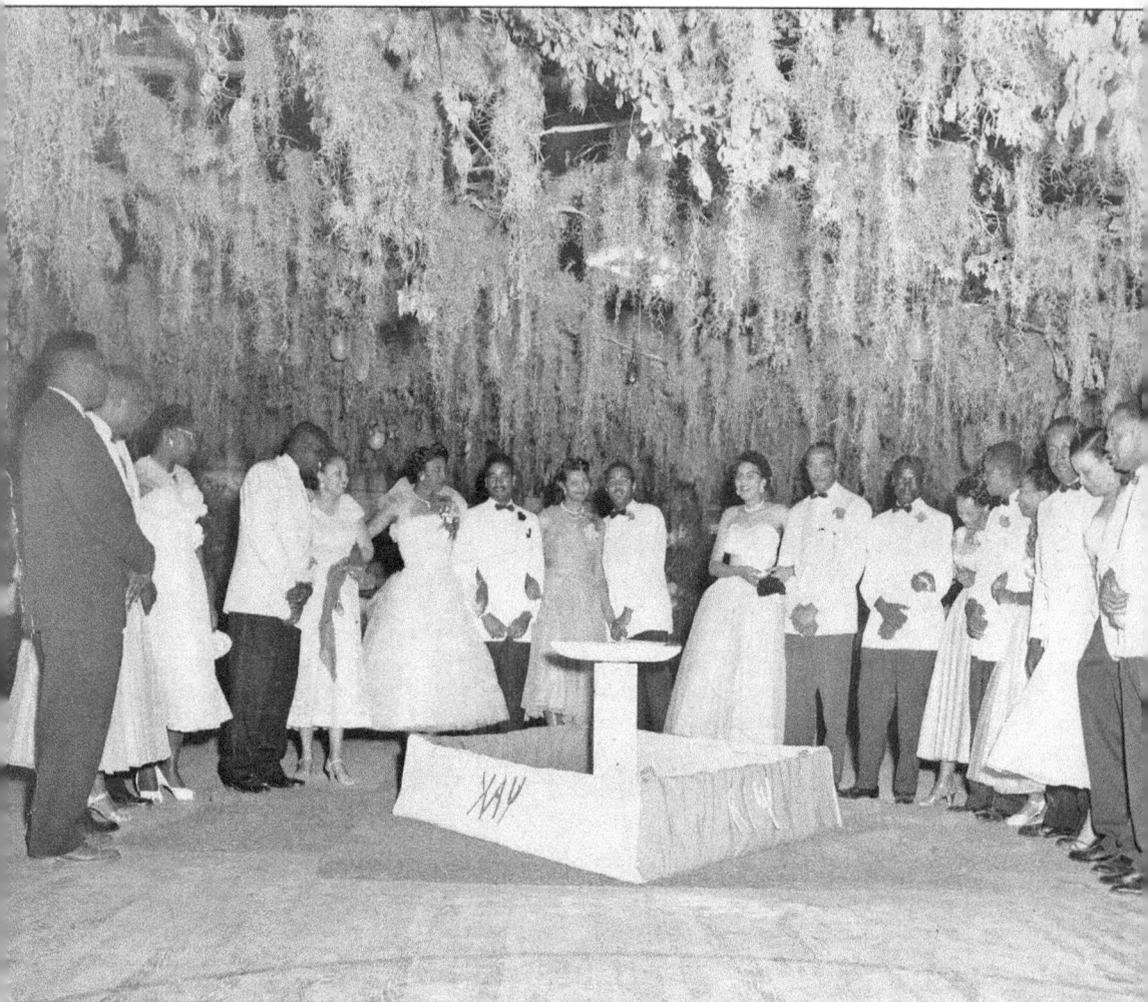

The prestigious Kappa Dance brought people to Cheraw from neighboring towns. This affair was held at the Long High School gymnasium in the late 1950s. The brothers went to great lengths to make it a night to remember. Pictured from left to right are four unidentified people, John and Gladys Cole, Atty. and Mrs. Frank Cain, Atty. John E. and Nellie McCall, Larrie and Mary Foster, Mr. and Mrs. James Austin, Mr. and Mrs. Warren Robinson, Mr. and Mrs. Jonas Kennedy, N. T. Robinson, and unidentified. (Courtesy of Larrie Foster.)

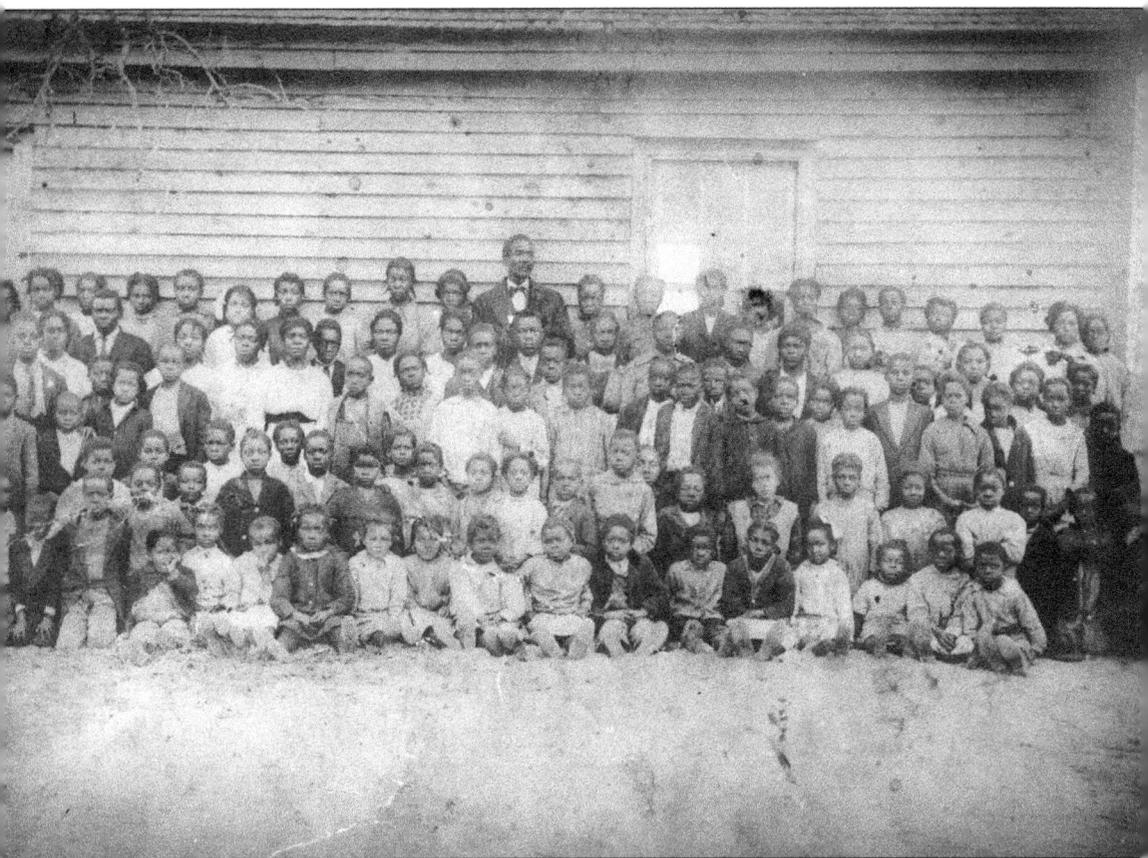

In this early-1900s photograph, Smithville Colored School students pose with their teacher, Professor Cash. Cora Lee (last row, fourth from the left) has descendants in the Cheraw and Chesterfield area. All other students are unidentified. (Courtesy of Naomi Jackson.)

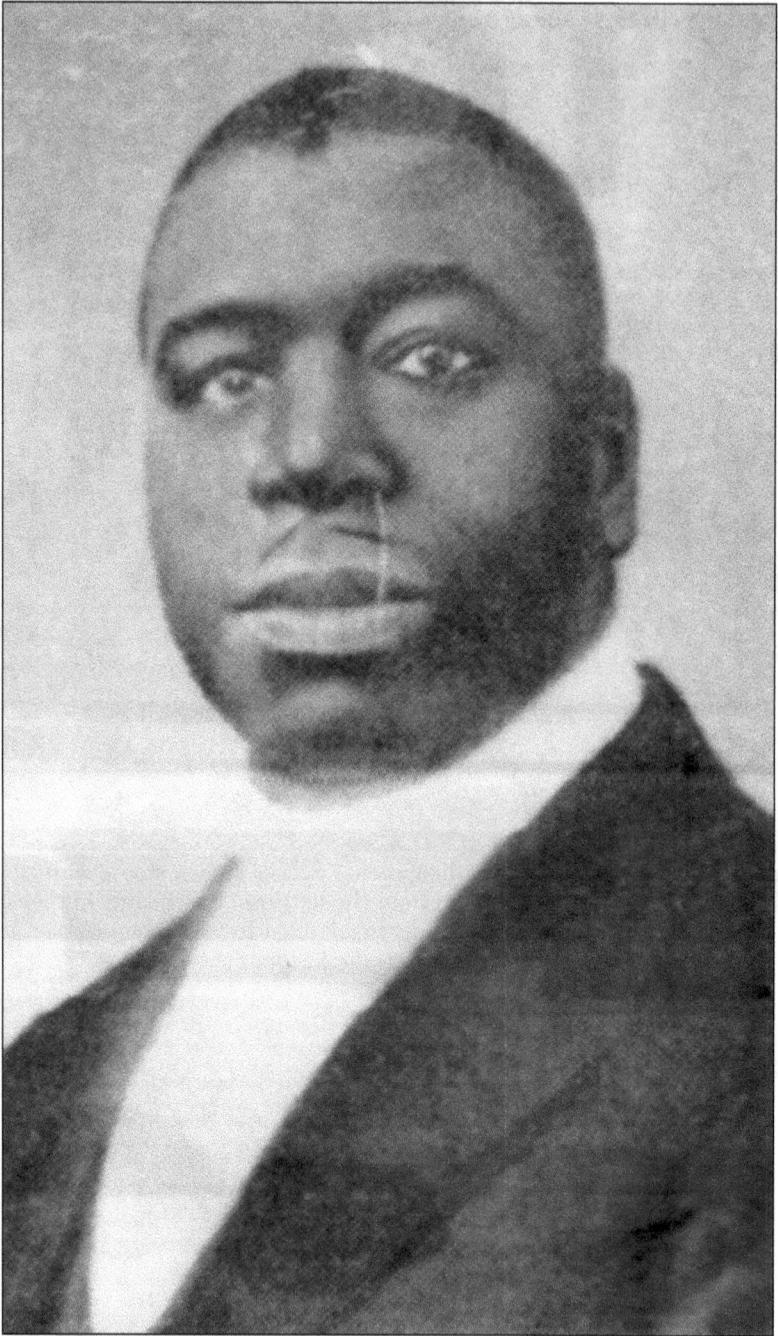

George Waldo Long, D.D., attended Brainerd Institute and graduated from the Divinity School at Biddle University. Dr. Long served as pastor of Cheraw Second Presbyterian Church and as principal of Coulter Memorial Academy. When he began his tenure with Coulter, he and his wife, Lillian Bull, worked tirelessly to improve the quality of the school. During his leadership, the academy became a coeducational boarding school with a high school and junior college. Before his death on August 3, 1943, Dr. Long witnessed the school grow from 87 students in 1908 to 509 students in 1943. (Courtesy of the *Cheraw Chronicle*.)

After graduating from Coulter Memorial Academy, Henry Louis Marshall earned his bachelor of arts from Johnson C. Smith University and his master of arts from Columbia University. Upon the death of Dr. G. W. Long, he was appointed acting executive of the academy until May 1944, at which time he was named full executive. When the academy closed in 1949, Marshall became the principal of Long High School. He actively participated in the G. W. Long Presbyterian Church and served in many civic organizations in the community. (Courtesy of the *Cheraw Chronicle*.)

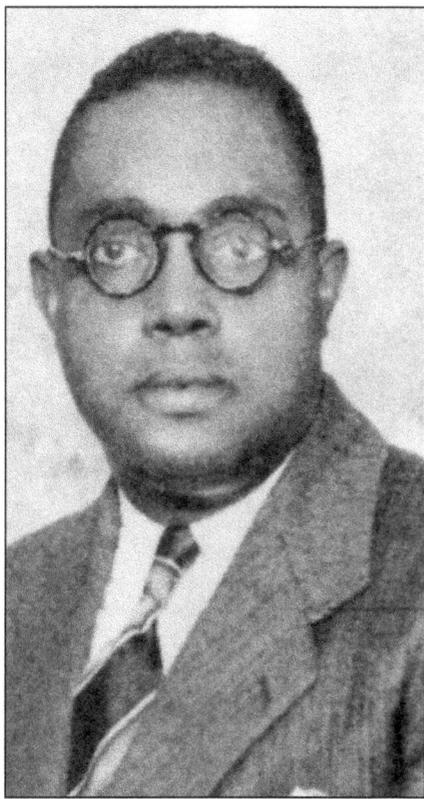

Flossie Hemphill came to Cheraw in the 1920s with her mother, Iva Hemphill, who was hired by Coulter Memorial Academy to teach the students how to cook. Flossie later graduated from the academy, attended Barber Scotia College, and taught at the Robert Smalls School. She married Henry Louis Marshall. (Courtesy of the *Cheraw Chronicle*.)

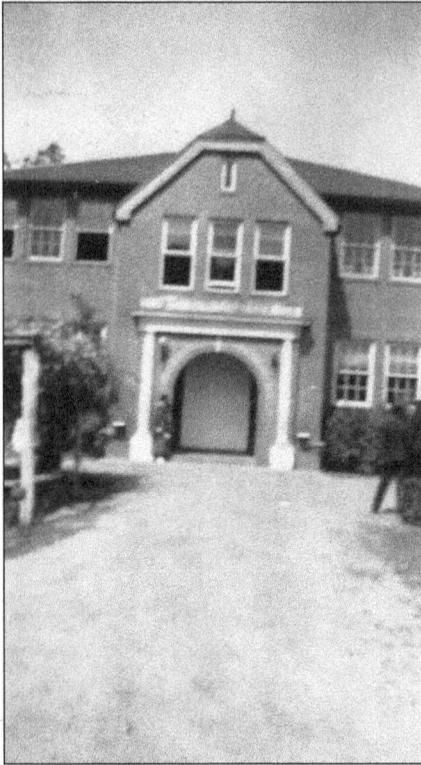

Students constructed Coulter Memorial Academy's administration building. This Negro Presbyterian institution was organized in 1881 and founded by Rev. J. P. Crawford, with support from Caroline E. Coulter of Hanover, Indiana, from whom the school received its name. (Courtesy of Dr. Margaret Ann Reid.)

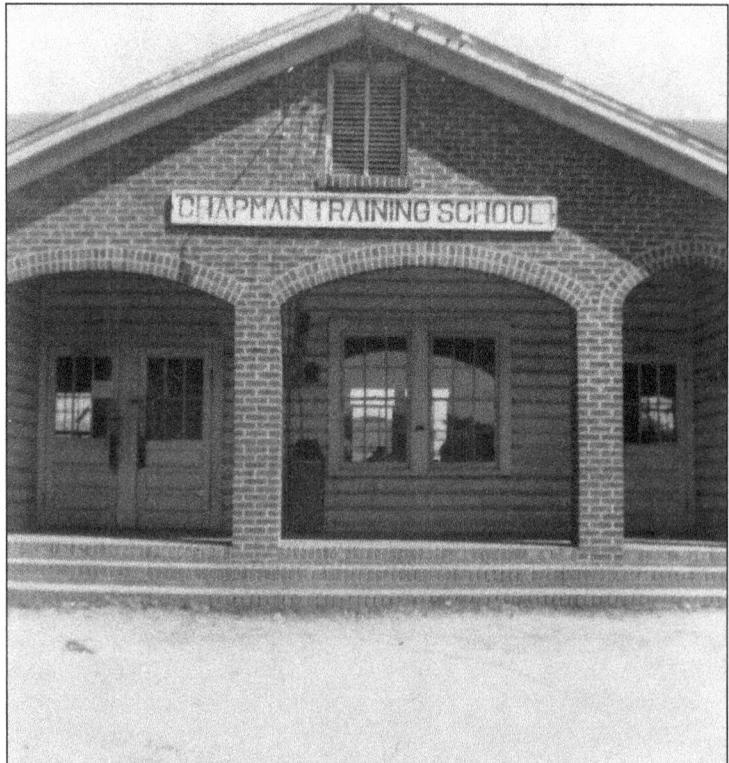

The Chapman Training School was part of the Coulter Memorial Academy campus. Located behind the administration building, it served as the junior college where students were trained to become teachers. (Courtesy of Larrie Foster.)

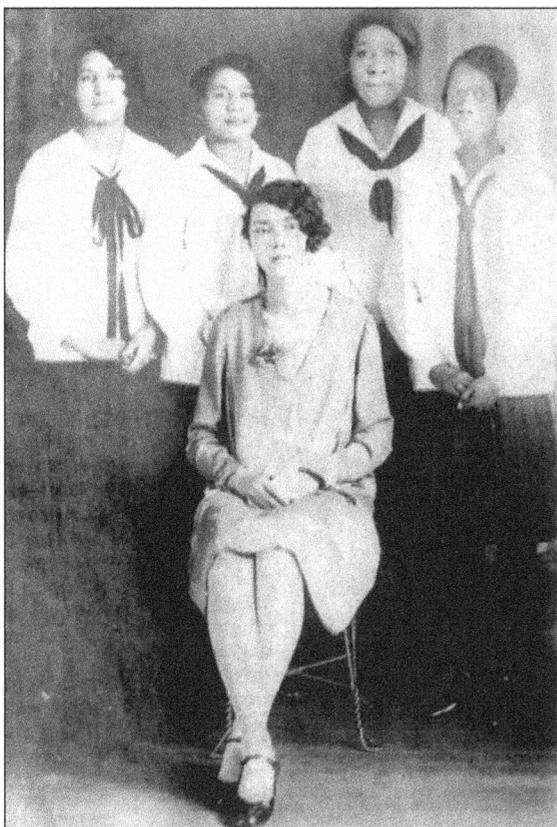

The Coulter Academy Quartet, sponsored by the women's organization of the Presbyterian church, traveled the eastern and midwestern states promoting work for the Board of National Missions. Pictured from left to right are Olethia Wilson, Flossie Hemphill, Susie McCullough, and Annie Gillespie. The group's music director was Naomi Williams, seated in front of the quartet. (Courtesy of the *Cheraw Chronicle*.)

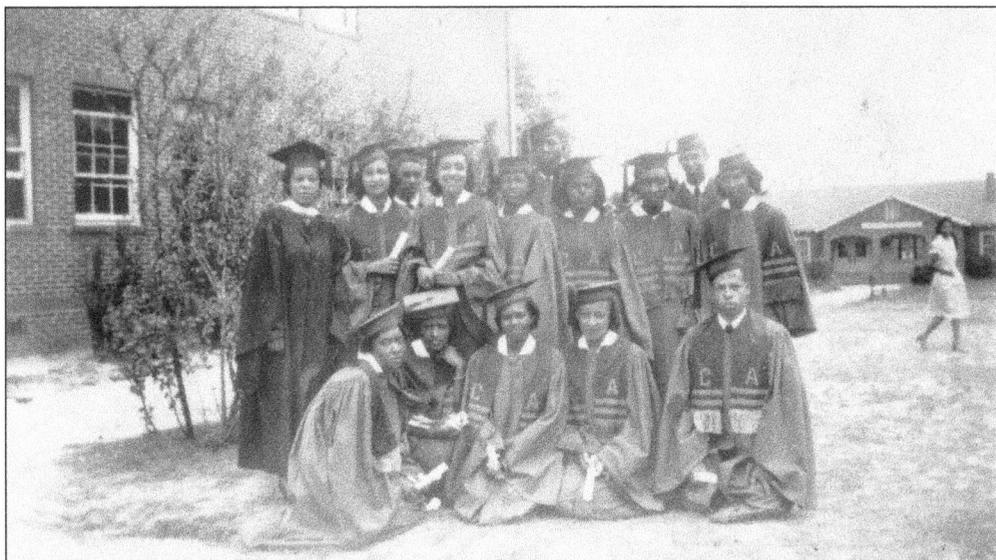

Coulter Academy's class of 1945 poses for a group photograph. Shown from left to right are the following: (first row) Dorothy Hilliard, Janie Furman, Mary Douglas, Mary Hardison, and Ernest Woods; (second row) teacher Nellie McCall, Margaret Boatwright, Elizabeth Talley, Marian Dorsey, Charlotte Davis, Nezzie Hilliard, and Amanda Poe; (third row) Ernest Gillespie Jr, Oliver Sims, and Charles McDonald. (Courtesy of Margaret Ann Boatwright Anderson.)

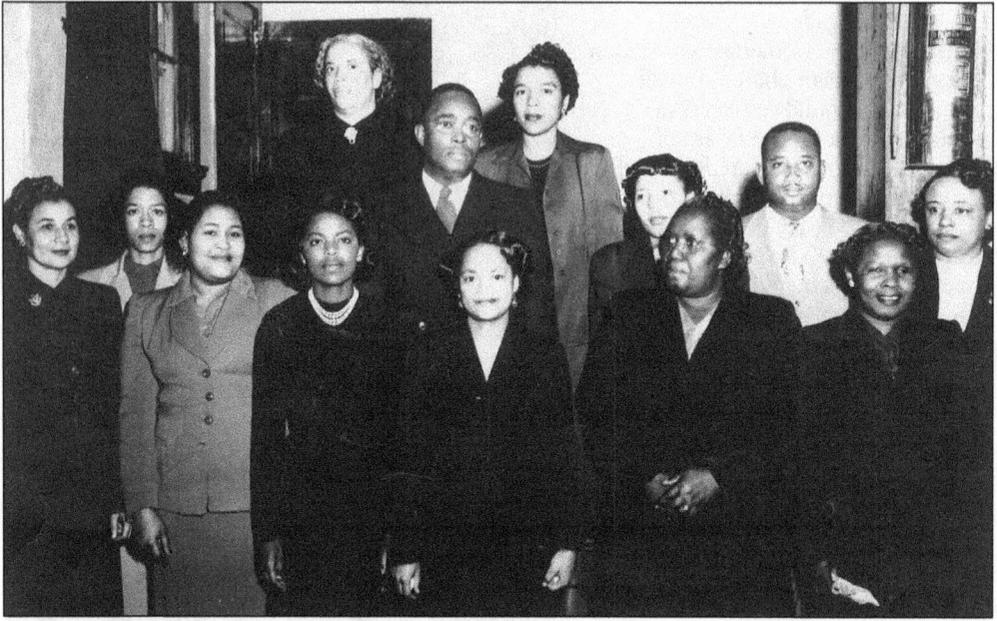

Faculty members gather in the Coulter Memorial Academy administration building in 1951. Pictured from left to right are the following: (first row) Gladys Hanna, Mary Ida Walker, unidentified, Charlotte Davis Atkins, Gertrude Brevard, Wilhelmina Gillespie, and Georgia Gillespie; (second row) ? Hicks, Henry Marshall, Lou Emma Pogue, Mary W. Foster, Rev. John M. Ellis, and ? Jackson. (Courtesy of Lovye Oesterlin.)

In the early 1950s, seventh-grade students perform the play *Wild Rose* at Coulter Memorial Academy under the direction of Gladys Hanna. Seen from left to right are Madelyne Long, Margaret Reid, Thomas Jackson, Lillian Sanders, Edgar McIver, and Carolyn Kennedy. (Courtesy of Dr. Margaret Ann Reid.)

These friends are all smiles while attending the 1957 prom at the Long High School gymnasium. Shown from left to right are Jimmy Talley, Ernestine Primus, Carolyn Hooks, Margaret Ann Reid, and Julia Wilson. (Courtesy of Dr. Margaret Ann Reid.)

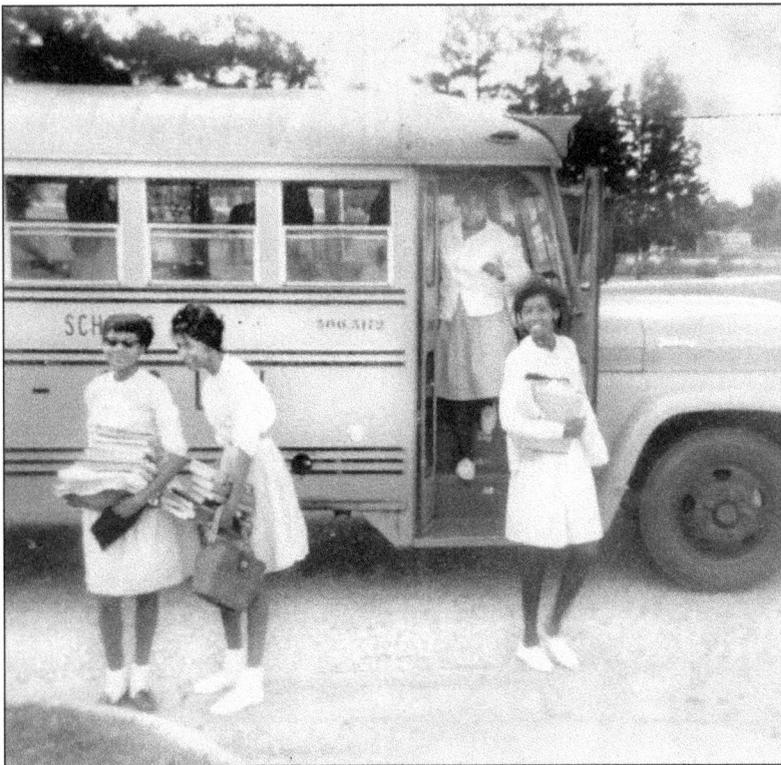

Nancy Ellison (left) and Mary Funderburk engage in a little girl talk while making their way off the bus in 1965. (Courtesy of Dr. Margaret Ann Reid.)

Julia Love DeBerry was active with the youth at Robinson African Methodist Episcopal Zion Church. She participated as a singer in the Wings of Zion Choir, as a deaconess and an usher, and as a class leader and Sunday school teacher. She also worked in the cafeteria at the Robert Smalls School. The founder of the junior choir, she is still affectionately called "Aunt Julia" by her former students and choir members. She was married to the late James DeBerry. (Courtesy of Virginia Love.)

Alphonso Wilson was the first African American to serve as deputy sheriff with the Chesterfield County Sheriff Department. At one point, black leaders met with Sheriff Don Hill to voice their concerns about law enforcement, job opportunities, and appointments for blacks on the county boards. As a result of that meeting, Wilson was sworn in on August 1, 1967, and worked in that capacity for 18.5 years. He wed Lillian Elizabeth Humphrey. (Courtesy of Elizabeth H. Wilson.)

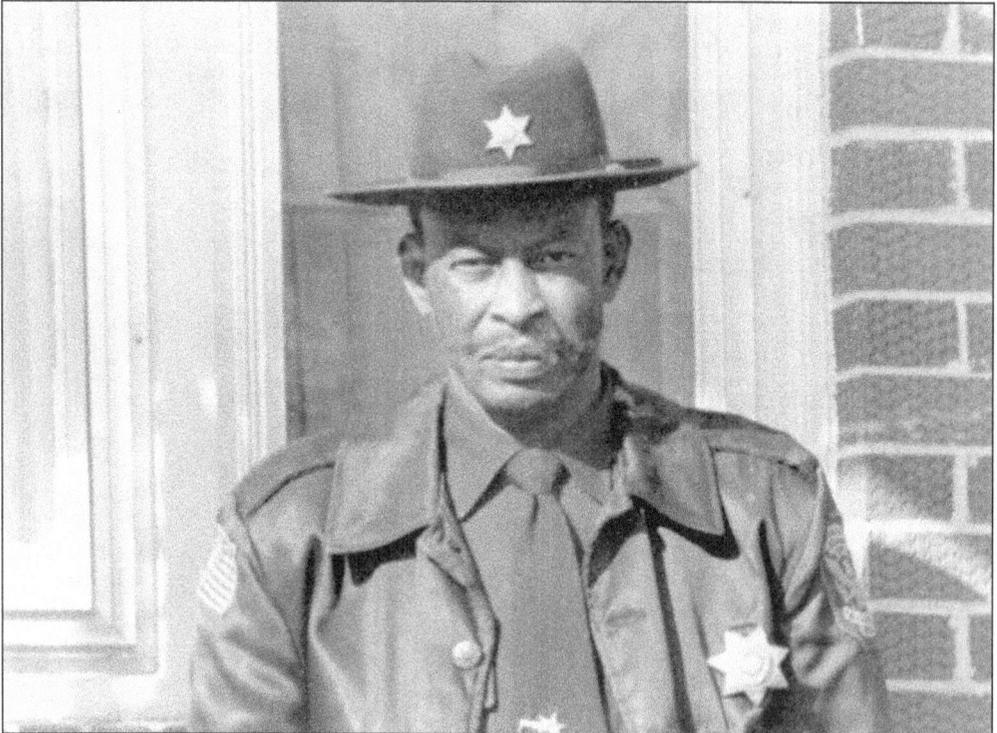

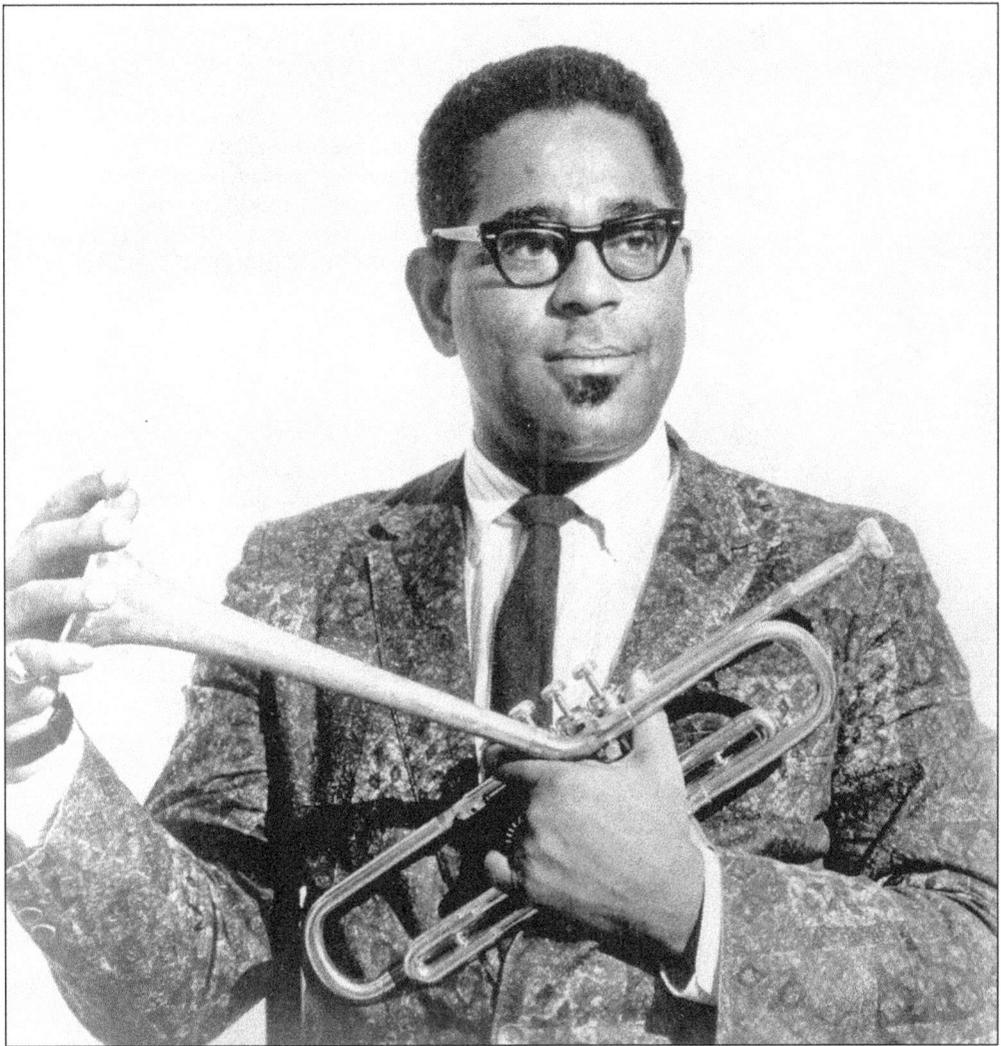

Jazz great John Birks "Dizzy" Gillespie was born in Cheraw in 1917 and, along with his family, attended Wesley Memorial United Methodist Church. After graduating from the Robert Smalls School, he received a scholarship to the Laurinburg Institute in North Carolina. Dizzy was later awarded a Kennedy Center Honor for life achievement in the arts. A jazz festival is held every October to commemorate his life and contributions. Here he is pictured with his signature bent horn. (Courtesy of Vereen M. Wilson.)

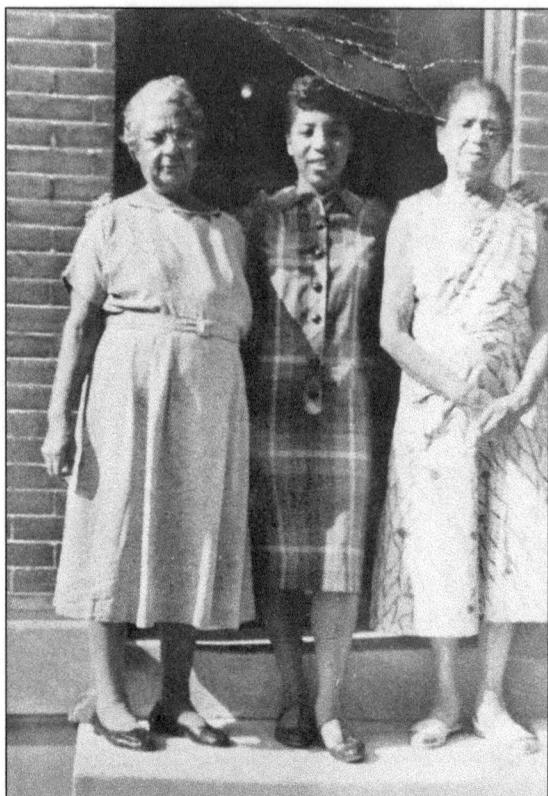

Dizzy Gillespie was raised by his mother, Lottie, as his father died when he was nine years old. Lottie Powe Gillespie is seen to the far right, with her sister Laura Powe McIntosh and her granddaughter Carolyn Gillespie (center). This snapshot was taken in the late 1950s. (Courtesy of Vereen M. Wilson.)

In the 1960s, Dizzy's family members smile during a dinner honoring the mothers of famous black musicians in New York. Shown from left to right are unidentified, Mattie Gillespie (sister), Euginia Gillespie (sister), Mary Lou ?, Vereen McIntosh (cousin), Lydia ?, Margaret M. Malloy (cousin), Harold Gillespie (nephew), Marie Summerville (sister), Lottie Gillespie (mother), and James P. Gillespie (brother). (Courtesy of Vereen M. Wilson.)

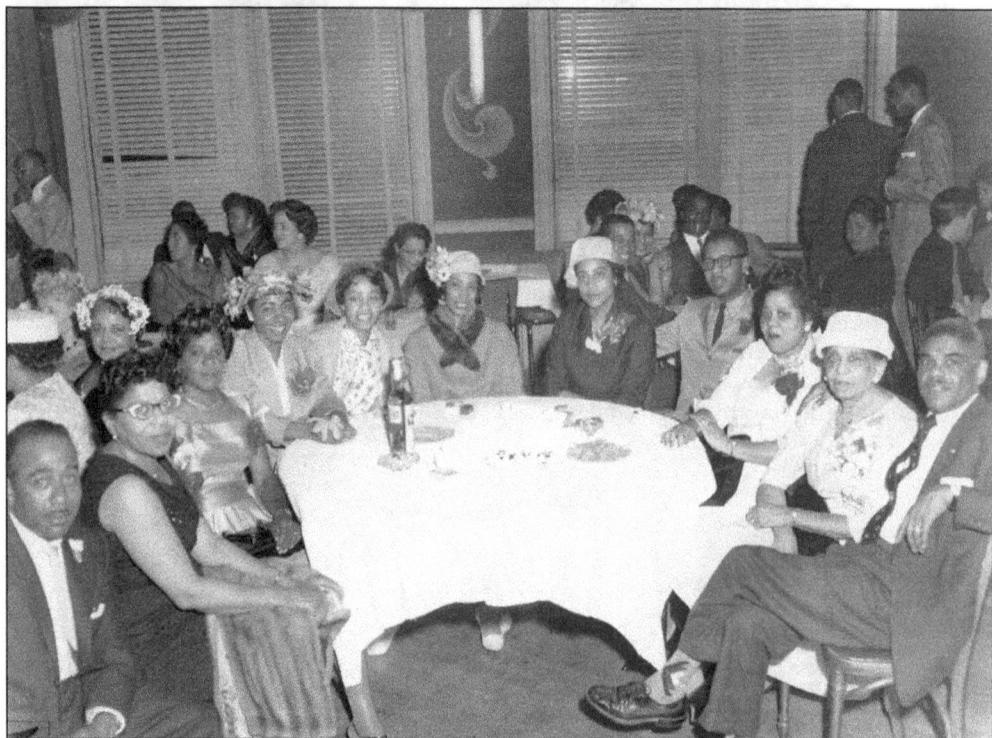

John L. Motley, the eldest of the Motley brothers, is the former music director of the New York City High School Chorus, which performs annually with the New York Philharmonic at the Lincoln Center. He also directed and conducted several choruses throughout New York and the surrounding states. The recipient of many music awards, he has received acclaim both nationally and internationally. Motley studied at Westminster Choir College at Princeton University and earned bachelor and master of arts degrees from New York University. Here he poses with his aunt Lucille McIver. (Courtesy of Lovye Osterlin.)

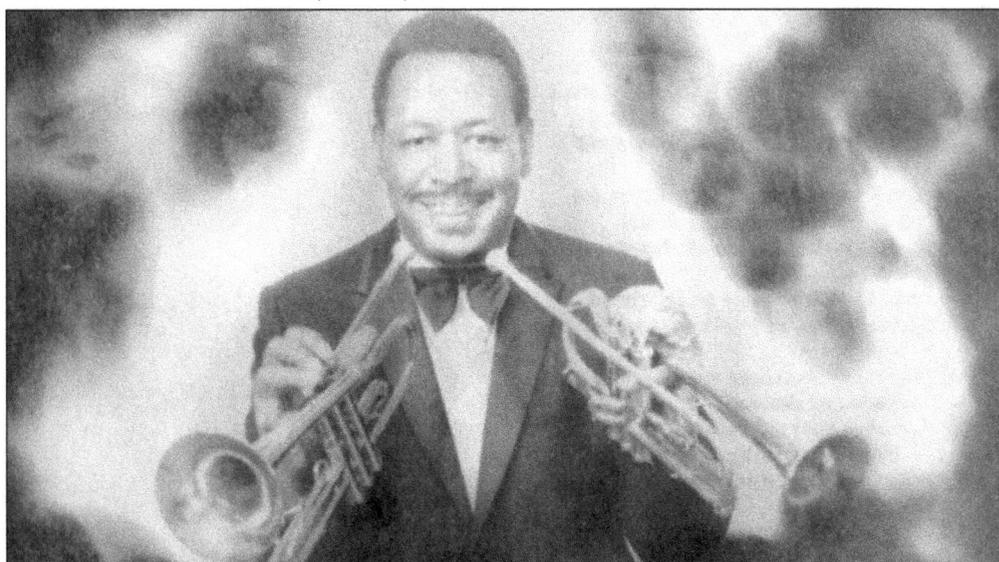

Also known as "the Dual Trumpeter," Frank Motley Jr. employs a unique style of playing two trumpets simultaneously. His first trumpet lesson came from Dizzy Gillespie, whom he joined in the be-bop movement, along with Charlie Parker, Theolonius Monk, and Kenny Clark. He is noted for writing music; many of his compositions have been recorded and are used among the rhythm and blues and jazz selections we hear today. He attended Georgia State College in Albany for two years before earning a degree in engineering at South Carolina State College in Orangeburg. (Courtesy of Wilbert Motley.)

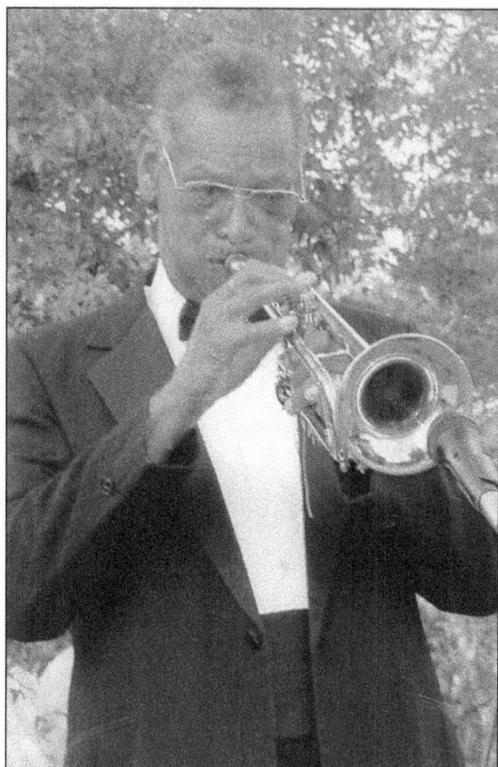

Wilbert S. Motley is a graduate of Coulter Memorial Academy and South Carolina State College. While attending, he played four years with the State College Collegian Orchestra. Certified in instrumental music and industrial arts education, Motley is the former director of personnel for the Chesterfield County School District, coordinator of adult and community education, director of Head Start, and coordinator for the Neighborhood Youth Corporation in Chesterfield and Marlboro Counties. He is an organizing member of the Red Toppers musical group, with whom he has performed for over 35 years. He is married to Gloria Motley. (Courtesy of Wilbert Motley.)

The Hillian Sisters began singing together in 1973 with the signature tune "Reach Out and Touch the Lord." Pictured from left to right are musician Callie Ellison, his wife Marilyn Hillian Ellison, Joyce Hillian Funderburk, and Gwendolyn Hillian Turnage. Not seen is their sister, Minnie Hillian Davis, also a part of the group. (Courtesy of Joyce H. Funderburk.)

# *Two*

# PATRICK

Carrol Campbell attended Coulter Memorial Academy, graduated from Johnson C. Smith University in Charlotte, North Carolina, and wed Lillie Mae Bennett. Campbell became the pastor of Huntersville Baptist Church, located in Huntersville, North Carolina. (Courtesy of Lucille Sellers.)

Vermel Dixon (above left) and her two daughters, Angeline (below left) and Hasker Dixon (below right), are shown at their family homestead in Middendorf around 1914. Middendorf was a little community situated between Patrick and McBee. (Courtesy of Floree Sellers.)

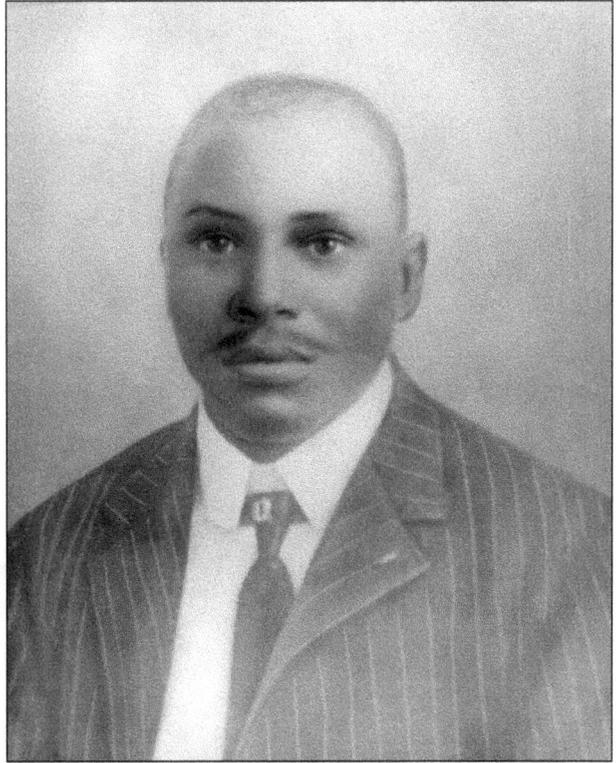

A farmer, Alexander Campbell hauled wood to the Rosenwald schools in the Patrick area. After marrying Florence Henderson, a teacher, he became the father of 16 children. The Campbells were members of the Morning Star Baptist Church. (Courtesy of Lucille Sellers.)

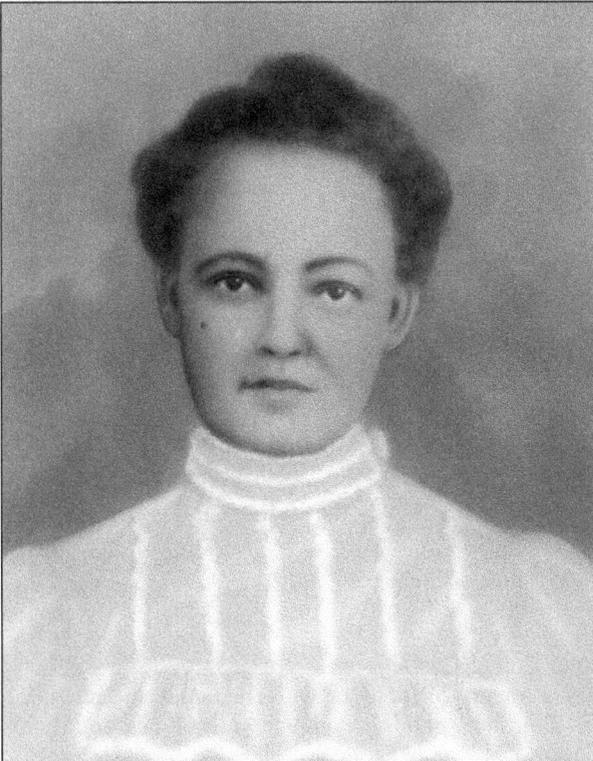

41

Mary Sellers began working for the Buies at the age of 16, living with the family and providing domestic services all of her adult life. The Buie family built her a home in the 1960s, and that is where she remained until her death. (Courtesy of Lucille Sellers.)

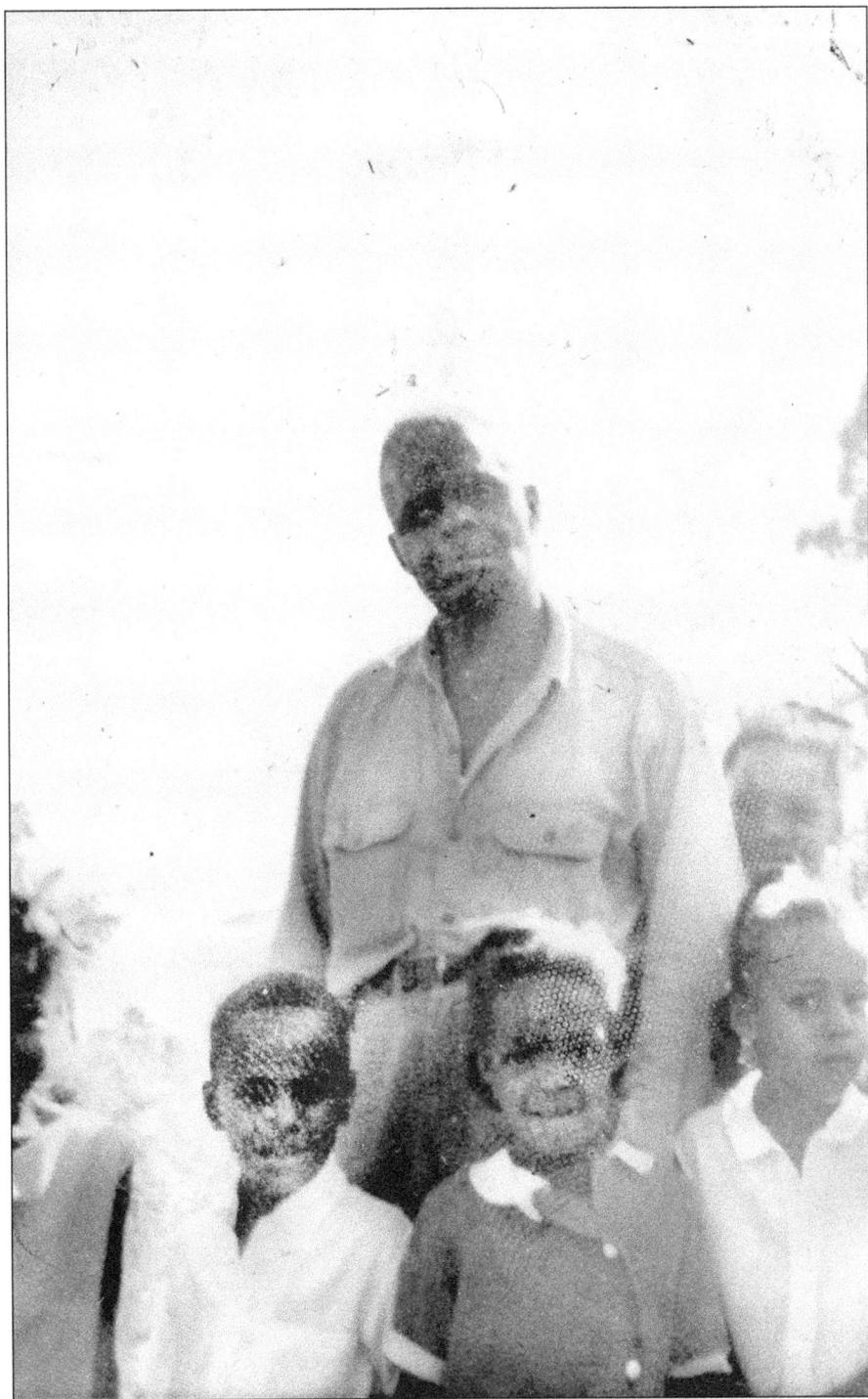

Charlie Sellers, pictured here with some of his grandchildren, was the husband of Maggie Wilkens and the father of eight children. He worked for the Seaboard Airline Railroad in Patrick and raised his family in the section houses located near the tracks. Sellers was also a member of the Morning Star Baptist Church. (Courtesy of Willie Sellers.)

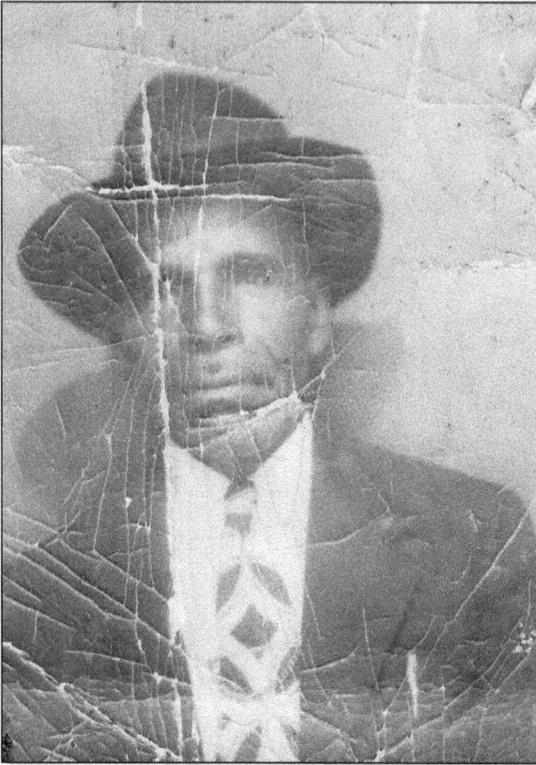

Though a farmer, Fess McQueen was more importantly known for his involvement in politics during school integration. He actively supported the black children of Patrick being bused to schools in Cheraw. (Courtesy of Thelma Bush.)

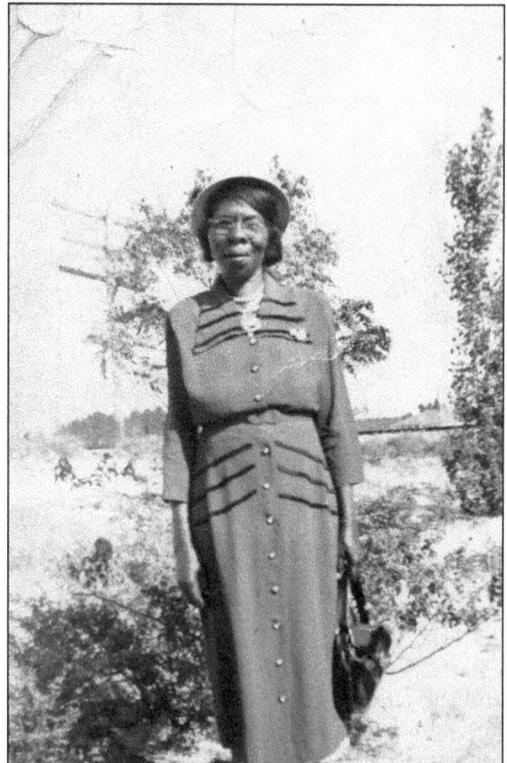

Emma Sellers McFarlan McQueen, born in the late 1800s, cooked for the schools in the Patrick area and participated in the Morning Star Baptist Church. After the untimely death of her first husband, Will McFarlan, in 1928, she married Fess McQueen. (Courtesy of Thelma Bush.)

Lucille Campbell Sellers is the wife of Jesse Sellers. Through the encouragement of Fess McQueen, she became the first African American to work with the voting polls in Patrick. She has also been instrumental in the Pine Straw Festival, held annually in May. Lucille continually serves in the community and is an active member of the Morning Star Baptist Church. (Courtesy of Lucille Sellers.)

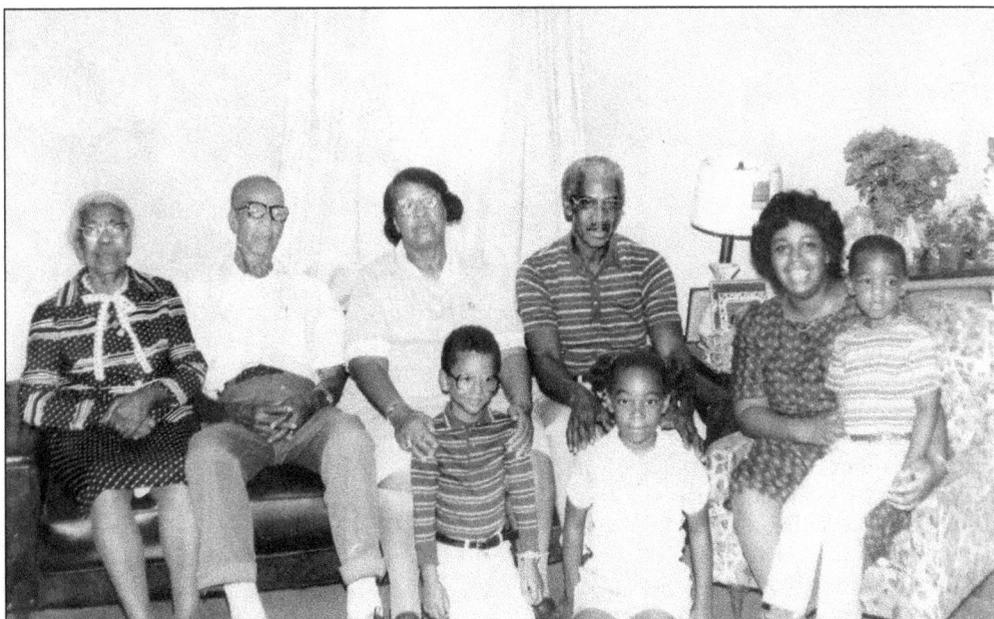

This photograph displays five generations of the Black family. Seen from left to right are Aline Black and Clarence Black, with their daughter Pleasant Sellers; their oldest grandchild, Jessie Sellers; their great-grandchild Patricia Ann Hudley; and great-great-grandchildren Charles Buchanan, Demetria Hudley, and Johnathan Hudley in his mother's lap. Clarence, a farmer, and Aline attended Piney Grove Baptist Church. (Courtesy of Patricia Hudley.)

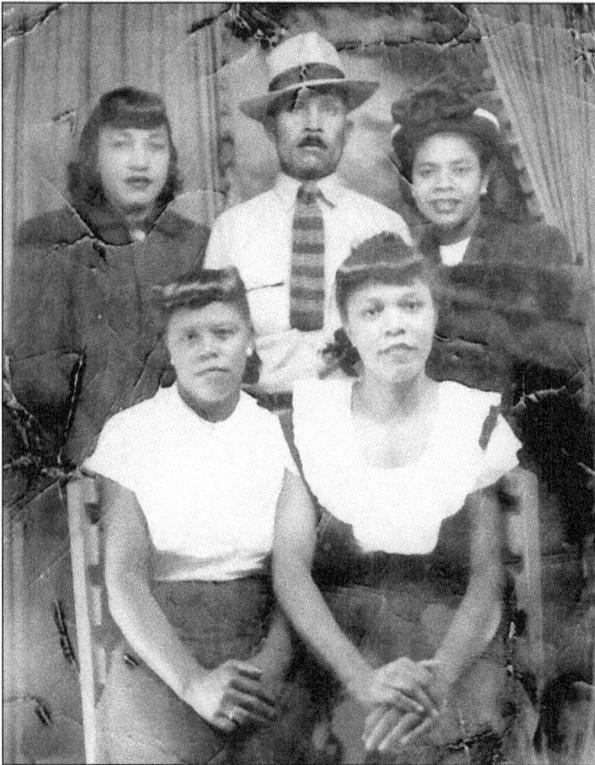

The children of Alexander and Florence Campbell pose for a portrait while visiting Cheraw. Shown from left to right are the following: (first row) Gladys C. Fann and Lucille Sellers; (second row) Beatrice C. Baptiste, Winston Campbell, and Birlee C. Morgan. (Courtesy of Lucille Sellers.)

The Truelight Gospel Singers group is comprised of family members who began singing together in the early 1960s. In the beginning, the group was managed by patriarch Frank Wilkes Sr., and it still performs today with additional members of the Wilkes family. Pictured from left to right are the following: (first row) Joeanna Wilkes, Dora Wilkes, and Rita Wilkes; (second row) James Wilkes Jr., Hubert Wilkes, Barbara Wilkes, Otis Little, and Frank Wilkes Jr. (Courtesy of Dora Wilkes.)

# *Three*

# CHESTERFIELD

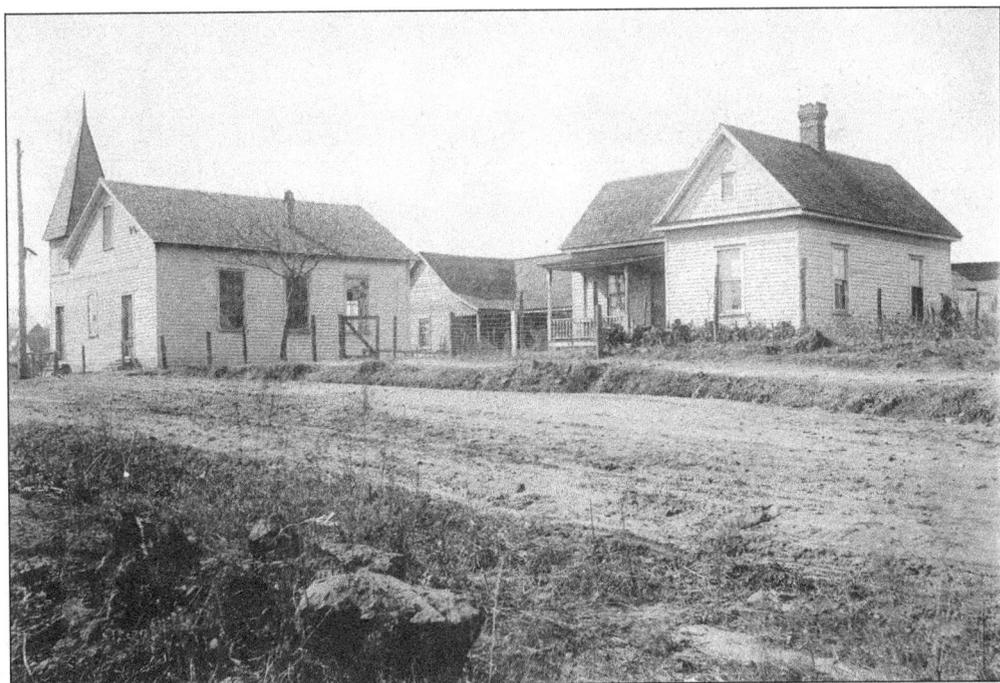

In this 1920s photograph of Mill Street, Grandview Presbyterian Church appears on the left, with the Presbyterian school behind it. On the right is the parsonage, where Rev. R. E. and Mary Foster lived with their three sons. (Courtesy of Larrie Foster.)

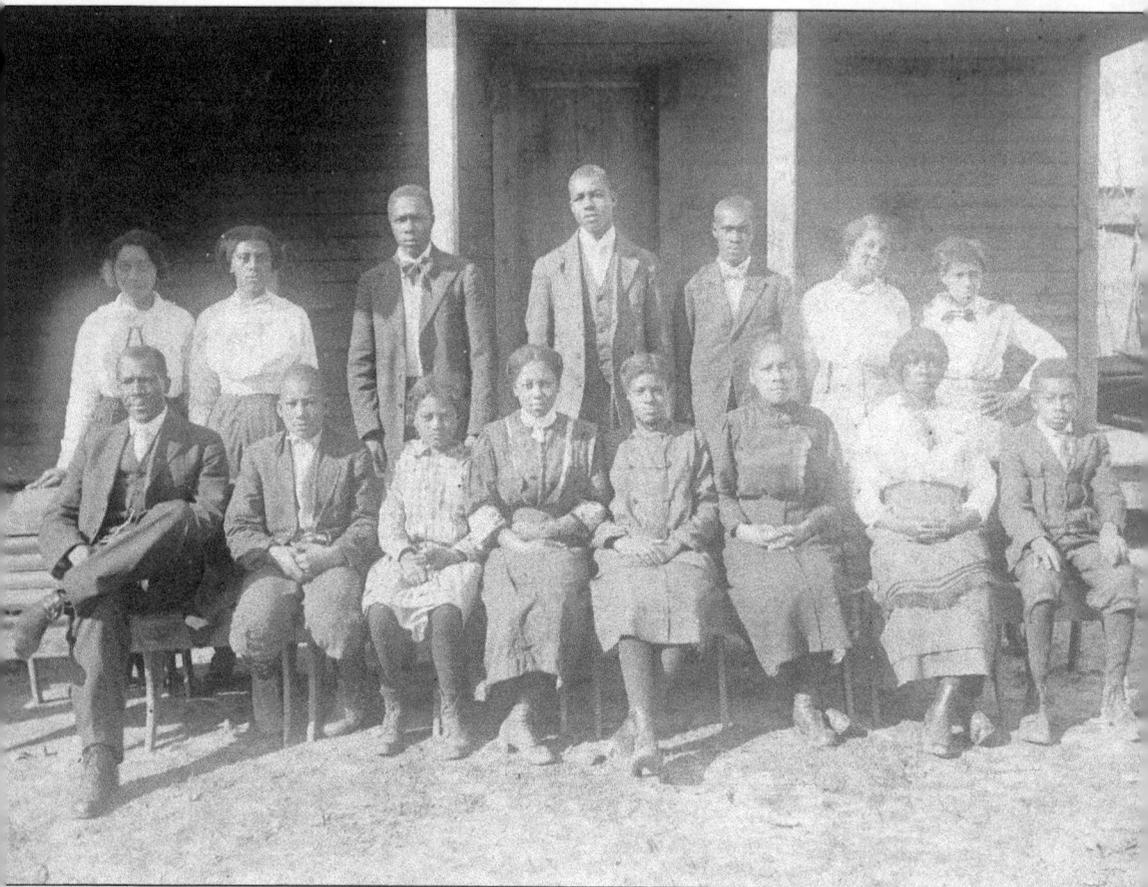

The class of 1918 is assembled in front of the Grandview Presbyterian School with principal Rev. R. E. Foster. Located behind the church, the school accommodated first through eighth grades. (Courtesy of Larrie Foster.)

A bright-eyed infant stands on a chair wearing a white full-length gown in the early 1900s. The circle embroidery on the front of the gown is mimicked on her sleeves. Her neck is adorned with a beaded necklace, and her hair has a big fluffy bow to match her gown.

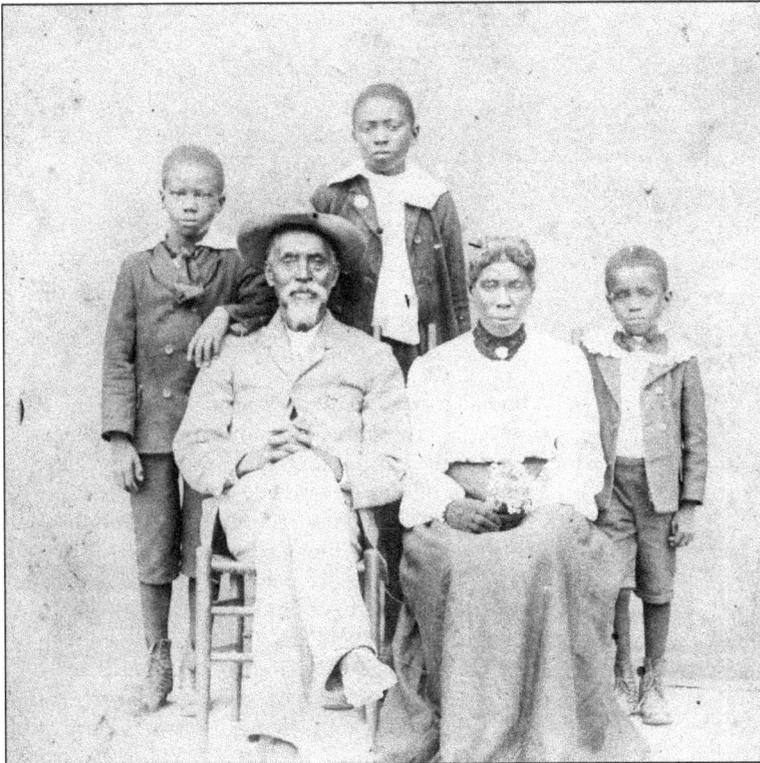

This American family appears worn from the same types of hardships experienced by many people in the early 20th century. The parents understand the importance of taking a family portrait. (Courtesy of Roseanna Hillian.)

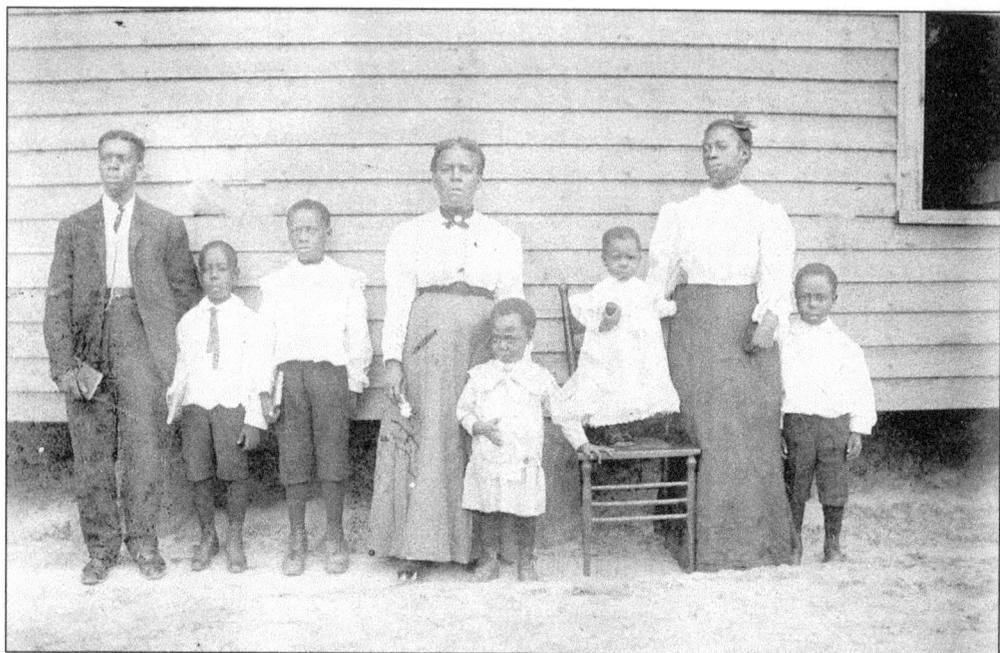

This early-1900s photograph, taken at home on Pleasant Grove Church Road, depicts Martha Ford Hillian with her children and grandchildren. Seen from left to right are Rufus Hillian, Lemuel Hillian, Timothy Hillian, Martha Hillian, Thomas Hillian, baby William Sanders, Rebecca Hillian Sanders, and Johnny Sanders. (Courtesy of Roseanna Hillian.)

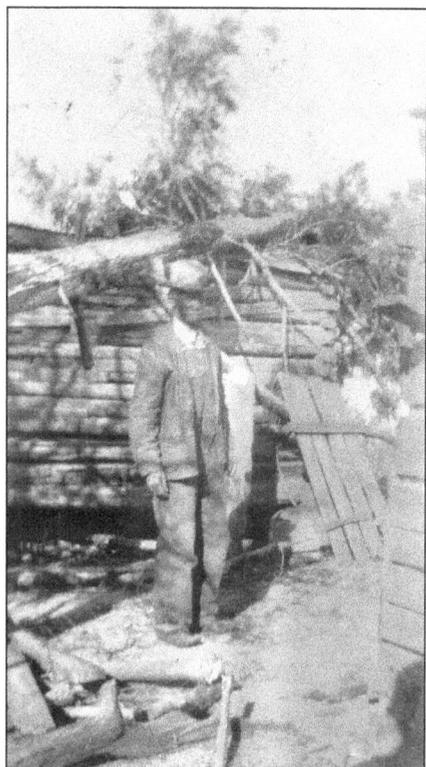

Thomas Jefferson Hillian was auctioned at the age of seven. He recounted to family members that he just smiled as he stood on the auction block, hoping to be chosen over the other little boys. At the time, he did not realize he was actually being selected for a life of servitude. After the Civil War, Thomas became a farmer and amassed more than 100 acres of land. Three of his sons became educators. He was also fortunate enough to be reunited with his parents. This 1940s photograph shows the spot where a cedar tree fell on Thomas's log cabin during a storm. (Courtesy of Roseanna Hillian.)

Born in 1881, Rev. William Walker Edwards graduated from the Clinton Normal and Industrial School in Lancaster, South Carolina, and also attended Benedict College in Columbia and Morris College in Sumter. He taught at various schools throughout the county but was disappointed with the formal education setting. Edwards began to organize groups to discuss building a public school for black children. Also an ordained minister in the African Methodist Episcopal Zion Church, he offered classes in his church for a couple of months to provide black children with educational opportunities. In the early 1950s, a school was constructed for black students and named in his honor. (Courtesy of Lottie Ruth Edwards.)

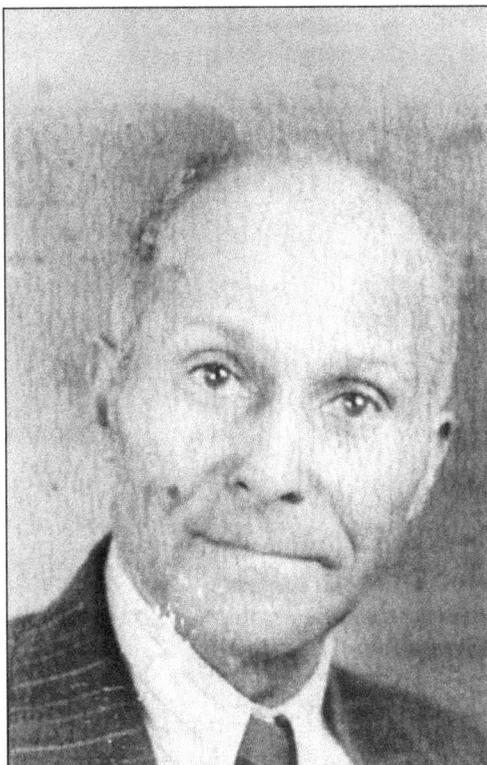

Lottie C. Lowery Edwards, the wife of Reverend Edwards, sponsored fund-raising programs with Pearl Edwards, Levan Edwards, Willie McCoy, and others to build a new black elementary school in Chesterfield. She and her husband were proponents of education, and all of their children obtained higher degrees. (Courtesy of Lottie Ruth Edwards.)

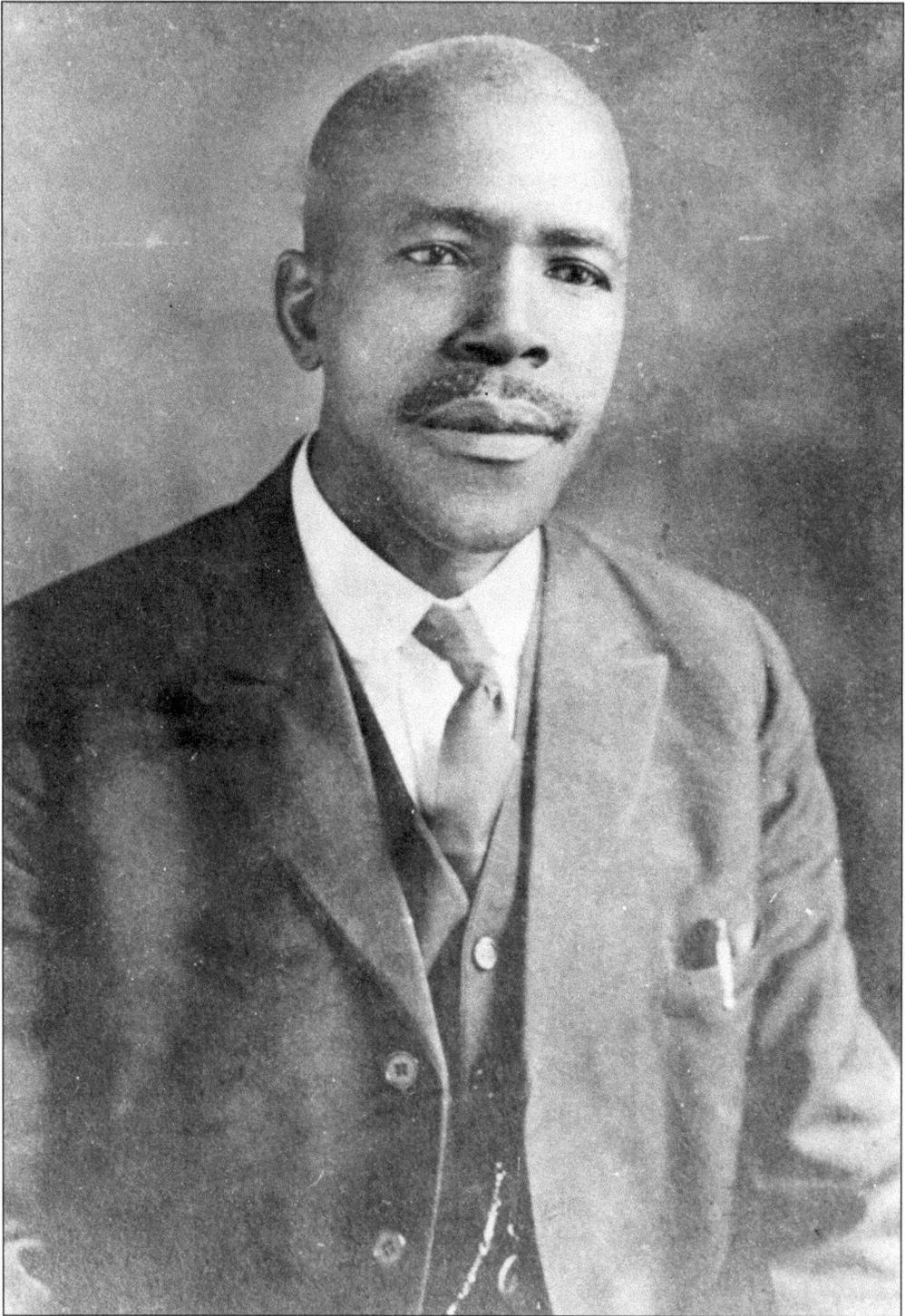

Robert E. Foster of Abbeville, South Carolina, served as pastor of Grandview Presbyterian Church and principal of the private school sponsored by the church. Reverend Foster came to Chesterfield in 1910 after completing divinity school at Biddle University. (Courtesy of Larrie Foster.)

The two Barber sisters, originally from Charlotte, North Carolina, both married ministers and became a part of the Chesterfield community. Mary Louise Foster (left) and Rev. Robert E. Foster were the parents of three sons. Rosa Toatley (right), who wed Rev. John Henry Toatley, mothered three daughters. (Courtesy of Larrie Foster.)

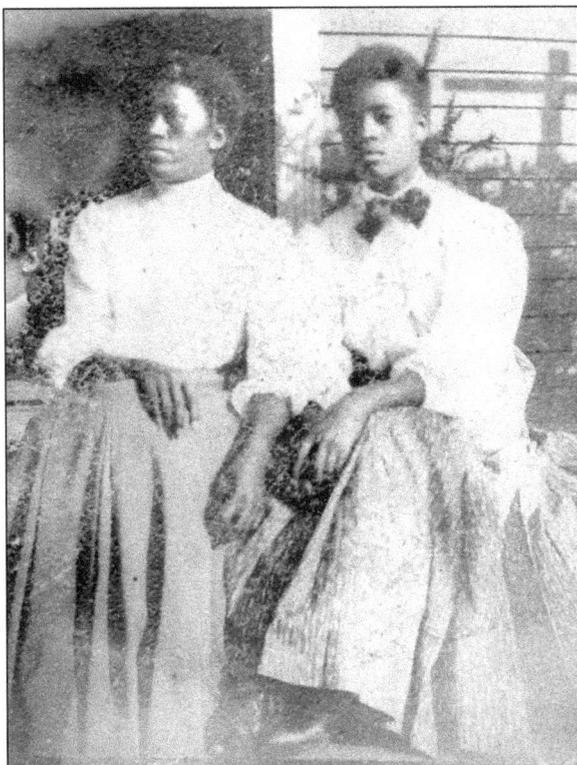

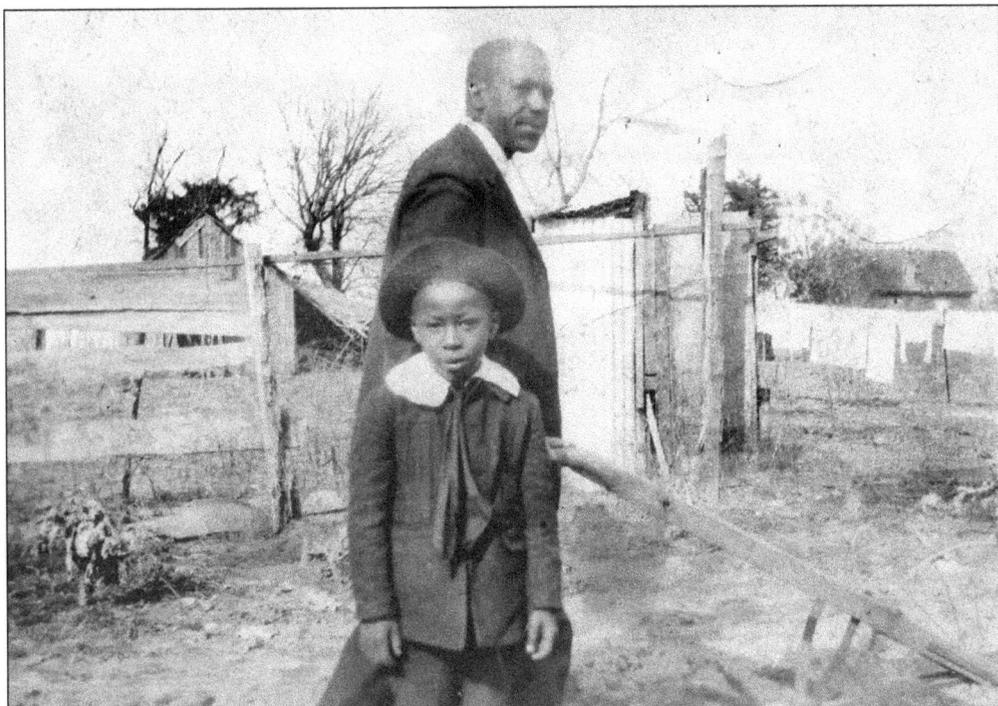

In the early 1900s, Reverend Foster works in the field along Mill Street as his son Robert Jr. looks on. (Courtesy of Larrie Foster.)

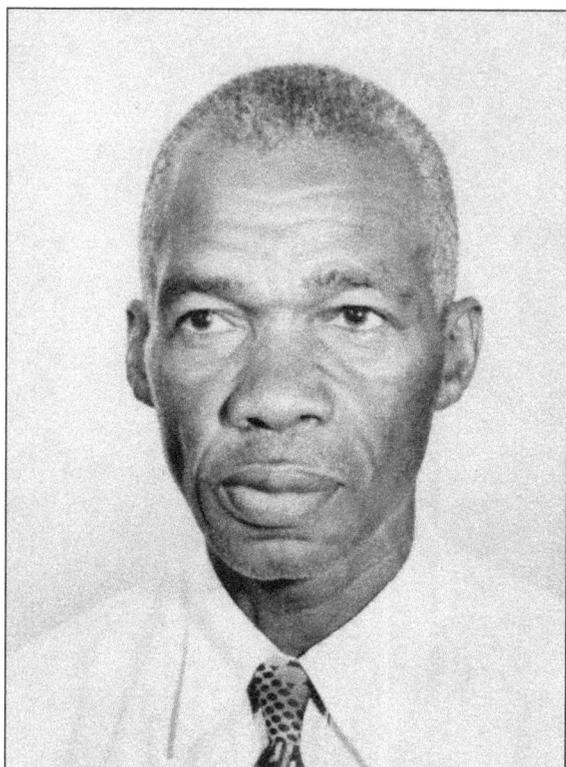

Lemuel Plenty Hillian graduated from the Colored Normal Industrial Agricultural and Mechanical College before becoming principal of the Pleasant Grove School and teaching at Edwards Elementary School. He was also a World War I veteran. Lemuel married Roseanna Merriman Hillian, and the couple raised seven children and many nieces and nephews in their home. (Courtesy of Roseanna Hillian.)

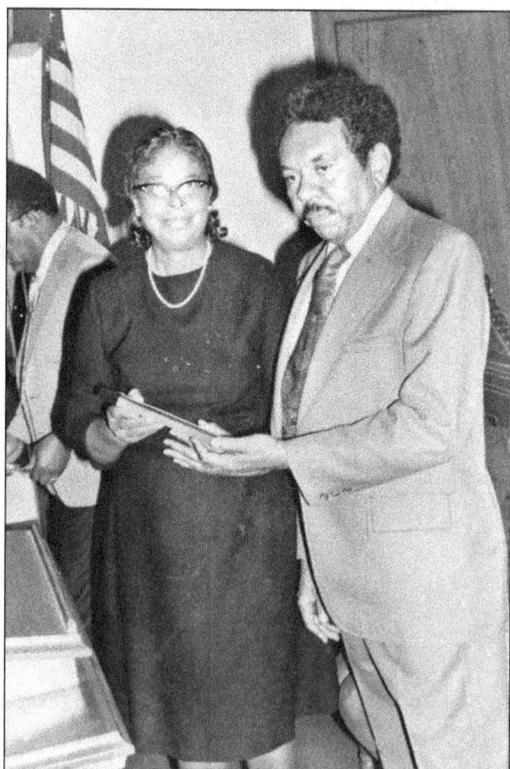

Here South Carolina Supreme Court chief justice Ernest Finney presents Roseanna Hillian with a plaque for her services to the NAACP. Roseanna is a charter member of the Chesterfield Branch of the NAACP and a 1937 graduate of Coulter Memorial Academy. (Courtesy of Roseanna Hillian.)

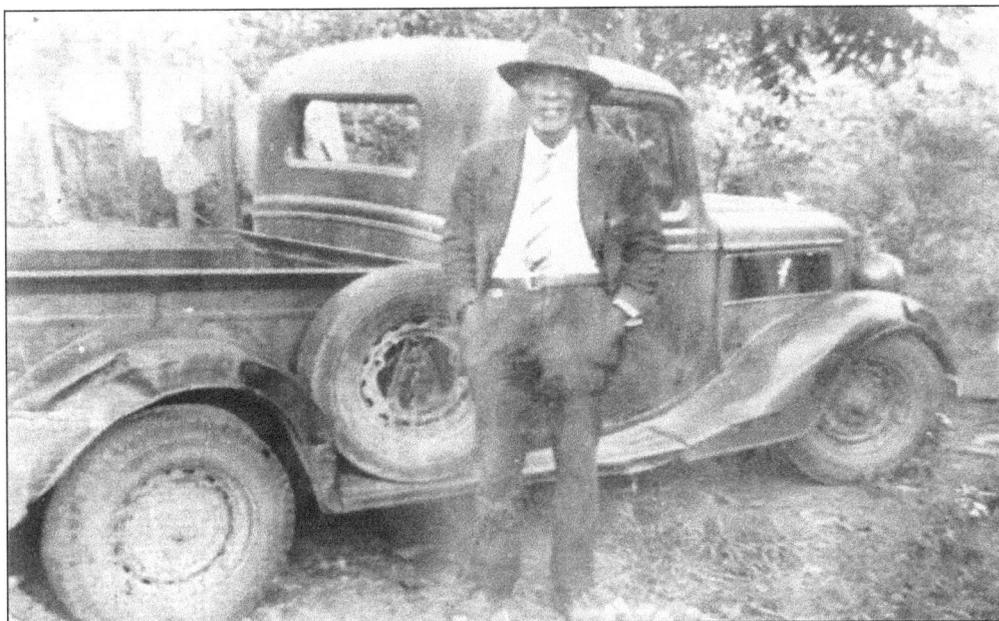

Born the son of slaves in 1880, Rev. James Leak married Nancy Tillman in 1902 and bought several lots in Chesterfield. He built a home in town and maintained several businesses. The proprietor of a funeral business, Leak organized a burial association for Chesterfield's African Americans. He was also an ordained Baptist minister, the founder of Mount Olive Baptist Church, and the organizer of numerous churches in Chesterfield County. (Courtesy of Lee Virn Leak, Ph.D.)

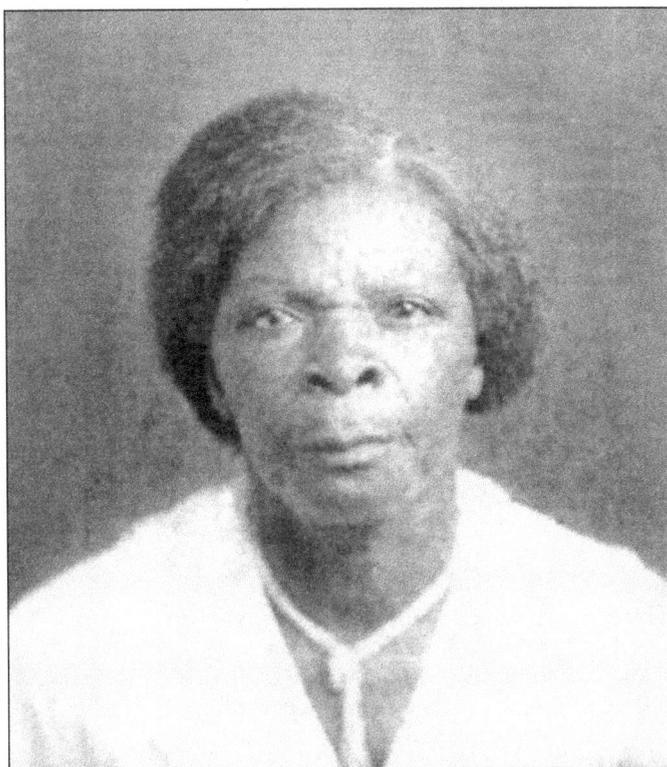

Nancy Tillman Leak owned and operated a café in Ruby, South Carolina. Upon moving to Chesterfield, she became the chief cook at the Chesterfield Hotel. She and Rev. James Leak parented 10 children. (Courtesy of Lee Virn Leak, Ph.D.)

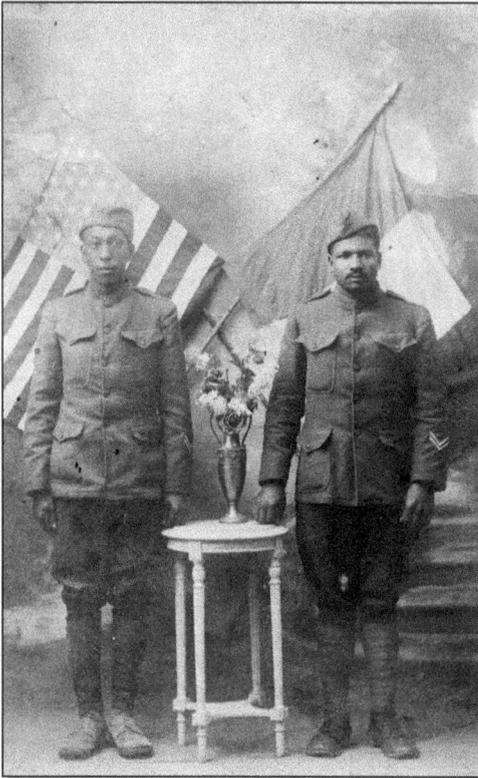

Charlie Robinson (left) and William Hailley served in World War I. (Courtesy of Roseanna Hillian.)

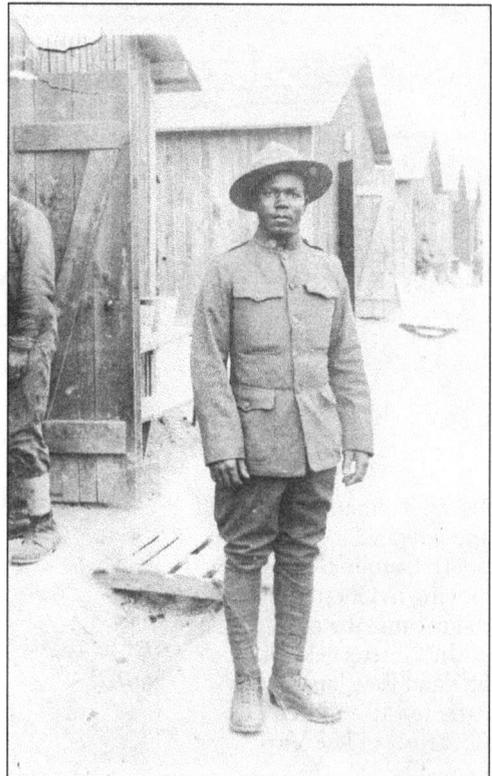

This postcard depicts an unidentified World War I soldier. Many African American soldiers served in the armed forces to free oppressed people in other countries but still had to face segregation when they returned home. (Courtesy of Roseanna Hillian.)

Robert Lincoln Leak Jr., born in 1908, wed Lucille Elizabeth Moore in 1929 and fathered four sons. A mechanic, Robert opened an auto repair business in the 1920s. During the mid-1930s, he also worked for the Chesterfield Postal Service, delivering mail to the post office from the trains that passed through town. (Courtesy of Lee Virn Leak, Ph.D.)

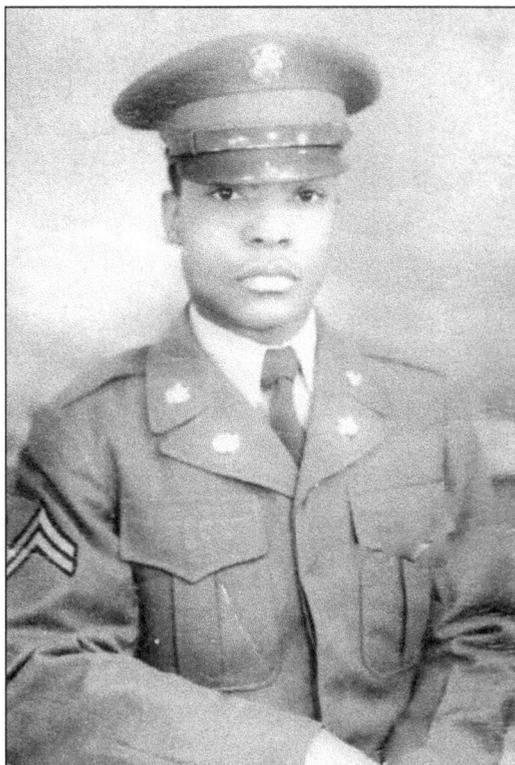

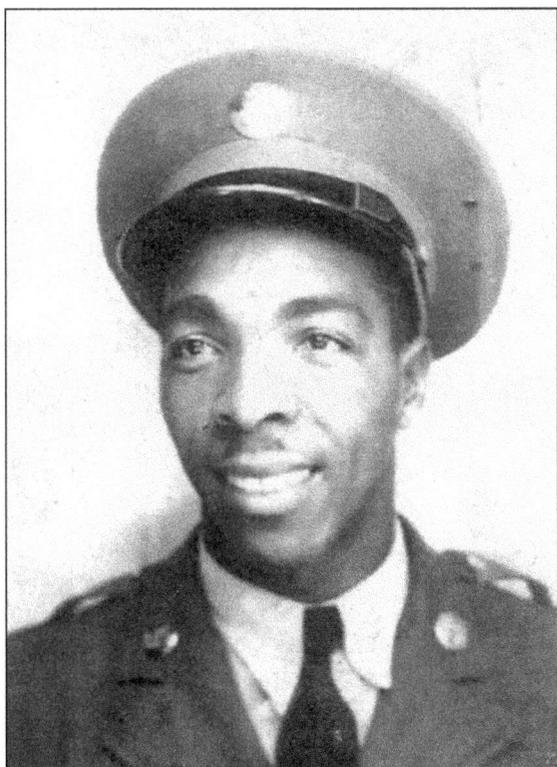

Alvin Poole Leak, the son of Rev. James and Nancy Tillman Leak, acquired his father's funeral home and store in Pageland after his 1951 death. A. P. continued the family business for another 20 years. (Courtesy of Lee Virn Leak, Ph.D.)

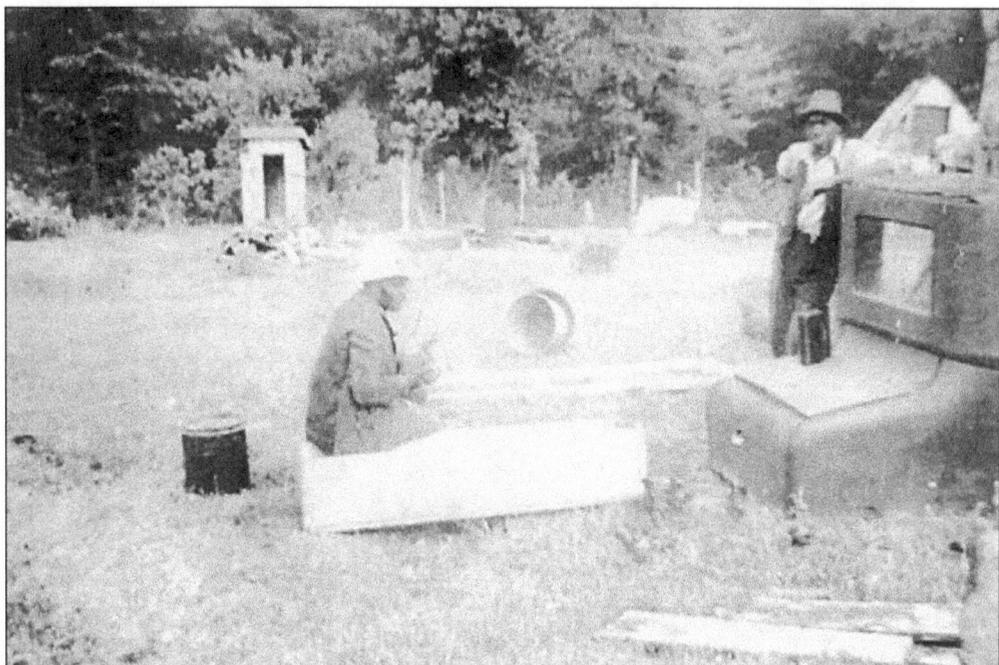

Brothers Robert L. (left) and James C. Leak build an automobile in the 1920s. This car would later catch fire due to the majority of its parts being constructed of wood. (Courtesy of Lee Virn Leak, Ph.D.)

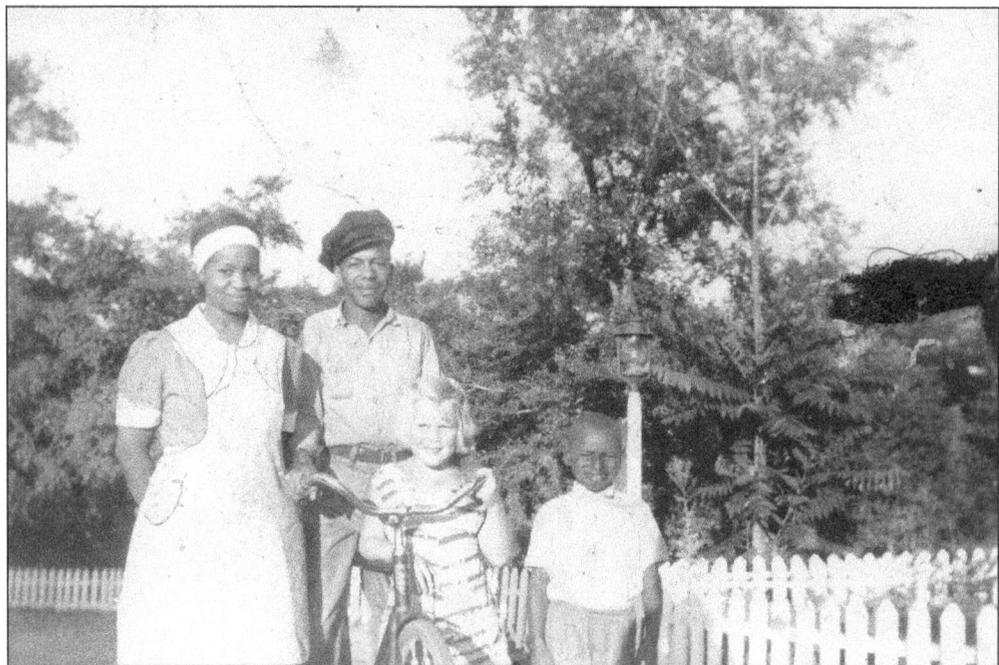

Ethel Lisenby, who provided domestic service in town, is seen wearing her work uniform in 1942. She stands by a white picket fence with her uncle Carl Streater and her son, Jimmie Lisenby. This photograph was taken at the Milk Dairy Farm, located on Highway 9. (Courtesy of Martha Burch.)

In this 1904 image, Emma Green dons a high-neck collar with a button in the center and a decorative eyelet to dress up her frock. Her wavy hair is split down the middle and pinned in the back. She is also wearing a watch as a pendant. Emma attended the Drucilla Colored School.

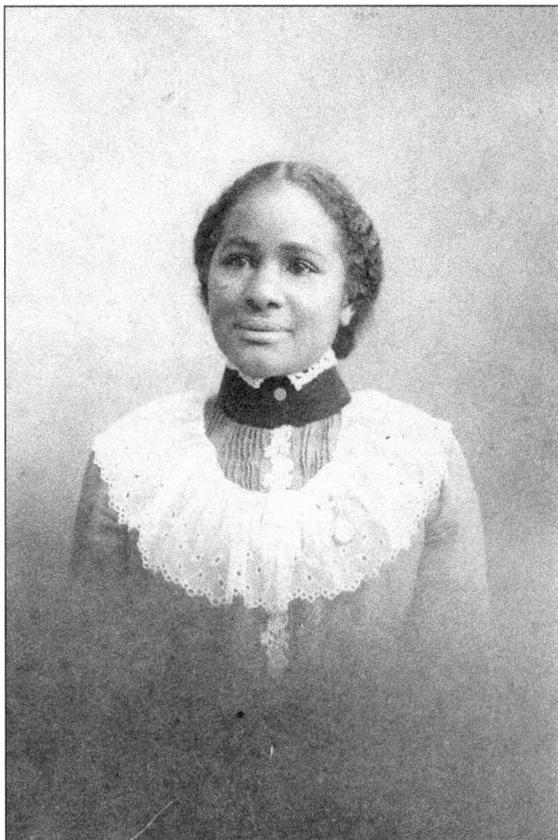

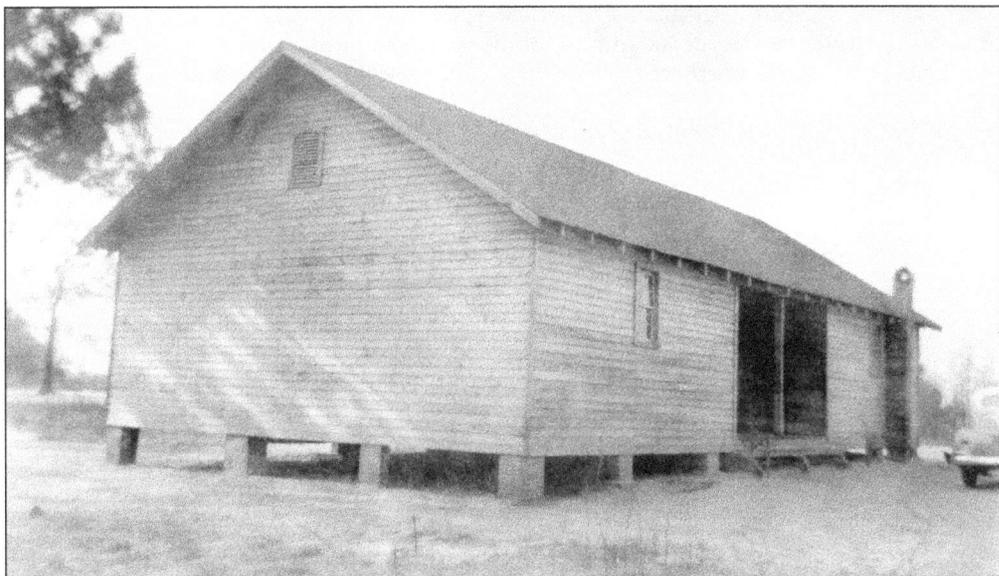

The Drucilla Colored School was named after the Drucilla African Methodist Episcopal Zion Church, where many students attended worship service. The building was later used as a community center for dances and social functions. (Courtesy of the South Carolina Department of Archives and History.)

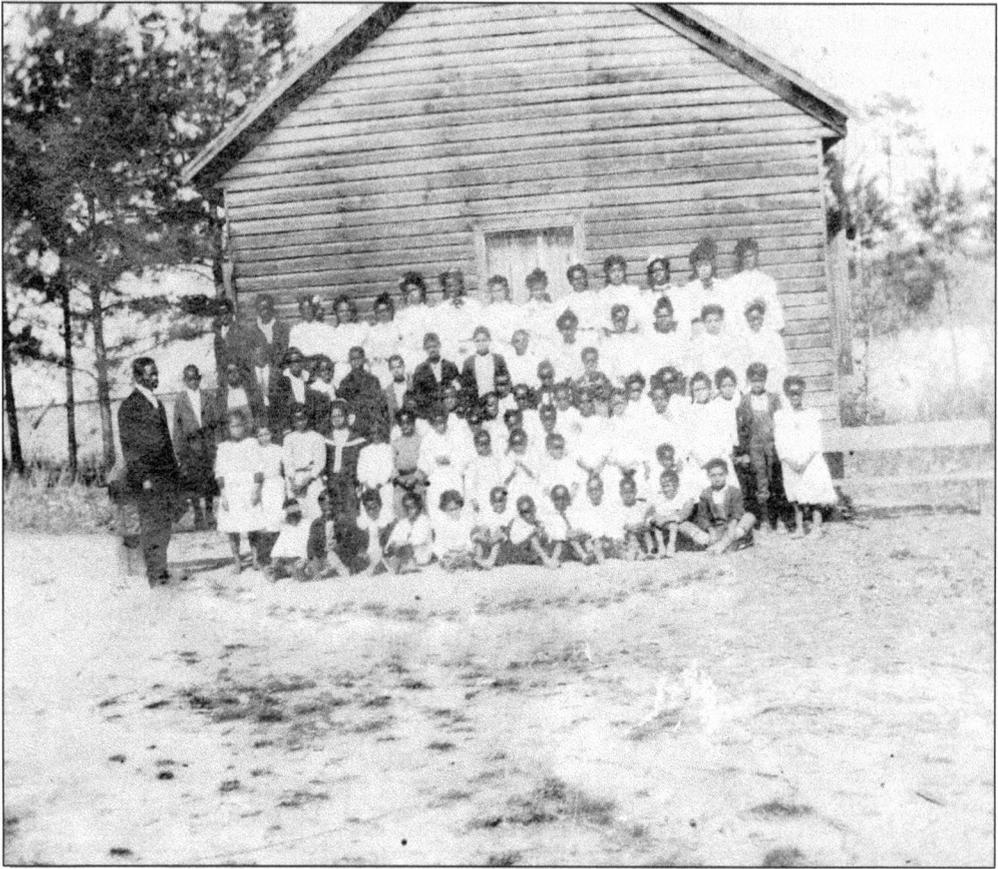

Students of all ages are assembled in front of the two-room Pleasant Grove School with their principal (far left, name unknown) in the 1920s. (Courtesy of Roseanna Hillian.)

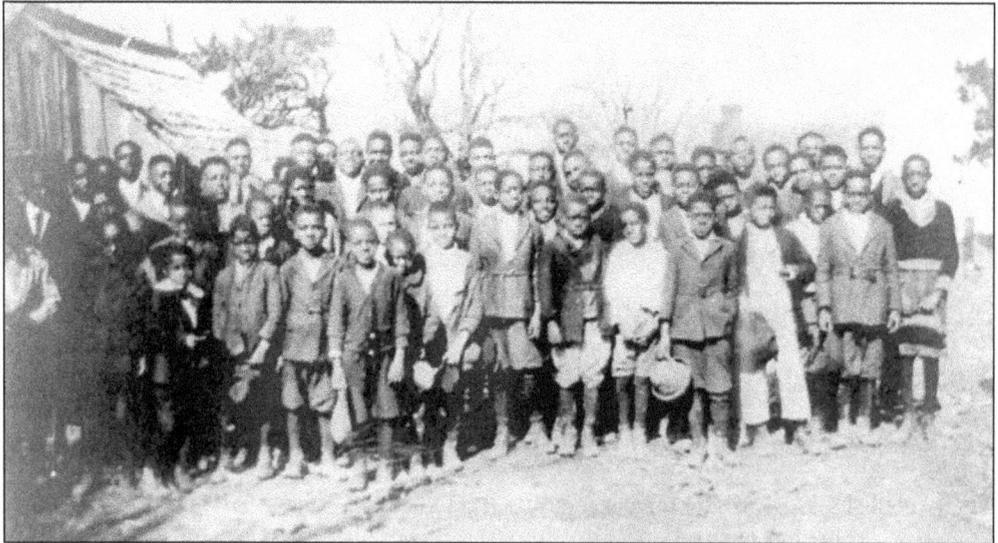

The St. Paul Baptist Association School, pictured in the 1920s, was one of many African American schools established by local churches. (Courtesy of Lee Virn Leak, Ph.D.)

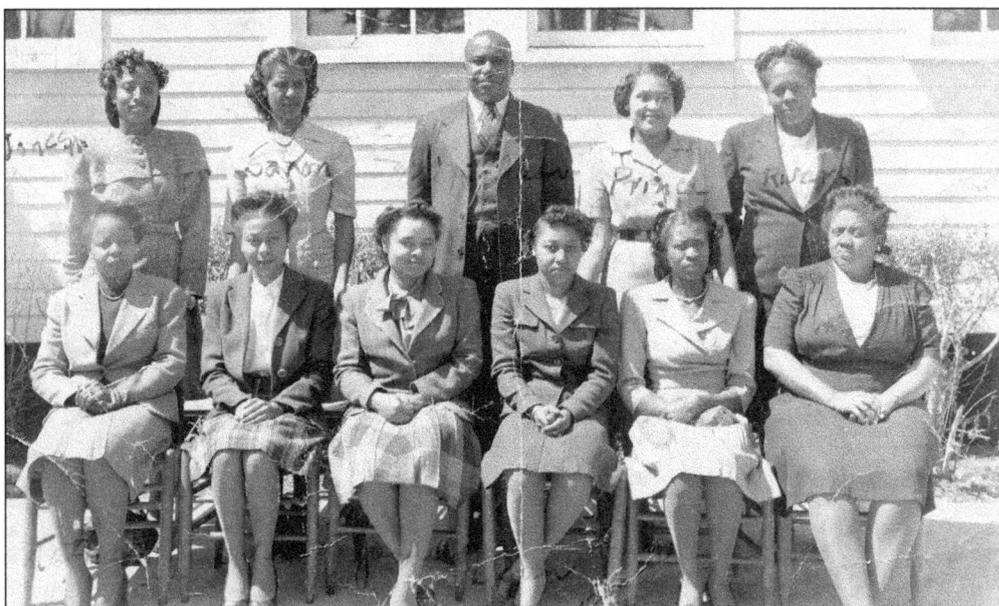

Teachers pose at the Chesterfield Colored School, which opened off Mill Street in Chesterfield around 1937. William Franklin Hickson served as principal. Seen from left to right are the following: (first row) four unidentified people, Miss Marshall, and Mrs. Hickson; (second row) Miss Jones, Dorothy Saxon, William Franklin Hickson, Miss Prince, and Elizabeth Johnson. (Courtesy of Thelma Rivers.)

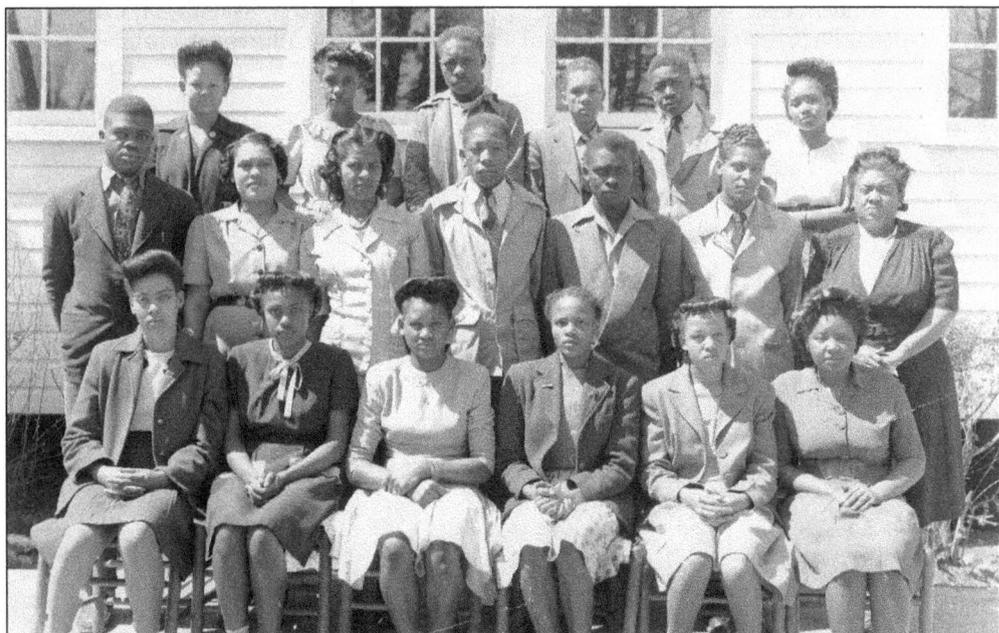

The Chesterfield Colored School's Minstrel Show included the following participants, from left to right: (first row) Gwendolyn Bryant, Arnetha Hamilton, Evelyn Davis, ? Allen, Bloncie Rivers, and Martha Mae Hillian; (second row) Johnny Sanders, Miss Jones, Dorothy Saxon, Benjamin Murvin, David Harrell, Curtis Crawford, and Mrs. Hickson; (third row) Velma Evans, unidentified, Robert Leak Jr., Timothy Hillian, Tom Bittle, and unidentified. (Courtesy of Thelma Rivers.)

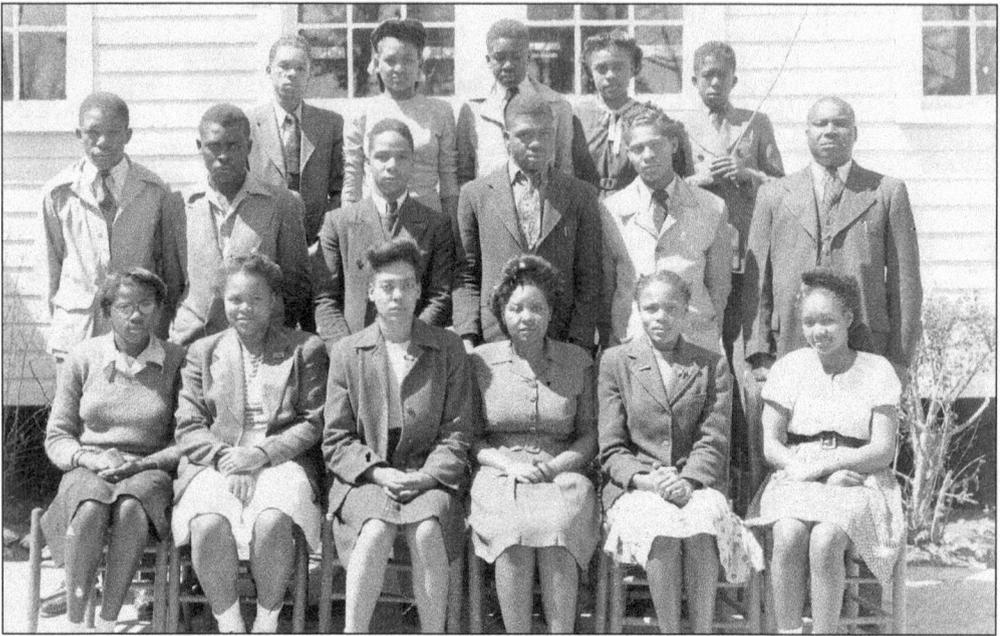

A student group known as the Minstrel Show performed in plays at black schools throughout the county. The switch held by Calvin Chapman was known as "the Boss." Shown from left to right are the following: (first row) Zedia Knight, ? Allen, Gwendolyn Bryant, Martha Mae Hillian, ? Allen, and Gwendolyn Hillian; (second row) Benjamin Murvin, David Harrell, Lemuel Crawford Sr., Johnny Sanders, Curtis Crawford, and Principal Hickson; (third row) Timothy Hillian, Evelyn Davis, Thomas Bittle, Arnetha Hamilton, and Calvin Chapman. (Courtesy of Thelma Rivers.)

Elizabeth Johnson Rivers coached the Chesterfield Colored School's basketball team, the Blue Devils. Basketball was one of the only sports offered at this time, so many young boys tried out for the team. The school also had a girls' basketball team. (Courtesy of Thelma Rivers.)

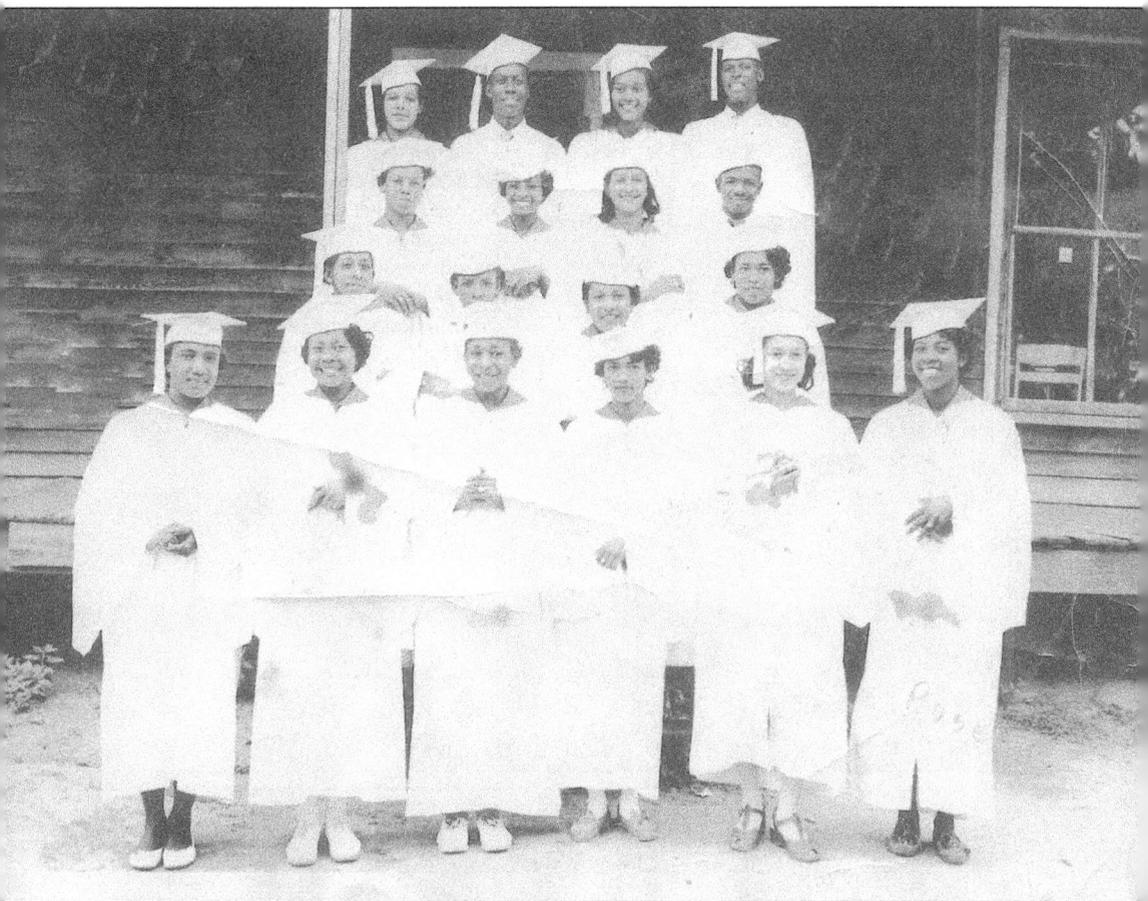

The Chesterfield Colored School graduating class poses for a group portrait in 1954. When the school burned down, classes were moved to the Old County Home Building. Edwards Elementary School has replaced that structure. Pictured from left to right are as follows: (first row) Elizabeth Redfearn, Ginnary Hillian, ? Lowery, Lera Mumford, Loretta Chapman, and Rose Pegues; (second row) Sadie Murvin, Ruth Bittle, Franzine Zinnerman, and Verlee Jefferson; (third row) Clara Harrell, Lee Doris Malloy, valedictorian Peggy Nivens, and David Bittle; (fourth row) Marie Hillian, Willie Cox, Martha Melton, and salutatorian James Johnson. (Courtesy of Thelma Rivers.)

Elizabeth Johnson Rivers taught at the Chesterfield Colored School and Edwards Elementary School before retiring from Chesterfield Elementary in 1973. She also served as principal of Center Point, a feeder school in Chesterfield. She received her bachelor of arts from Benedict College and her master's from New York University. A member of the Grandview Presbyterian Church, Elizabeth was married to James W. Rivers. (Courtesy of Thelma Rivers.)

These cheerful girls and boys attended Center Point School in the 1950s. The girls wear beautiful white dresses with socks and shoes to match, while the boys are dressed in slacks and jackets. (Courtesy of Thelma Rivers.)

Larrie Foster attended Coulter Memorial Academy and Johnson C. Smith University and completed graduate work at North Carolina Central. The principal of Edwards Elementary School, he has also served as moderator for the Presbyterian church and many civic organizations. Foster fought during World War II and, along with Michael Melton, became one of the first African Americans elected to the Chesterfield Town Council. (Courtesy of Larrie Foster.)

Born in Batesburg, South Carolina, Mary Williams Foster graduated from A&T University in Greensboro, North Carolina. As an educator, she taught business administration at Coulter Memorial Academy and was the secretary to Principal Henry L. Marshall. She retired from Chesterfield Elementary School as a guidance counselor. She was the wife of Larrie Foster and a member of the Grandview Presbyterian Church. (Courtesy of Larrie Foster.)

Herbert A. Blassengale Sr. of Saluda, South Carolina, attended Bettis Academy and South Carolina State College in Orangeburg, where he received a degree in agriculture education, and received his master's degree from the University of Pennsylvania. In 1954, he became principal of the Old County School and then Gary High School. He retired as assistant principal of Chesterfield High School. (Courtesy of Loretta McNeal.)

Shida Williams Blassengale, the wife of Herbert Blassengale Sr., taught history and English at Gary High School and retired from teaching at Chesterfield High School. She was a graduate of Bettis Academy, Paine College in Augusta, Georgia, and Columbia University. (Courtesy of Herbert Blassengale Jr.)

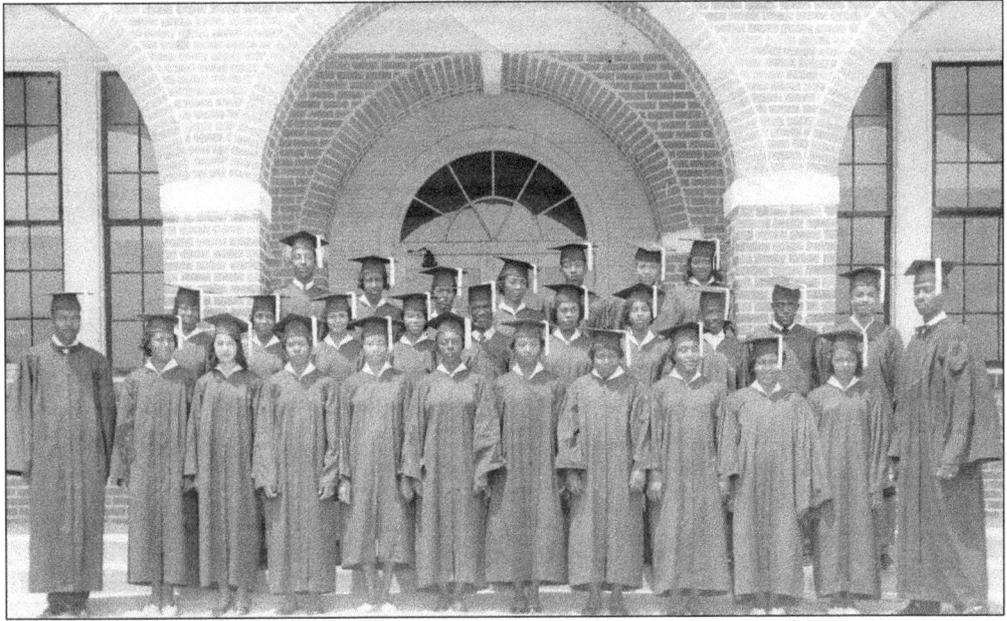

Gary High School, once located in the Zoar community, was built in 1927 as Zoar High School. When Zoar and Chesterfield consolidated, the name changed. It became the school for African American students in the Chesterfield area and remained that way until integration in 1970. The class of 1958 is seen here. (Courtesy of Roseanna Hillian.)

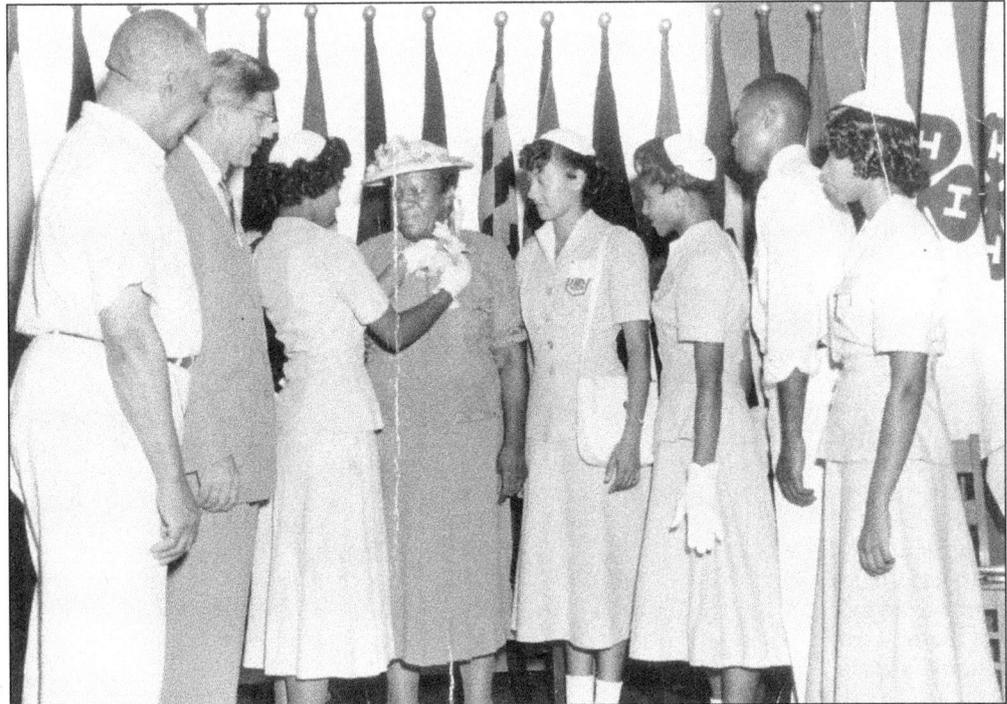

Mary McLeod Bethune is honored by the 4-H Club during an event at Howard University in Washington, D.C., in the 1950s. Lemuel Glenn Hillian, also part of the ceremony, is standing seventh from left. (Courtesy of Roseanna Hillian.)

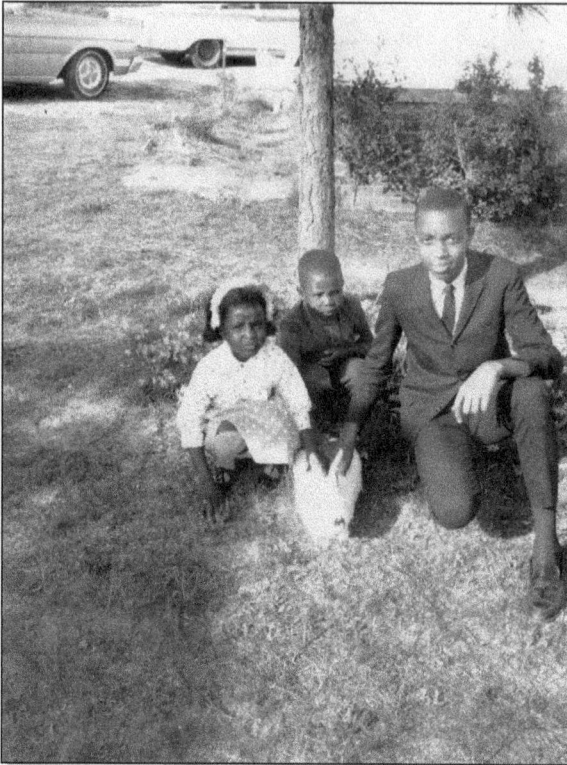

Dressed in church attire, Elaine (left), Anthony (center), and Duronnie Harrell pose with their rabbit on Easter Sunday. This 1969 photograph was probably taken after the service when they had returned home. (Courtesy of Gloria Pfeiffer.)

A group enjoys a Sunday afternoon stroll on Community Road in 1952, when it was still a dirt path. Siblings Mary (left) and Oralee Hannah are in the first row, while Laverne Watson (left) and Martha Burch are in the second. (Courtesy of Martha Burch.)

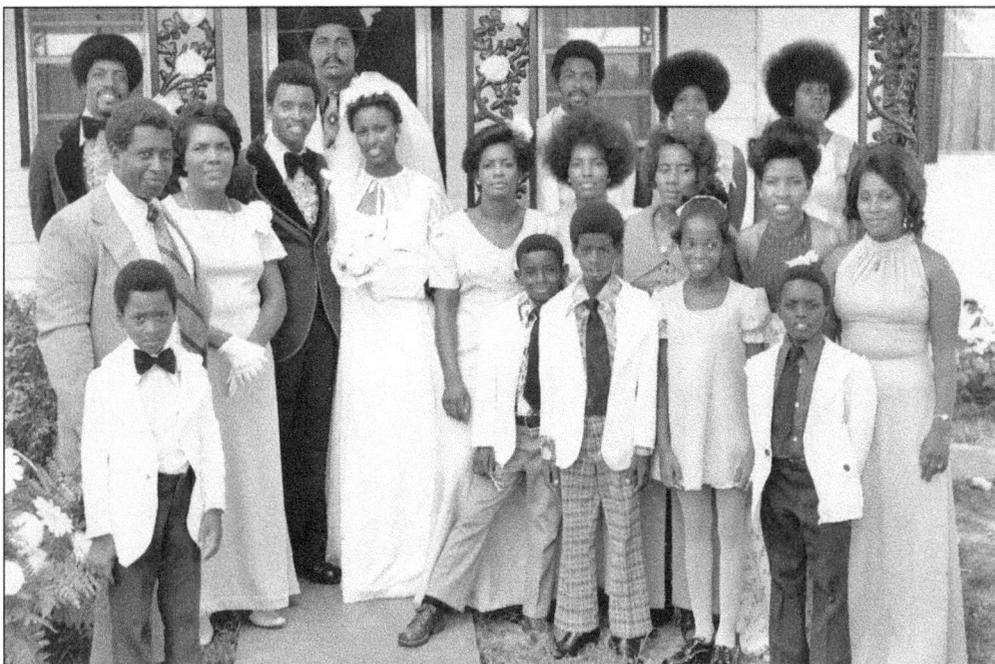

To the far left are Wardell and Naomi Howard Jackson, pictured with family at their son Jerry's wedding on August 23, 1971. The Jacksons have always been dynamic members of the Mount Mary community, where they raised their children. Wardell was one of the first African Americans to serve on the Chesterfield County Rural Water Committee. He was active in the Democratic Party when it came to campaigning. Both he and his wife were members of the NAACP. (Courtesy of Naomi Jackson.)

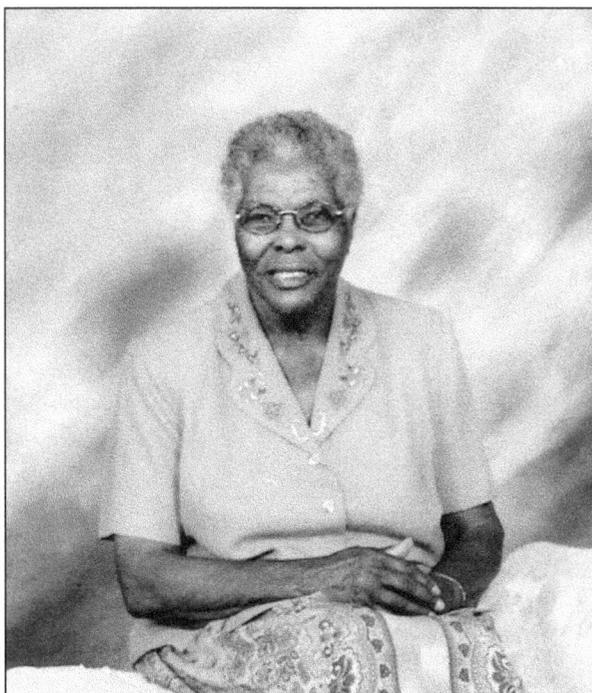

Geneva Finlayson was born on November 1, 1917, and attended the Building School, sponsored by the St. Paul Baptist Association. At age 50, she returned to receive her diploma from Gary High School. Geneva furthered her education at Chesterfield-Marlboro Technical College, where she earned her nurse's aide certificate. Known as the local historian, she has written several editorials about African American history in Chesterfield. (Courtesy of Geneva Finlayson.)

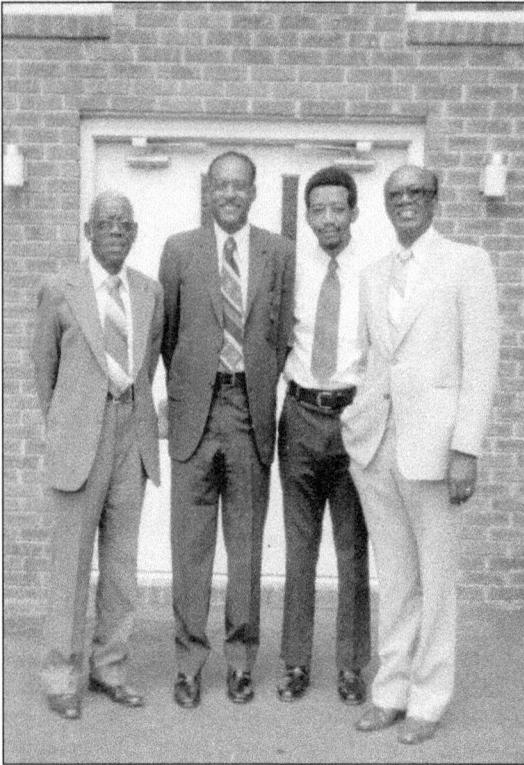

Standing from left to right in front of the Grandview Presbyterian Church are elders H. A. Blassengale, James Bryant Jr., Threadgill Redfearn, and Larrie Foster. (Courtesy of Larrie Foster.)

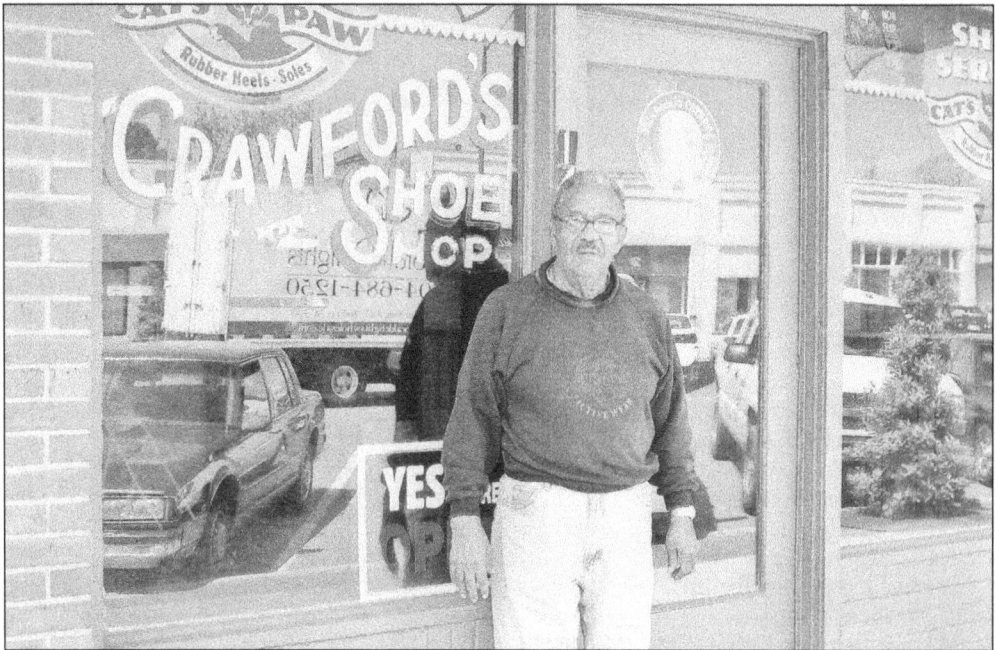

Lemuel Crawford was the first African American to own a business on Chesterfield's Main Street. He opened Crawford and Sons Shoe Service in 1962, providing repair services to all of Chesterfield County and the neighboring region. His business afforded him the opportunity to send all three of his children to college. (Courtesy of Lemuel Crawford.)

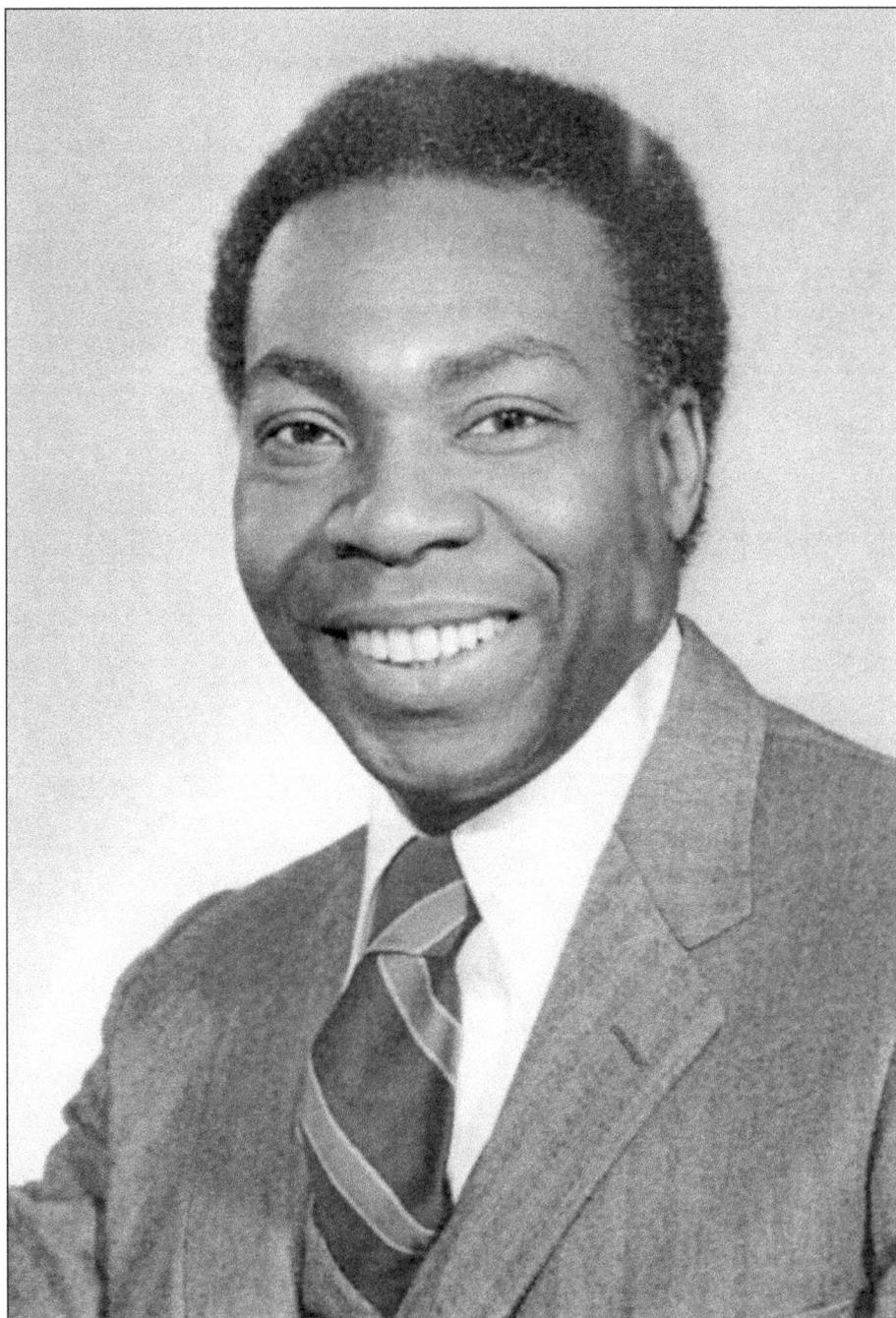

Lee Virn Leak, the second son of Robert and Lucille Leak, graduated from Gary High School. He received a bachelor of science in biology from South Carolina State College in 1954 and attended graduate school at Michigan State University, where he received his doctor of philosophy degree in 1962. Lee Virn then pursued postdoctoral training in cell biology at Harvard Medical School. In 1971, he was named professor and chairman of the Department of Anatomy in the College of Medicine at Howard University. He is married to Eleanor Merrick Leak, and the couple has two children. (Courtesy of Lee Virn Leak, Ph.D.)

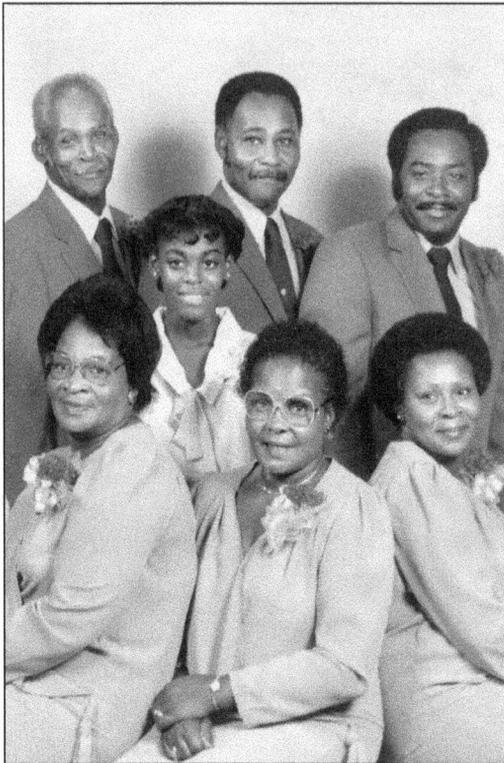

The Malloy Family Gospel Singers began singing together in 1965 and have since performed throughout the Carolinas. In 1991, they were the recipients of the Folk Heritage Award from the South Carolina House of Representatives. Shown from left to right are the following: (first row) Arlene D. Edwards, Loreain D. Malloy, and Sandra M. Hardison; (center) Katrina Malloy; (second row) Robert Malloy, John A. Malloy, and Clarence Malloy. (Courtesy of Clarence Malloy.)

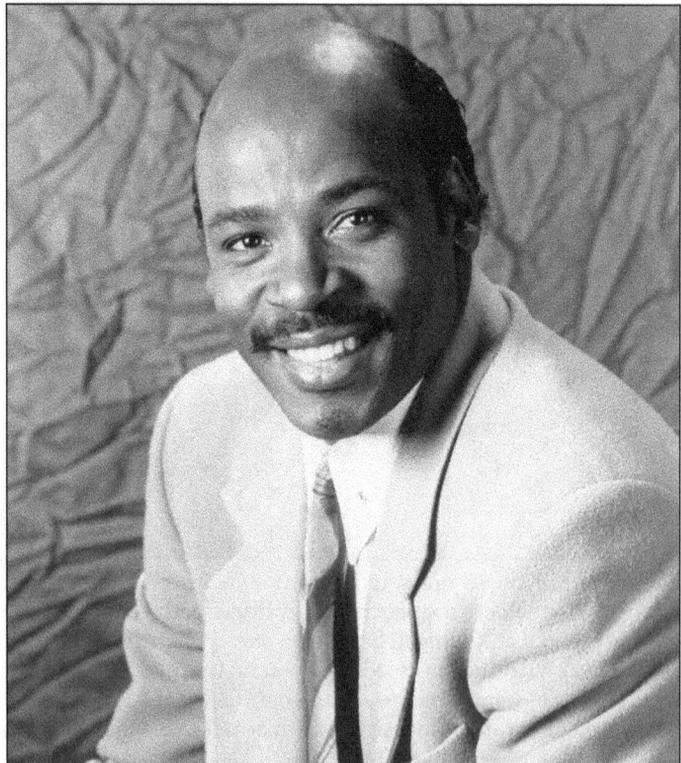

Donald Malloy started his singing career at his childhood church, Pleasant Grove African Methodist Episcopal Zion in Cheraw. He has performed and collaborated with the likes of the late Rev. James Cleveland, Rev. John P. Kee, and the New Jersey Mass Choir, among other gospel artists. A regular on *The Bobby Jones Gospel Explosion*, Donald has spread the gospel with his music throughout the United States, the Caribbean, and Europe. (Courtesy of Clarence Malloy.)

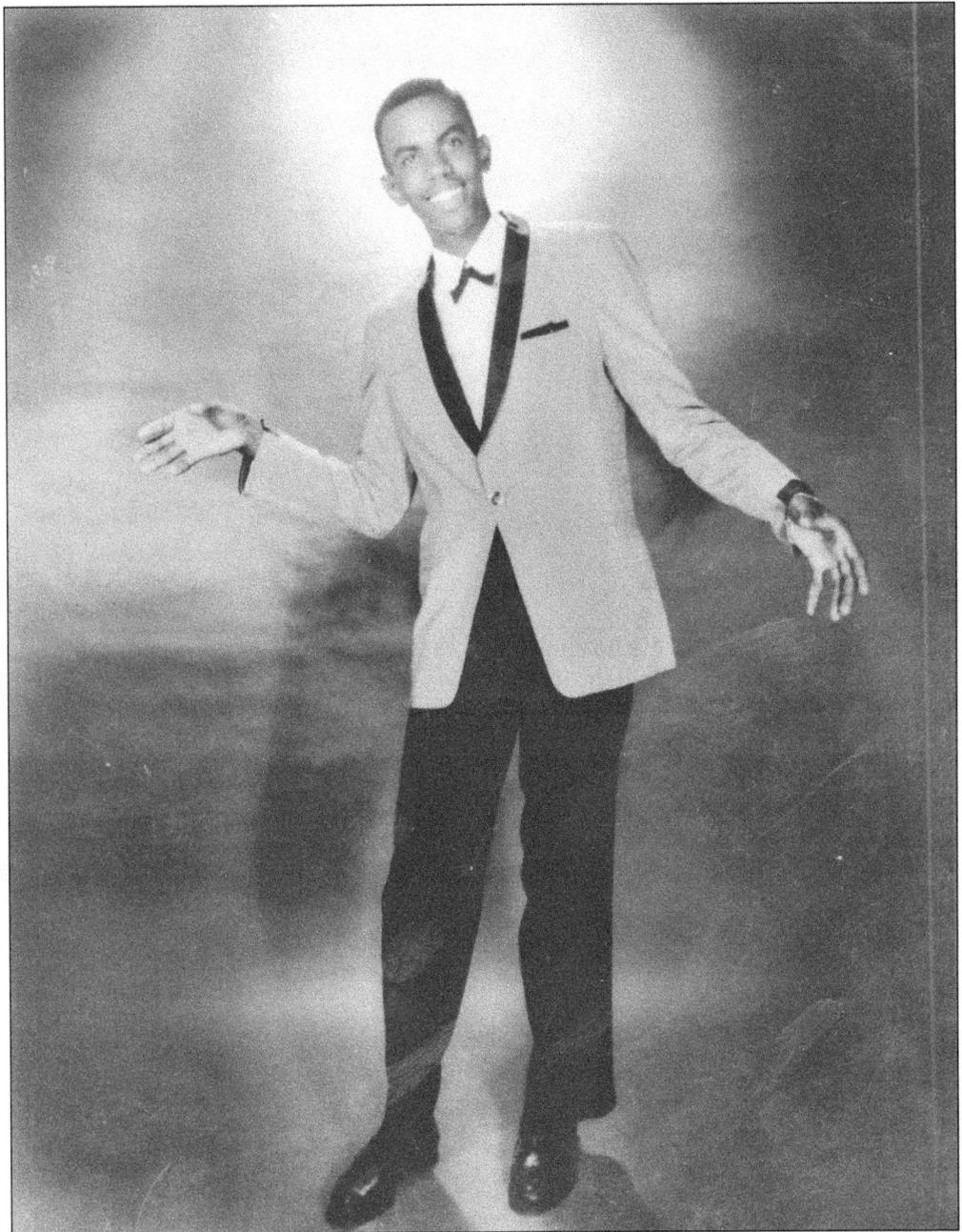

Wiley Bennett sang high tenor with Maurice Williams and the Zodiacs, a musical group formed in 1960. Because of their style, the members became a big part of the Southern coastal music scene. One of their favorite hits was "Stay," and in 1985, they were inducted into the Beach Music Hall of Fame. (Courtesy of Larrie Foster.)

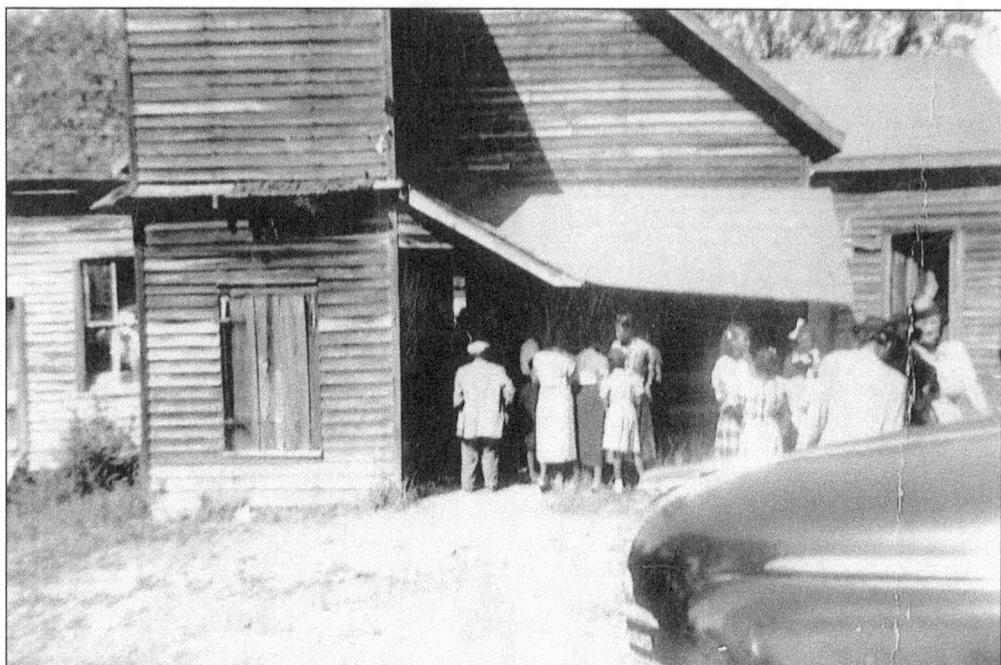

Salem Baptist Church was established in 1884. After the first edifice burned, the land was used to bury African Americans, the spot becoming known as the Chesterfield Community Cemetery. This photograph depicts the second church structure, built in 1906. (Courtesy of Geneva Finlayson.)

Mount Tabor United Methodist Church, located on West Boulevard and Academy Street, was constructed in 1878 by freedmen. The wood-frame building is listed on the National Register of Historic Places because it is the oldest African American church in town.

# *Four*

# RUBY

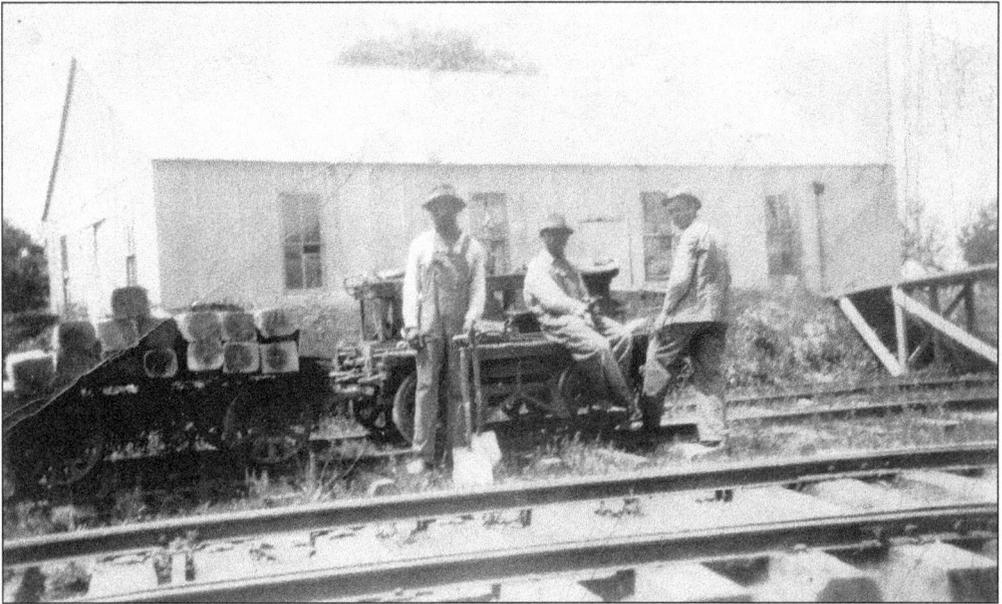

Town workers Willis McBride (left); his father, Marshall McBride (center); and foreman Henry Lear are pictured in the early 1900s. These hardworking men were building tracks in Ruby for the Chesterfield and Lancaster Railroad Company. The Ruby depot, visible behind them, closed in 1940. (Courtesy of Rev. Caralee Moser.)

Grandchildren gather on the steps of the Marshall and Daisy McBride house in the 1930s. Seen from left to right are the following: (first row) unidentified, June Moser, and three unidentified children; (second row) unidentified, Thomas McBride, and Mayrow Myers; (third row) unidentified, Marguerite Moser, Ruthie Lee McBride, Nezzie Myers, and Clerow Myers; (fourth row) Caralee Moser, Ulysses McBride, Daisy Moser, and unidentified. (Courtesy of Rev. Caralee Moser.)

Willis McBride poses with his wife, Glennie Little McBride, and his children, Thomas and Linda. Because of racial tension, Willis had to flee Ruby with his family when the children were small. The McBrides settled in Ohio, and it was years before they would return to visit. Thomas and Linda have purchased the land on which their ancestors once toiled as slaves. Now known as the McBride Village, the property will serve as a retirement community. (Courtesy of Redessa Myers.)

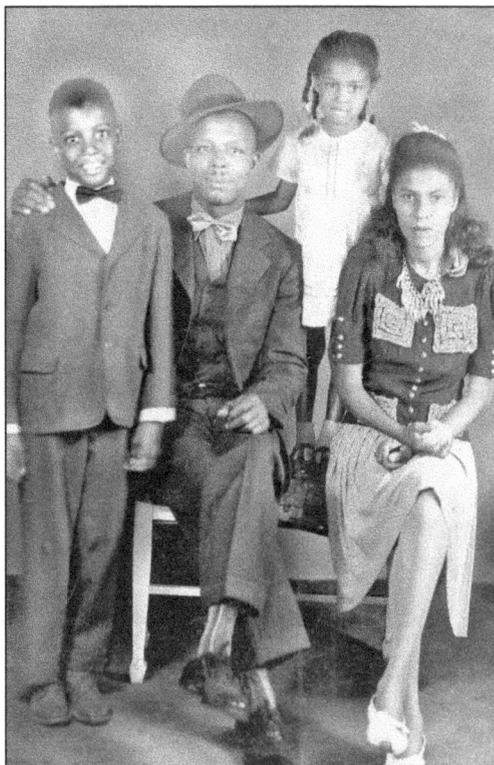

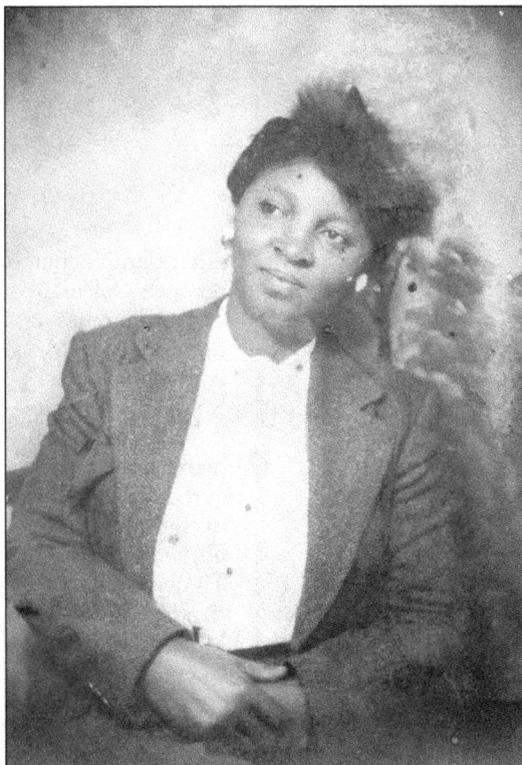

The daughter of Marshall and Daisy McNair McBride, Queenie McBride never married and was known for her flair of style in dressing. Acting as the family historian, she used to make her nephew Thomas recount the ancestors back nine generations. (Courtesy of Redessa Myers.)

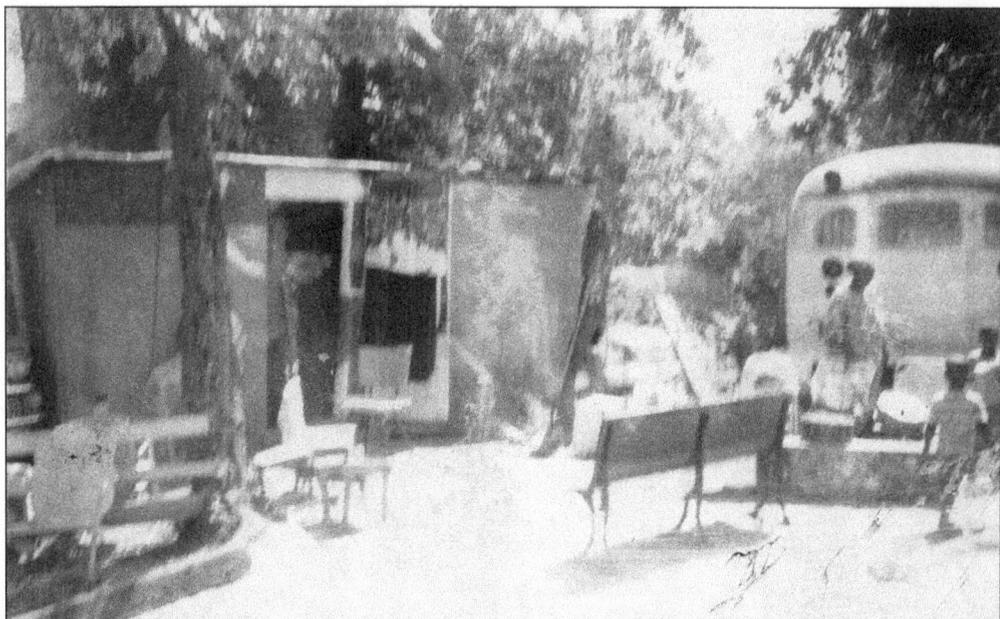

Along with his mother, Hattie McBride, Rev. Caralee Moser established the Holy Temple Church behind his home in 1966. The bus on the right, with little children playing behind it, transported members to and from the property. A pew and a couple of chairs were spread out in the yard for the congregation. The church resembled a praise house, often found on the South Carolina coast. (Courtesy of Rev. Caralee Moser.)

After Sunday church services, Coleman C. Harrell poses in front of his 1956 Ford at his home in Ruby. Coleman ran the apple and pear orchard and worked at the hosiery mill in Ruby. He and his family attended Timmonsville Baptist Church in Mount Croghan, where he served as church clerk and deacon. (Courtesy of Gloria Pfeiffer.)

Born in 1906, John Roland McKay married Juanita Sowell and fathered nine children. He attended the Mount Elon School and became a farmer who worked at Lynches Rivers before retiring. He raised his family on the 16 acres of land he owned. Remaining in the McKay family, the property is now home to second and third generations. (Courtesy of Betty Harris.)

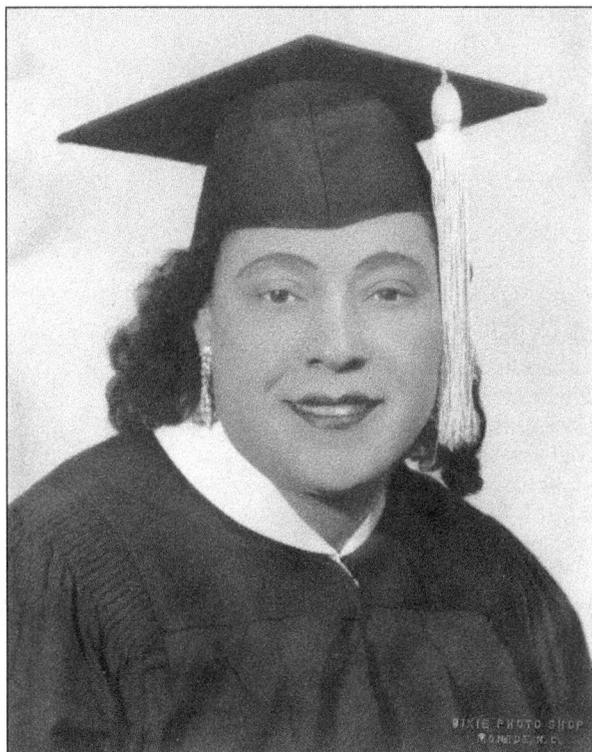

Eva McKay received her education from Coulter Memorial Academy, Johnson C. Smith University, and Benedict College in Columbia, where she earned a master's degree. She was one of the first teachers at the two-room Taylor Chapel in Ruby. Eva also taught at several other schools throughout the county. (Courtesy of Betty Harris.)

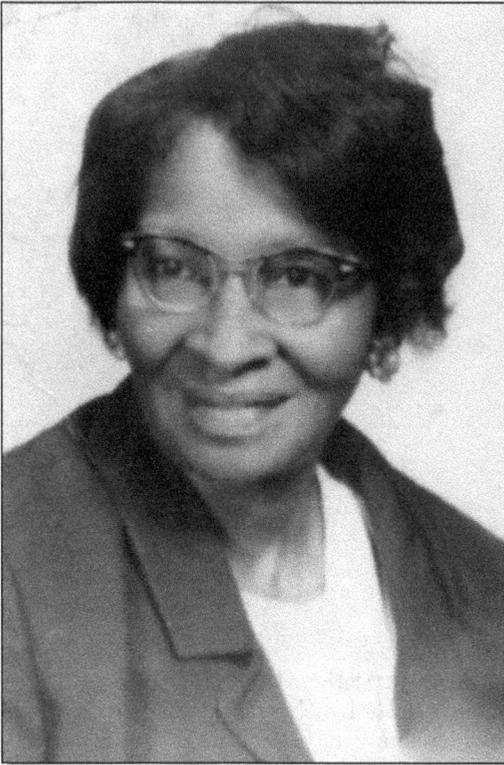

Annie S. Sellers was born on February 14, 1905. While living in Ruby, she ran a Home Demonstration Project consisting of teaching homemakers the importance of keeping a clean home, canning, and sewing. After the death of her husband, Annie moved to the North in hope of establishing a better life for herself and her children. Upon settling in Connecticut, she began advocating for senior citizens and has received numerous awards for her service. In 1996, the Ann Sellers Community Administration Building was named in her honor. (Courtesy of Lucille Redding.)

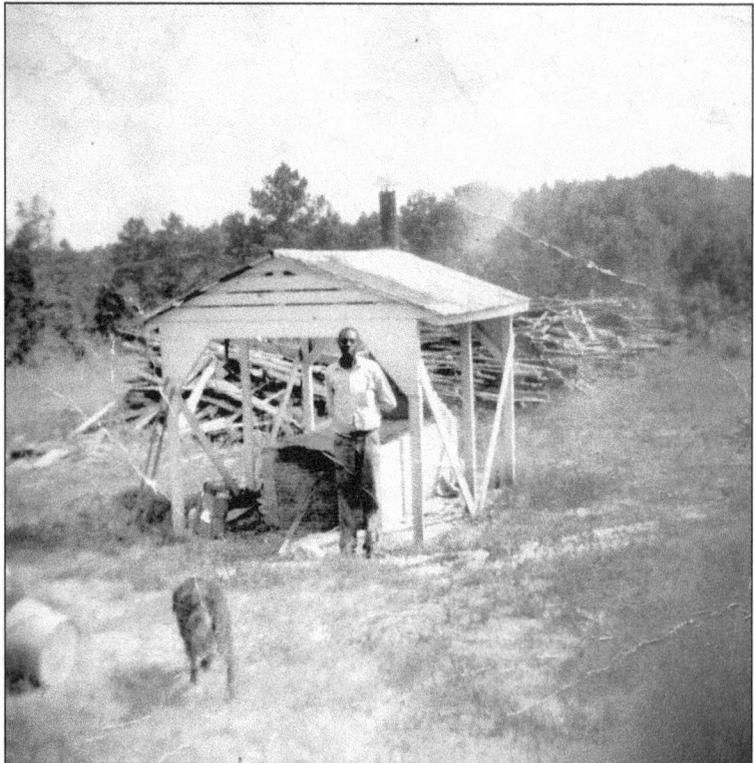

Owen and Annie Sellers lived on Highway 9 in Ruby. Owen, who was well known for his great barbecue, used to cook for several area eateries. In this 1940s photograph, he stands in front of the barbecue pit located behind Pete Zoner's restaurant. (Courtesy of Lucille Redding.)

# Five

# MOUNT CROGHAN

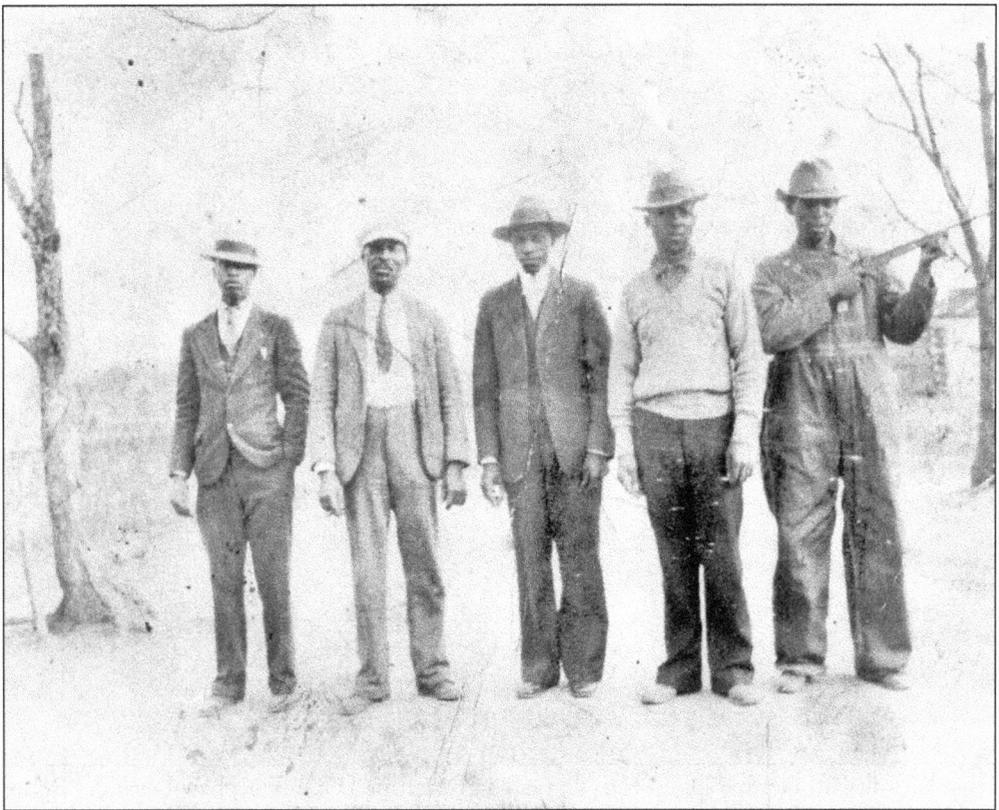

The Burch men pause for the camera on a cold day in the early 1900s. Seen from left to right are Burris, Raeford, Johnnie, Hayward, and Norman Burch, who points his rifle while looking straight ahead. It was common for people to own rifles for hunting and protecting their homestead. (Courtesy of Martha Burch.)

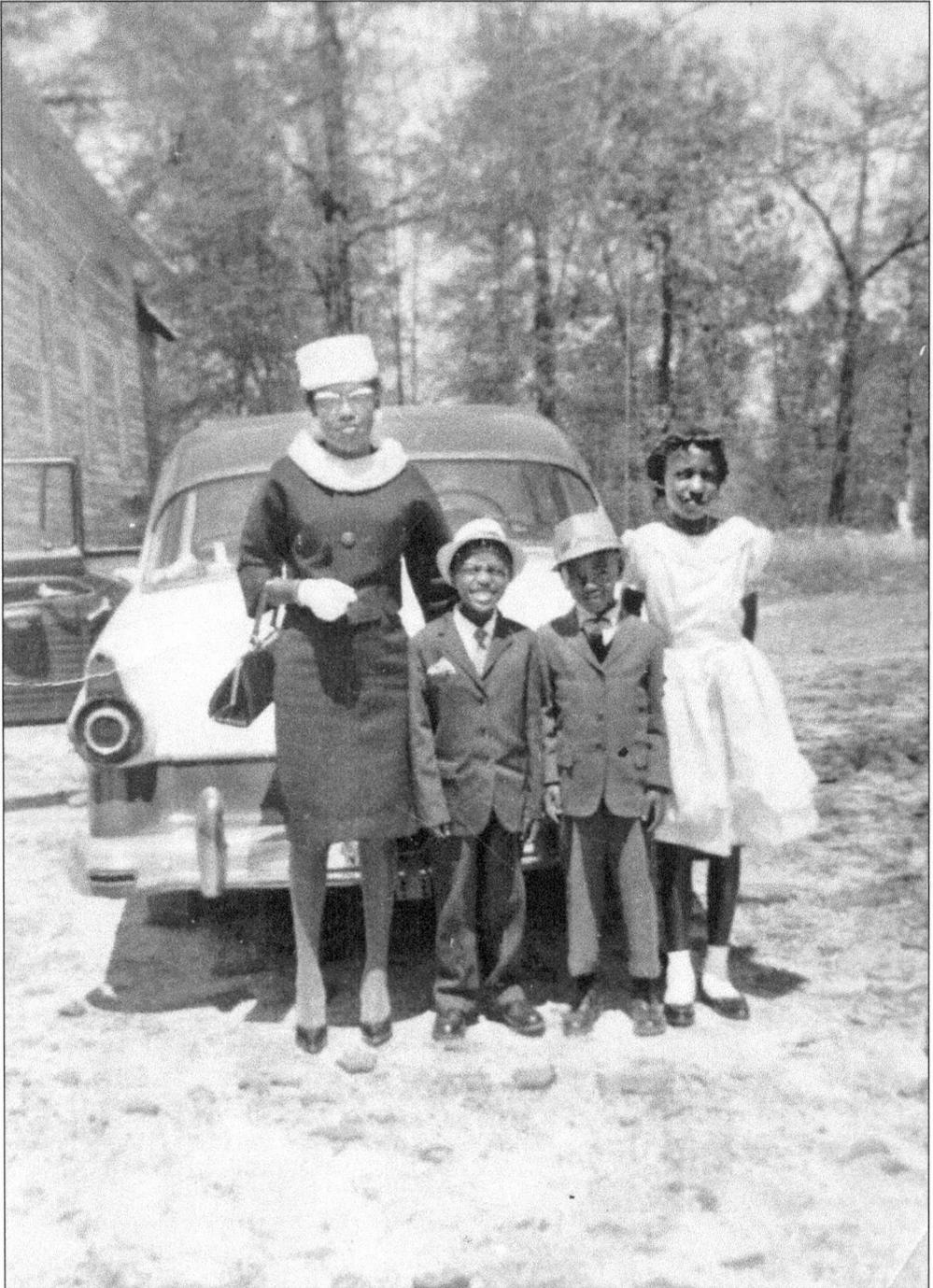

From left to right, Flonnie Joines Harrell, her son Duronnie Lee, her nephew Levander Rorie, and her daughter Linda are just leaving the service at Timmonsville Baptist Church in Mount Croghan. Flonnie served as church clerk and as a deaconess. She married Coleman C. Harrell and had 10 children. (Courtesy of Gloria Pfeiffer.)

Leak Burch, standing in front of his 1958 Chevy, was a deacon at Timmonsville Baptist Church, seen at the right corner. In addition to farming, he worked at the winery in Patrick. (Courtesy of Clarice Hogbrok.)

Ross Melton was a farmer who lived in Mount Croghan growing corn and cane. This photograph was taken at his sister Mozelle Covington's home. (Courtesy of Devenia Melton.)

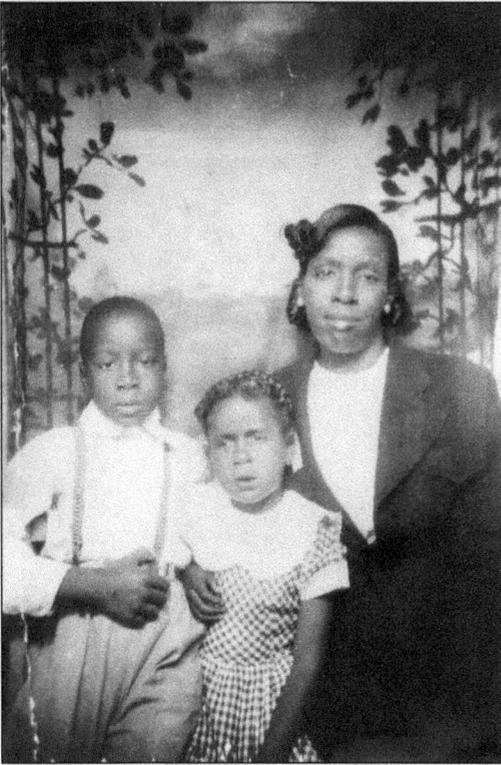

Jessie Sellers Burch is shown with her children, John Bennett and Creola Elizabeth, in the early 1940s. (Courtesy of Minister Jessie S. Burch.)

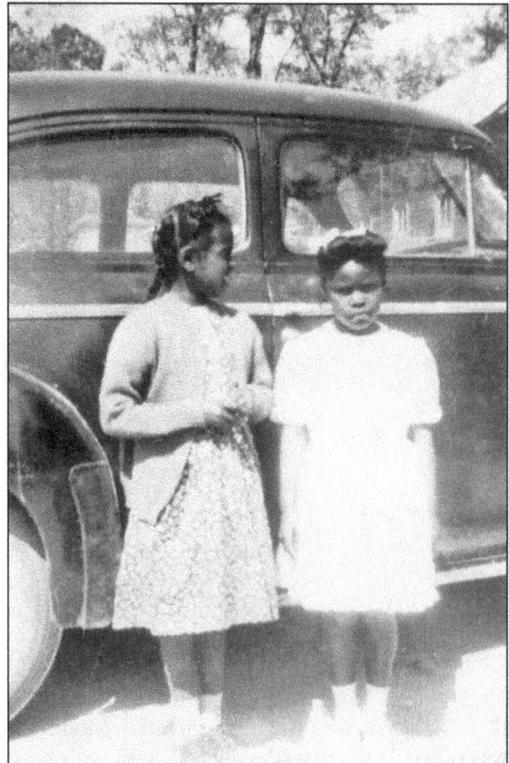

Cousins Creola Blakeney (left) and Mary Sellers are dressed in their Sunday outfits for worship service in the 1940s. (Courtesy of Minister Jessie S. Burch.)

*Six*

# McBee

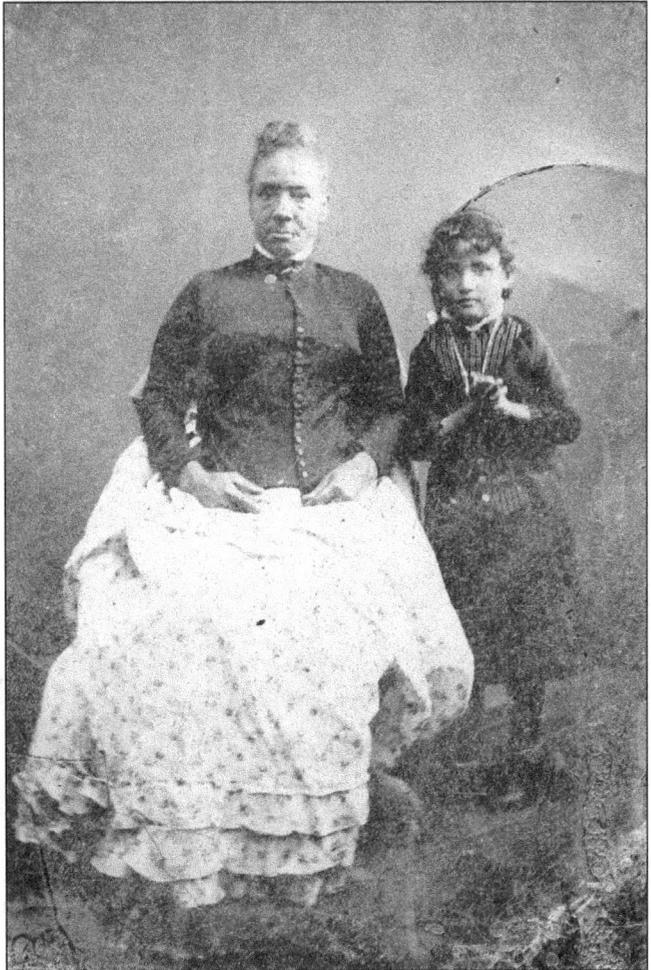

In this tintype photograph, former slave Mary O'Neal wears a dark button-down jacket and a hoop skirt, the fashions of the late 1800s. Mary's granddaughter Lula is at her side, smiling angelically with her hands clasped together. Notice Lula's curly hair with the big bow at the end of her plait. When Lula became an adult, she sometimes "passed" in society as a white woman due to her mixed parentage.

Andrew McFarland, born in 1880, purchased 54 acres of land in the Alligator Township in 1926. He and his wife, Carrie, operated a syrup mill and raised their family on this land. (Courtesy of Lorraine O'Neal.)

Born in 1885, Carrie McFarland ran a syrup mill where local residents brought their cane to make syrup. She was also a midwife. (Courtesy of Lorraine O'Neal.)

Emma Tillman, a midwife, delivered many of the black babies in the community. She participated in Galilee Baptist Church and served on many auxiliaries. Emma and her husband, Sidney Tillman, had one daughter, Ruth. (Courtesy of Nola Alford.)

Adger Rogers was a skilled carpenter who performed odd jobs in the community during the early 1900s. (Courtesy of Nola Alford.)

After graduating from Morris College in Sumter, Zechariah A. Matthews taught at several African American schools in the McBee area. He and his wife, Maybelle Brown, raised one daughter, Florence Matthews Pouncey. (Courtesy of Cornelia Carr.)

Belle H. McClain attended Allen University in Columbia before beginning her 42-year teaching career. She served on the faculty of New Hope Colored School, among other institutions. (Courtesy of Elizabeth Sowell.)

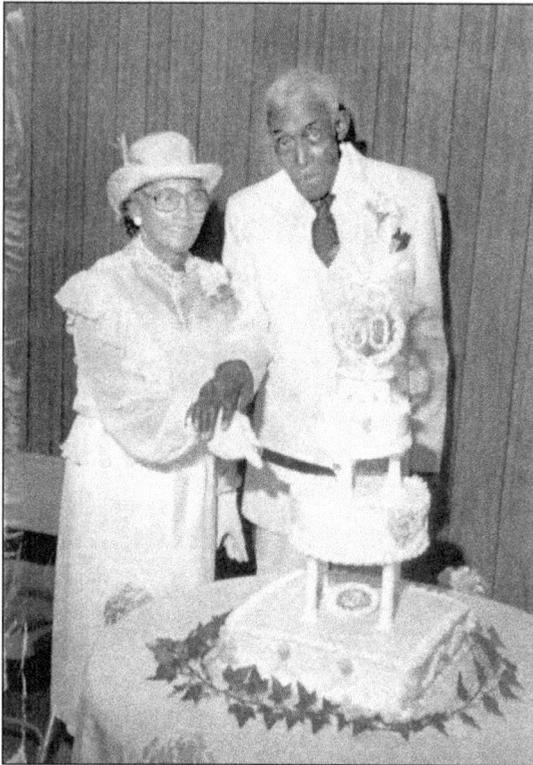

James and Annie Eliza Linton celebrate their 50th wedding anniversary. (Courtesy of Cornelia Carr.)

In 1950, James Edward Linton opened Linton Grocery; in 1967, he built a new store and renamed it Linton Grill and Grocery. The business was located in the Middendorf community on Highway 1. James's wife, Annie, operated the store on a daily basis while he continued working at Sonoco Products in Hartsville. Linton Grill and Grocery was a gathering place for socializing and listening to the jukebox. (Courtesy of Cornelia Carr.)

Mabel Jackson Hall was married to Thomas Hall Sr., who worked for the Seaboard Airline Railroad building tracks from McBee to Bethune, South Carolina. Mabel provided domestic help to several homes in the community. She was also the mother of Galilee Baptist Church. Mabel died at age 101. (Courtesy of Alberta Brewster.)

Zezzie Horton, born on June 26, 1900, was the wife of Frank Horton. A skilled seamstress, she provided washing and ironing services to the community. She could look at a dress and make a replica without ever using a pattern. (Courtesy of Elizabeth Nelson.)

Willie Clifton Sullivan was born on April 26, 1910. As a youth, he attended the Mount Elon Colored School and continues to live in the Angelus community. He is an active member of the Sand Run Baptist Church, has served on numerous auxiliaries for 70-plus years, and is known as the church historian. Clifton and his great-grandson Tyrinn Moton pose for a photograph together after church services. (Courtesy of Lorie Sullivan Hawkins.)

Born in 1893, Sarah W. Pate owned Sarah's Restaurant in the African American section of town, which was known as "the Hangout." (Courtesy of Rufus Newman.)

New Hope Colored School was named for its neighboring church, New Hope United Methodist. The school was heated with a potbelly stove, and later another room and a kitchen were added to the structure. Zechariah Matthews and Belle McClain both taught here. (Courtesy of the South Carolina Department of Archives and History.)

Another facility that educated black students in the McBee area was the McBee Colored School. Here students run around and play during recess. (Courtesy of the South Carolina Department of Archives and History.)

Located in the New Hope United Methodist Church Cemetery, these grave markers are the craftsmanship of Carl Cosom, who owned a blacksmith business during the early 1900s.

Carl Cosom, born in the late 1800s, reportedly created these markers for his own family members' graves. The wooden marker is made in the design of a cross.

# Seven

# JEFFERSON

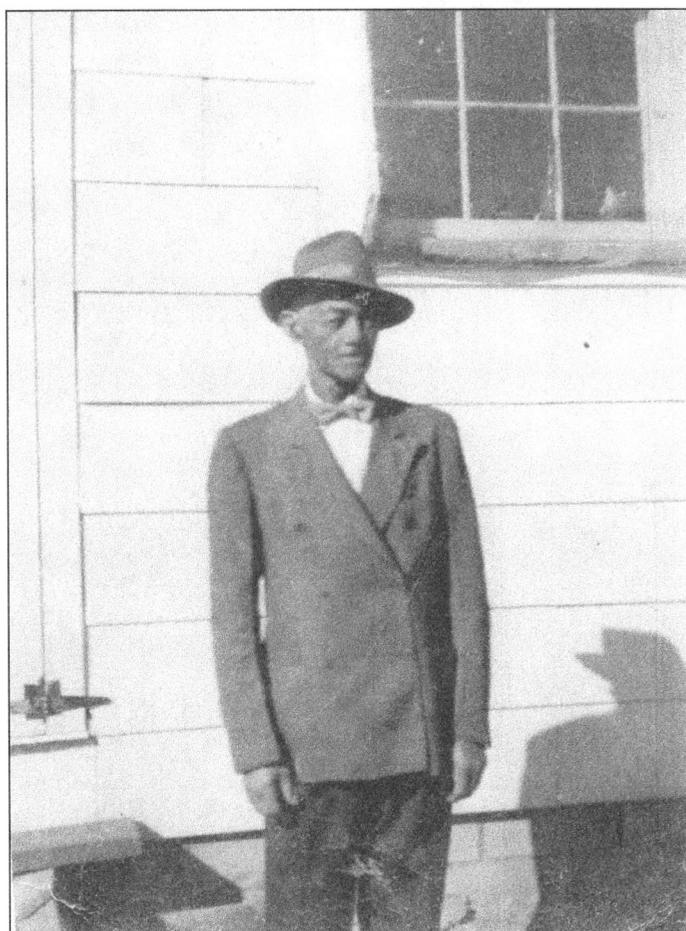

Born in 1879, James Lemuel Love worked as a farmer before opening Love's Shoe Shop. He later added a barbershop to the establishment. As a brick mason, Love built several fireplaces and chimneys for homes in the community. Here he stands in front of his house in the 1930s. (Courtesy of Evelyn Love Reid.)

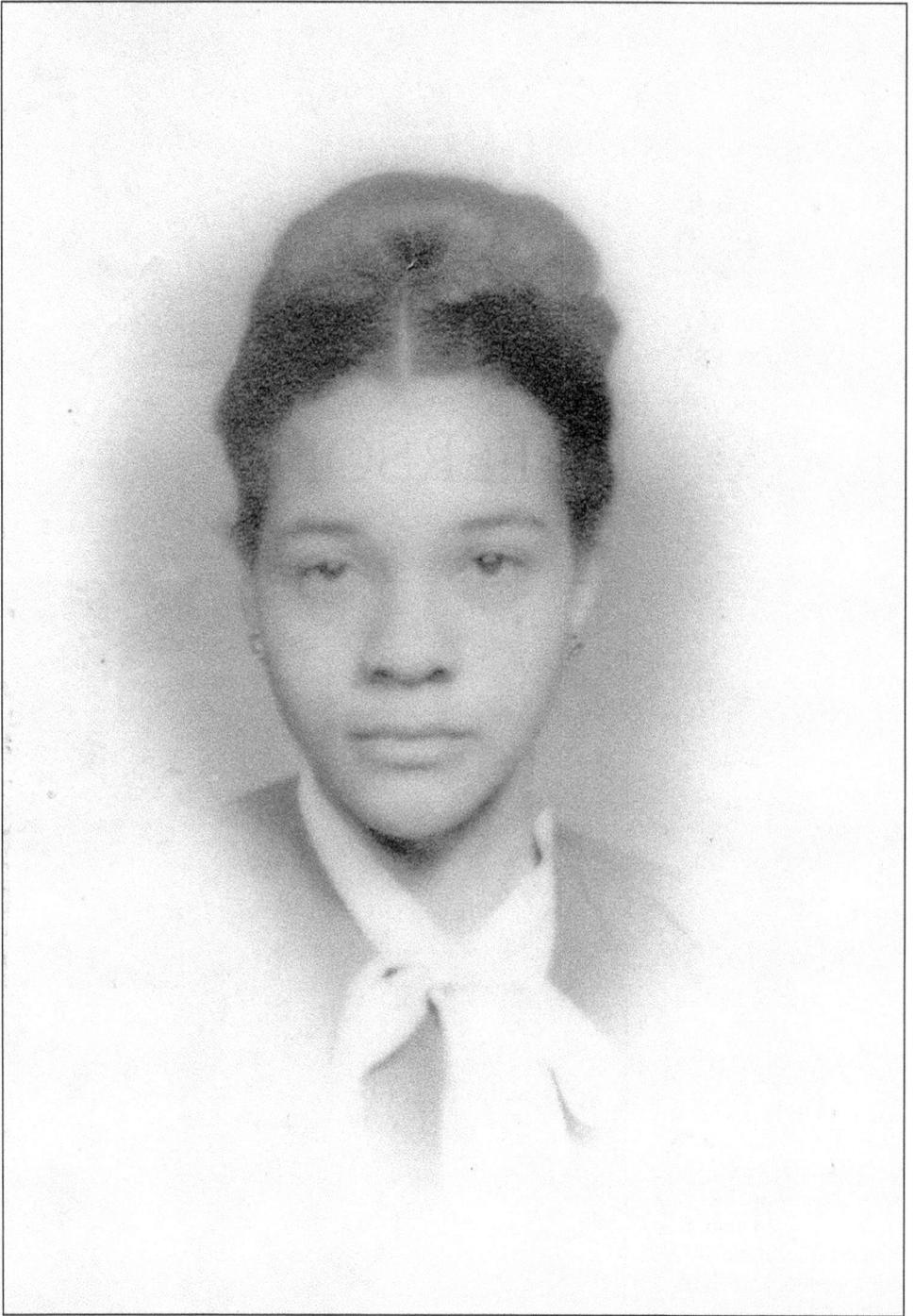

This photograph of Evelyn Love was taken in the 1930s while she was attending Mather Academy in Camden, South Carolina. She later became valedictorian for the class of 1942 at Bennett College in Greensboro, North Carolina. Evelyn taught at the Shannon High Colored School in Jefferson, retiring from the school system in 1978. She is the wife of the late Robert Reid. (Courtesy of Evelyn Love Reid.)

Ollie Miller Lockhart sits on the family porch with her children in the 1920s. Surrounding Ollie are, from left to right, Roberta, Novella, Rozella, and baby Ileader Lockhart. Ollie and her husband, Richard, were the owners of a restaurant. (Courtesy of Roberta McMillan.)

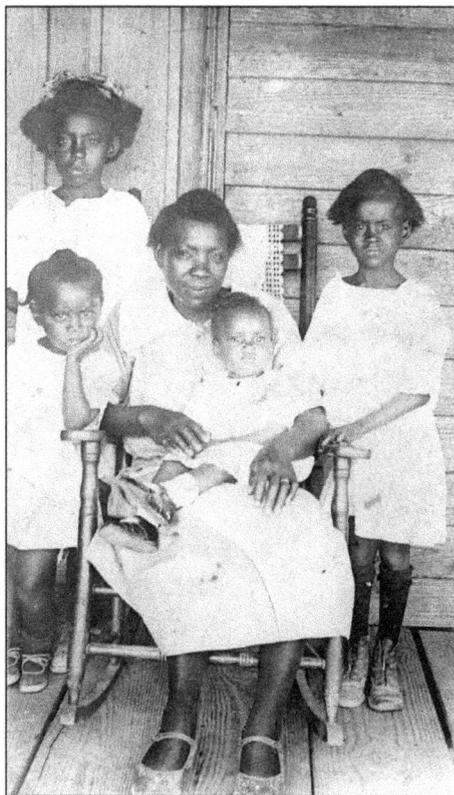

Novella (left), Emsley (center), and Rozella Lockhart pose for a snapshot at the family home. (Courtesy of Roberta McMillan.)

Susie Love and her two children sit for a family portrait at a photography studio. On the left, her daughter wears a crisp dress with a scalloped edge and a large bow in her hair. Her baby, wearing a little white gown, sits comfortably in her lap. (Courtesy of Mildred M. Blakeney.)

Sadie Love Reynolds and an unidentified woman are pictured in front of a makeshift chicken coop in the backyard at the home place. (Courtesy of Mildred M. Blakeney.)

Eular Miller, born in 1896, was a first cousin of Beckham Miller. He enlisted in the armed forces in 1917 and served during World War I. Here he wears his uniform and stands by the American flag. (Courtesy of Claudette Miller.)

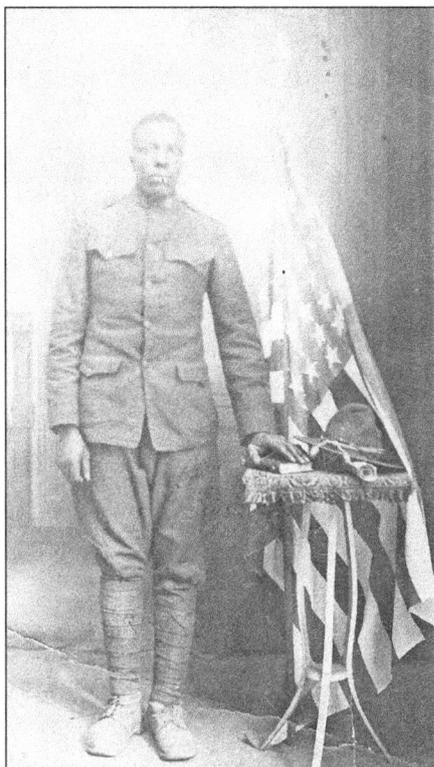

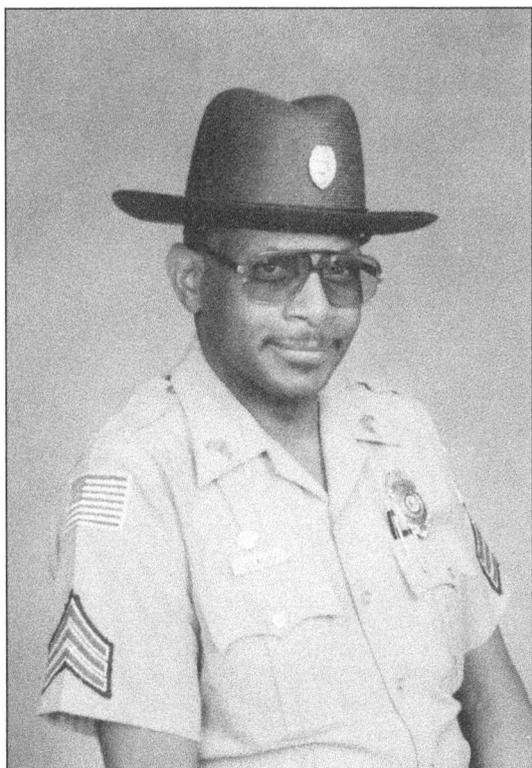

Charles Coleman Miller was the first African American police officer with the Jefferson Police Department. He graduated from the Criminal Justice Academy in Columbia and retired with the rank of captain. He was married to Helen Miller. (Courtesy of Helen Miller.)

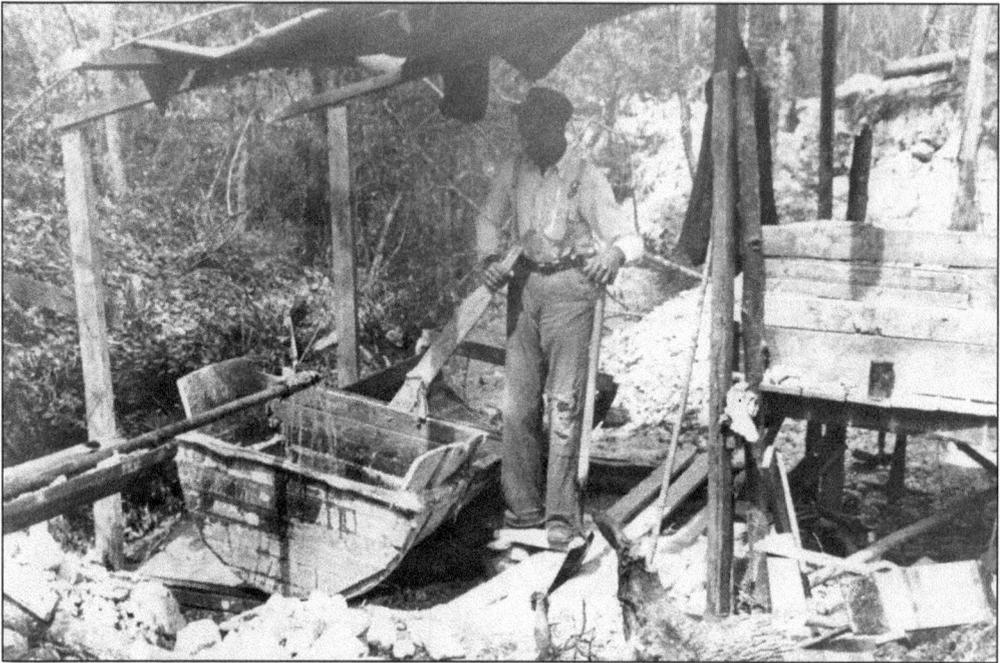

In this early-1900s photograph, Jake Miller pans for gold at the Jefferson Gold Mine. During his many years of work at the mine, he reportedly traveled to 48 states delivering gold. (Courtesy of Aster Truesdale.)

Jake Miller (pictured) and his wife, Mary Strafford Miller, raised six sons and three daughters. Jake was the owner of a clothes-pressing business. (Courtesy of Aster Truesdale.)

Dressed in her midwife uniform, Bonnie Miller Louallen holds an infant in 1954. She delivered both black and white babies in the community. Bonnie owned a washerette in Jefferson and, along with her son Moses, operated the Louallen Lunchroom in the Petersburg section of Pageland. (Courtesy of Aster Truesdale.)

Overseer Bonnie Louallen was the founder and pastor of three churches in Chesterfield County. She physically assisted in building Morning Star Holiness Church in Jefferson, Lilly of the Valley Holiness Church in Chesterfield, and Lilly Grove Holiness Church in Cheraw. (Courtesy of Aster Truesdale.)

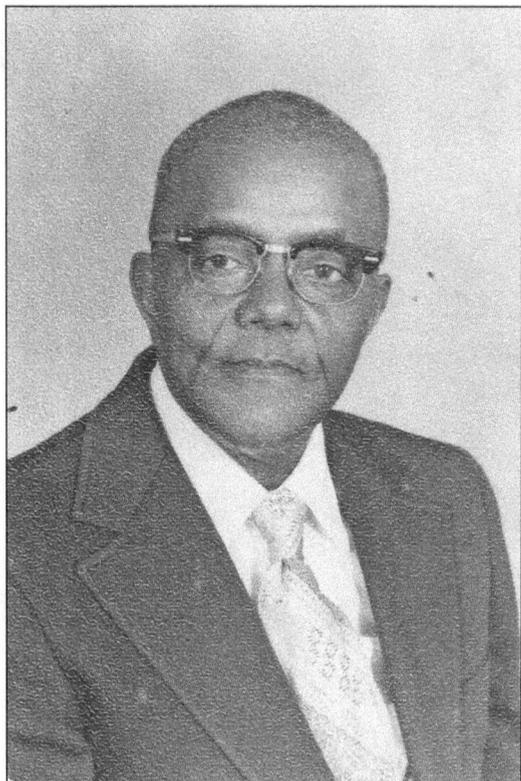

Beckham Miller Sr. began his career working at James Love's barbershop. In the early 1940s, he opened Beck's Place, a barbershop and grocery store, right across the street from his house. The barbershop building stands today as a mechanic shop run by his grandson. Miller voluntarily drove a school bus during segregation in the Angelus community. (Courtesy of Claudette Miller.)

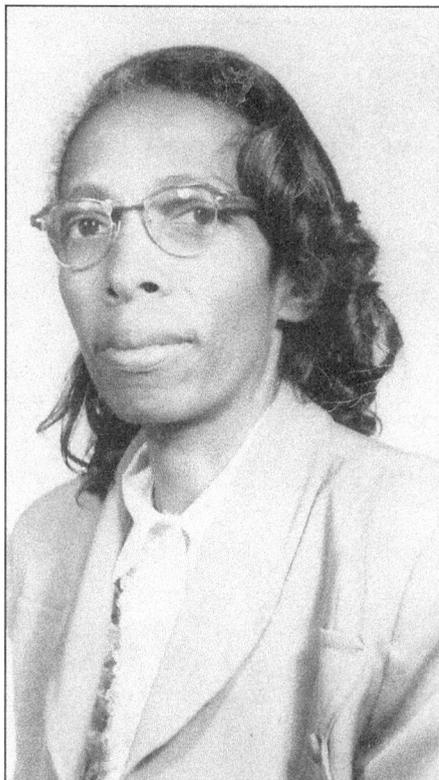

Grace Robinson Miller moved to Jefferson from Bennettsville, South Carolina, in order to teach. She worked at numerous African American schools, including those in the Black Creek, White Plains, and Oak Hill communities. She married Beckham Miller and mothered four children. (Courtesy of Claudette Miller.)

Ethel Miller McMillan started an upholstery business in her home in 1959. In 1970, she purchased a building on Miller Street, thus becoming the first African American to own and operate an upholstery shop in Jefferson. (Courtesy of Sim McMillan.)

Lelorine Miller graduated from Claflin College with an English and history degree in 1950. Continuing her schooling, she received a master of education from the University of South Carolina in 1974. Lelorine began her teaching career at Shannon Elementary School. She became the first African American teacher to integrate Jefferson High School. (Courtesy of Lelorine Miller.)

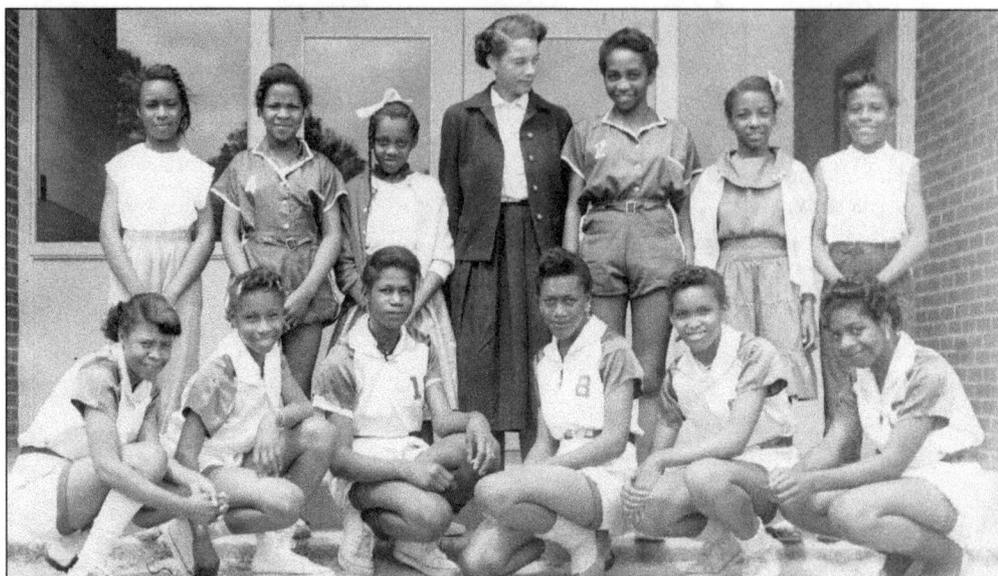

These smiling girls comprise the Shannon High School girls' basketball team. Pictured from left to right are the following: (first row) Mary Hazel Miller, Lavilla Louallen, Bobby Jean Sullivan, Margie Evans, Ernestine Louallen, and Penny Blakeney; (second row) Joyce Ann Louallen, Jeanette Blackwell, Lillie Ingram, Evelyn Love Reid (teacher and coach), Betty Love, Mary Ingram, and Ruth Miller. (Courtesy of Evelyn Love Reid.)

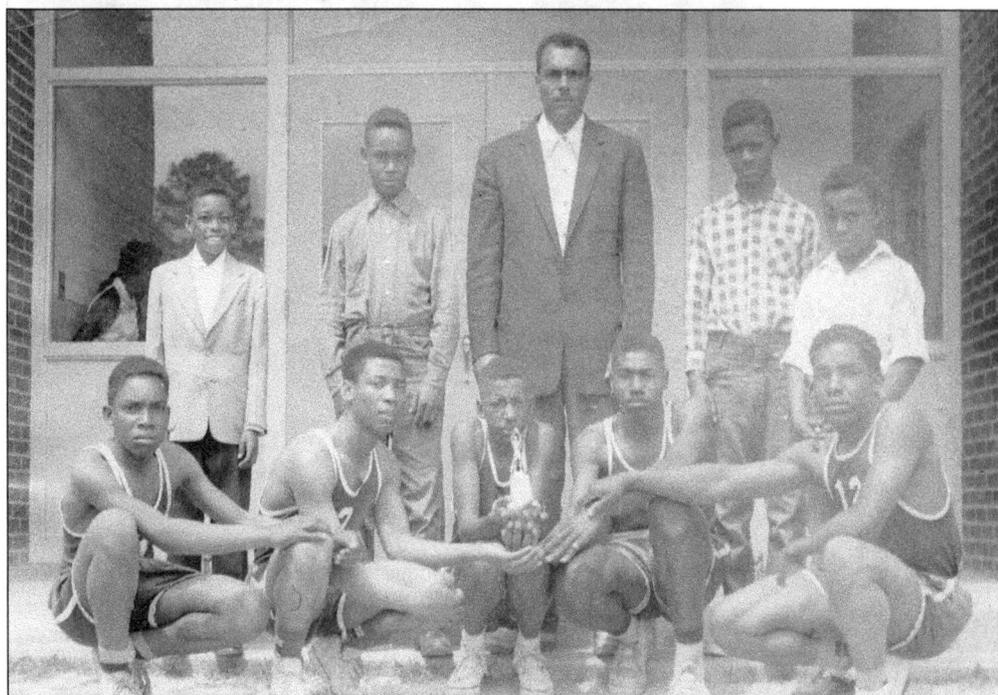

Shannon High School boys' basketball players pose with their trophy in the 1950s. Shown from left to right are the following: (first row) Fred Blakeley, Wylie Nicholson, James Thomas, Sim Sullivan, and Roy Garner; (second row) Beckham Miller Jr., James Hough, Robert Reid (principal and coach), L. C. McCoy, and Pete Louallen. (Courtesy of Evelyn Love Reid.)

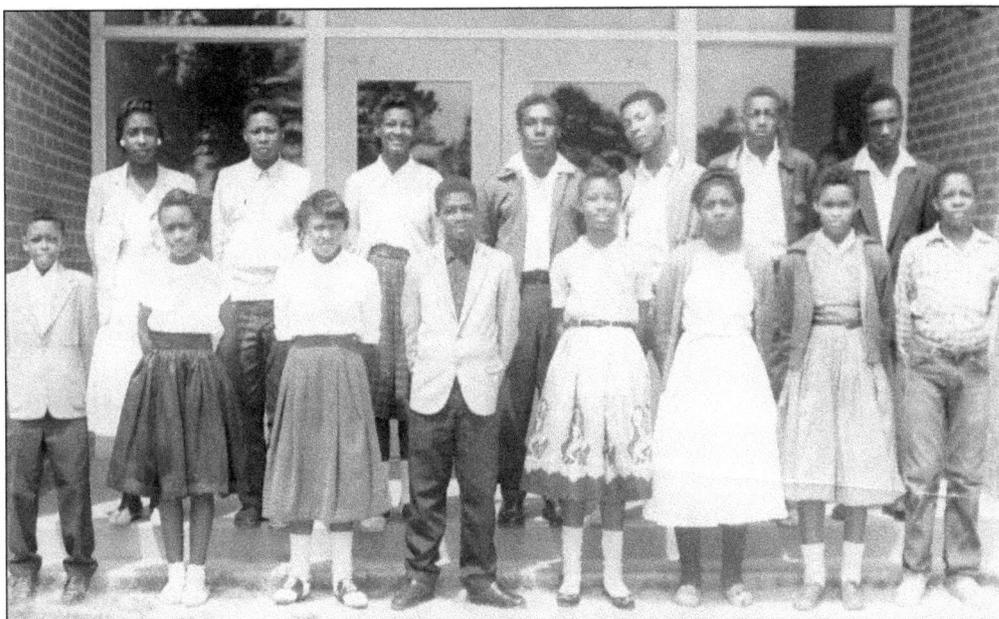

Members of the seventh-grade class at Shannon High School in the early 1950s included the following, from left to right: (first row) Beckham Miller Jr., Joyce Ann Louallen, Mary Hazel Miller, Norris Clark, Lavilla Louallen, Penny Blakeney, Ernestine Louallen, and Caldwell Staton; (second row) Penny Blakeney, Howard Blakeney, Barbara Caulder, Roy Garner, Wylie Nicholson, James Thomas, and Freddie Sowell. (Courtesy of Evelyn Love Reid.)

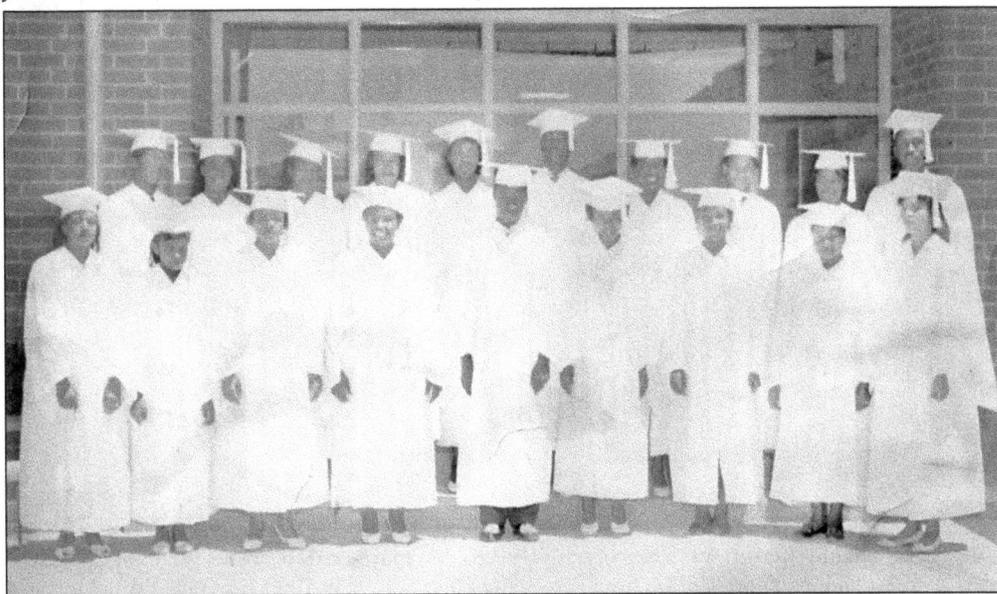

Jefferson and Pageland combined to form Petersburg Colored School in 1956. Members of the graduating class were as follows, from left to right: (first row) Carrie McManus, Claudette Miller, Henrietta Massey, Maecrosha Blakeney, George Louallen, Celia Threatt, Nancy Miller, Betty Miller, and Utha Robinson; (second row) Henry Johnson, Joyce Clyburn, Mary Robinson, Naomi Laney, Annelle Truesdale, Clarence Miller, Betty Jo Johnson, Carrie Funderburk, Elouise Williams, and Sam Clark. (Courtesy of Claudette Miller.)

James Louallen of Jefferson was a singer with the Golden Harmonizers gospel group of Brooklyn, New York. Upon James's graduation from Petersburg High School in 1960, his uncle Daniel Jackson asked him to join. The group's first recording was "I'm Traveling Alone," and James wrote the song "If I Never Reach Perfection Oh I Tried." He no longer sings with the group but rather serves as manager. Performing in the early 1960s at Petersburg High School are the following, from left to right: (first row) Lucious Lee and Daniel Jackson; (second row) James Louallen, ? Palmer, Jimmy James, and Henry Williams. (Courtesy of Lavilla Evans.)

# *Eight*

# PAGELAND

Born into slavery near Pageland in the 1840s, Emiline Watts Brewer was of mixed parentage and adopted the surname of her owner. She married Robert Brewer, and the couple raised 11 children. The Brewers accumulated enough land to give each of their children a homestead and thus planted a seed of economic independence. Many of their descendants have attained higher educations as doctors, lawyers, ministers, teachers, and businessmen and women. Emiline's headstone reads, "Founder and Mother of Wesley United Methodist Church." (Courtesy of Shawn Fisher.)

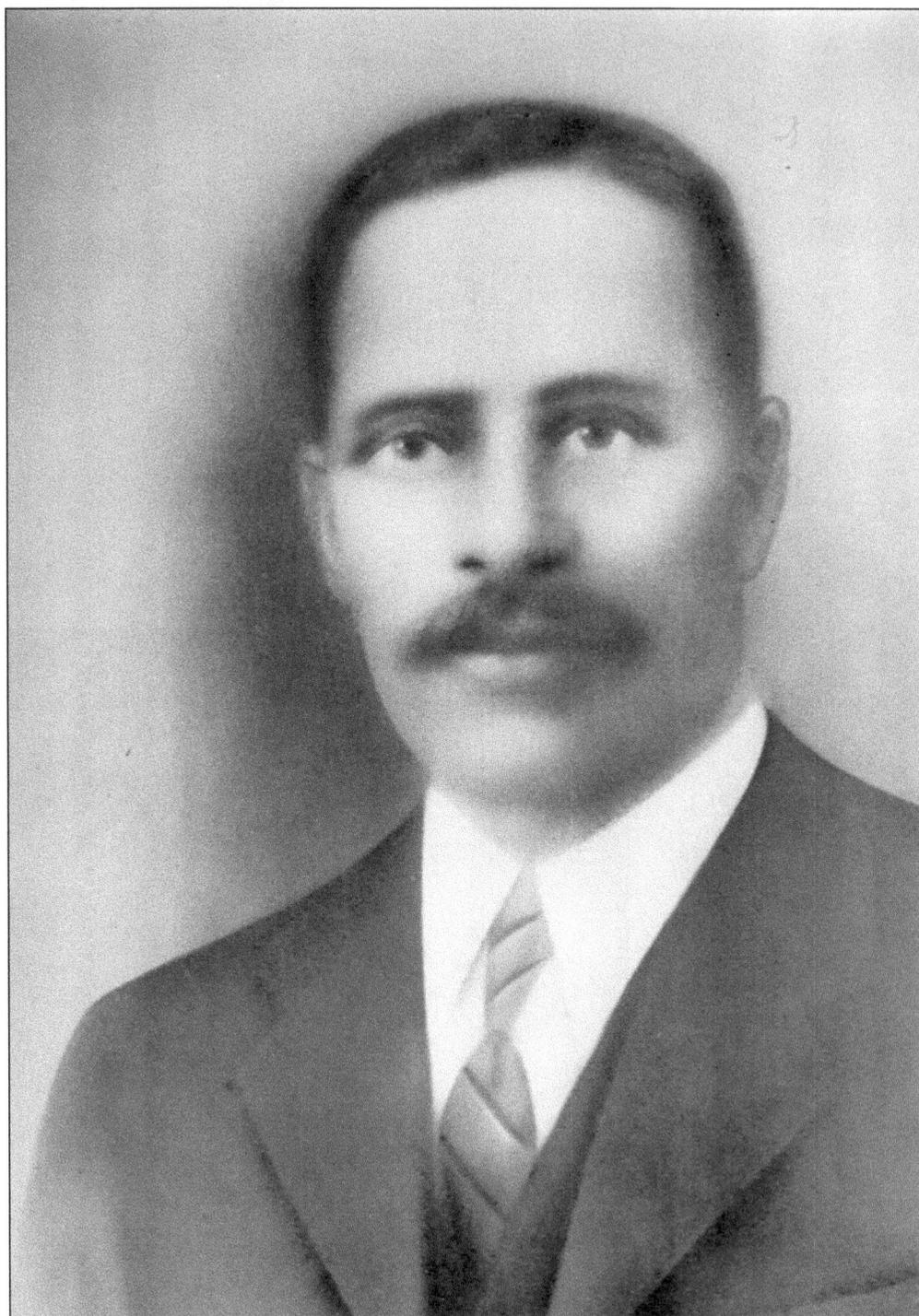

Joseph Cephus Brewer was born on October 9, 1968, to Robert and Emiline Watts Brewer. He wed Emma Covington and fathered 14 children. The children rotated attending school so someone would always be home to assist their parents on the farm. Joseph was a founder of Wesley Chapel Church. (Courtesy of Shawn Fisher.)

Thomas F. Brewer was born on September 30, 1880, and his wife, Nannie Robinson Brewer, was born on July 30, 1885. The Brewers raised a family in the area known as Guess, where they taught school in the winter and farmed in the summer. They were also referred to as the "free funeral directors" because they assisted families in the community when loved ones died by preparing the bodies and taking care of funeral details. Thomas drove the hearse, a two-horse wagon, while Nannie carried the survivors in the buggy. (Courtesy of William T. Dargan.)

In this early-1900s postcard, sisters Perlener (left), Loana (center), and Lillian Edgeworth are dressed in the same fashion. (Courtesy of Betty Jean Blakeney.)

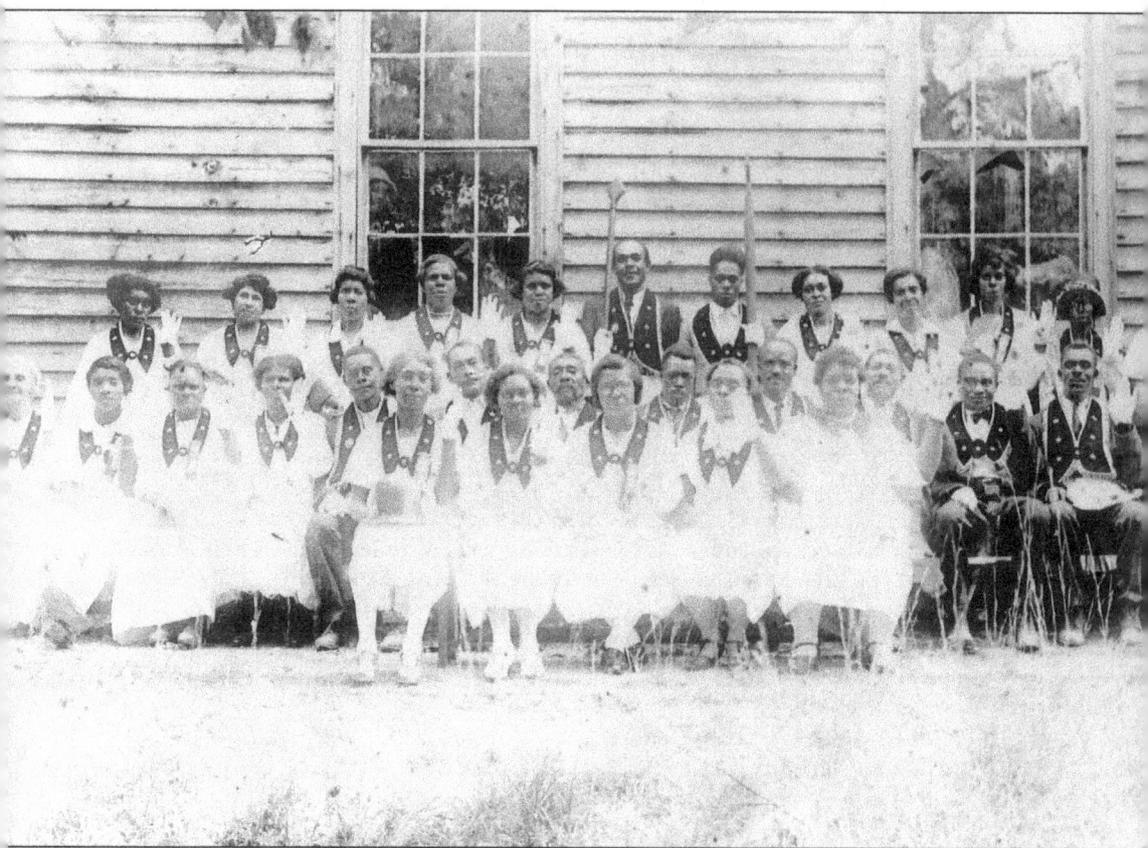

This photograph of a Pageland Masonic lodge and the Eastern Stars was taken in the 1930s, likely outside of the old Popular Hill African Methodist Episcopal Zion Church that was razed in the early 1940s. Pictured from left to right are the following: (first row) unidentified, Clara Clyburn, unidentified, Sally Blakeney, and Lola Blakeney; (second row) ? Lockhart, two unidentified people, Bessie Blakeney, two unidentified people, George Lockhart, Dude Clyburn, three unidentified people, Howard Blakeney, and unidentified; (third row) Eva Clyburn, four unidentified people, Wade Lockhart, Roy Baker, two unidentified people, Onesia Lowery, ? Robinson, and unidentified. (Courtesy of Betty Jean Blakeney.)

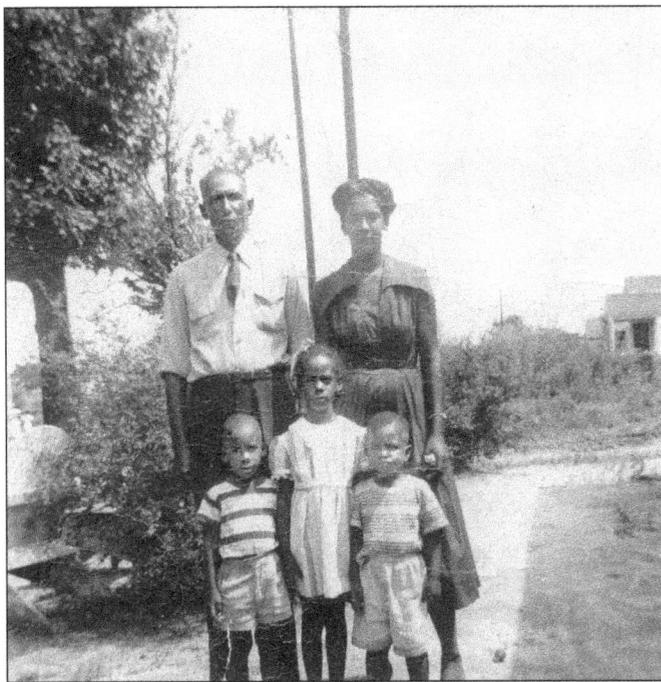

William Blakeney and his wife, Pratus, lived in the Petersburg community and purchased 18 acres of land. On their property, they built six small shotgun-style houses and rented them to families who wanted to leave the farm and move closer to town. Blakeney also constructed a two-story building that served as the community center. It was comprised of a general store, a barbershop, and a beauty parlor, with living quarters upstairs. Blakeney is pictured with his daughter Louise, her children Horace Jr. (left) and Claudia (center), and an unidentified friend of the family. (Courtesy of Louise Nichols.)

Henry and Mary Threatt enjoy a picnic at Cheraw State Park. Both educators, they met while teaching at the Black Creek Colored School. Henry was also an evangelist. Mary taught fourth grade at the Petersburg School from 1927 to 1965. (Courtesy of Doreatha Jordan.)

William Dargan was a farmer, a barber, and the founder of Pageland's American Legion Post. He also served as a deacon at the Gum Springs Baptist Church in Pageland. His wife, Vashti, graduated from Coulter Memorial Academy and Benedict College in Columbia. She then taught 45 years in the Chesterfield County school system. (Courtesy of Dr. William T. Dargan, Stories About Us Project.)

During segregation, Early Blakeney, along with Bill Blakeney, Richard Blakeney, and William Robinson, succeeded in building a high school in the Petersburg community for the "negro children." The first black man to work for the Coca-Cola bottling plant, Early also served as president of the NAACP. He is shown here with his wife, Mavis Blakeney. (Courtesy of Luther Benson.)

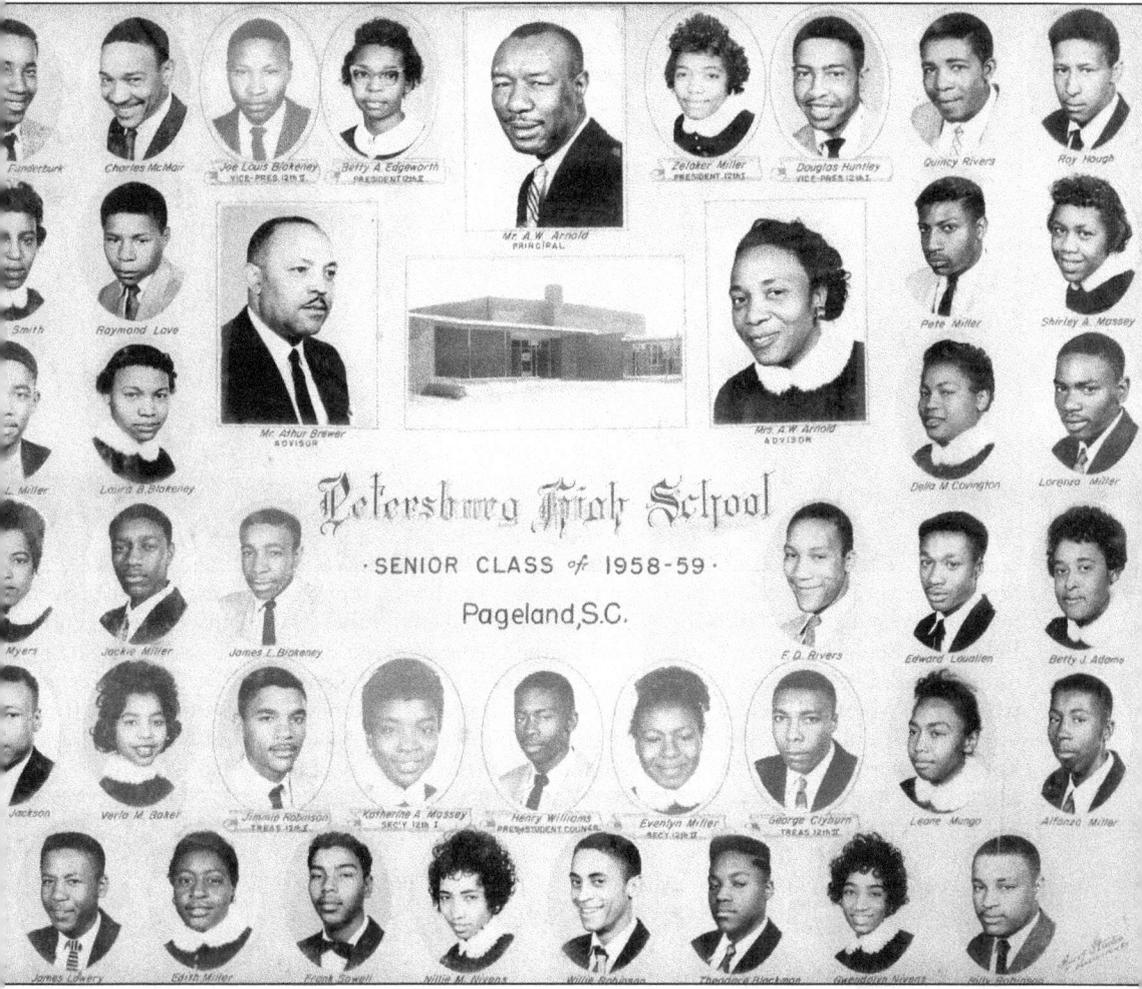

This Petersburg High School class picture is of the senior class of 1958–1959. Alvin Arnold was the principal of the school. Arthur Brewer and Dorothy Arnold were the advisors for the school. In the center of this photograph is a picture of the school. (Courtesy of Dorothy Arnold.)

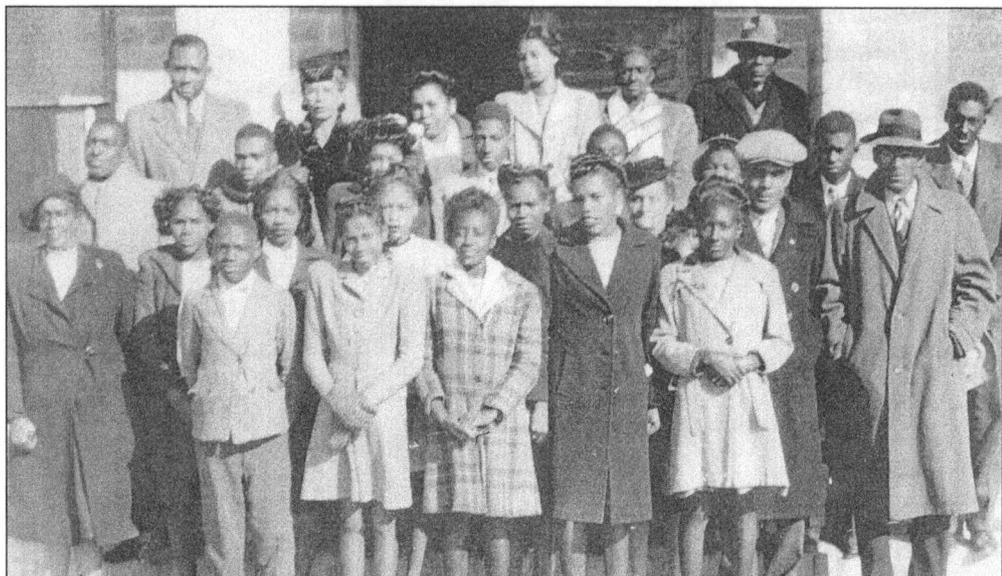

Students at the Presbyterian church Sunday school gather for a photograph in the 1940s. Seen from left to right are the following: (first row) Artis Blakeney, Ethel Baker, Pansy Threatt, Eutha Baker, and Beulah Threatt; (second row) Curlie Baker, Marcine Blakeney, Ernestine Blakeney, unidentified, Elmer Blakeney, Emerline Blakeney, Fletcher Blakeney, and Richard Blakeney; (third row) Mitchell Brewer, Caldwell Blakeney, Luzetta Blakeney, Douglas Crawford, three unidentified, and Harry Wadsworth; (fourth row) unidentified, Avis Robinson, Susie Robinson, Kate Wadsworth, Lillie Brewer, and William Blakeney. (Courtesy of Flora Mae Arkorful.)

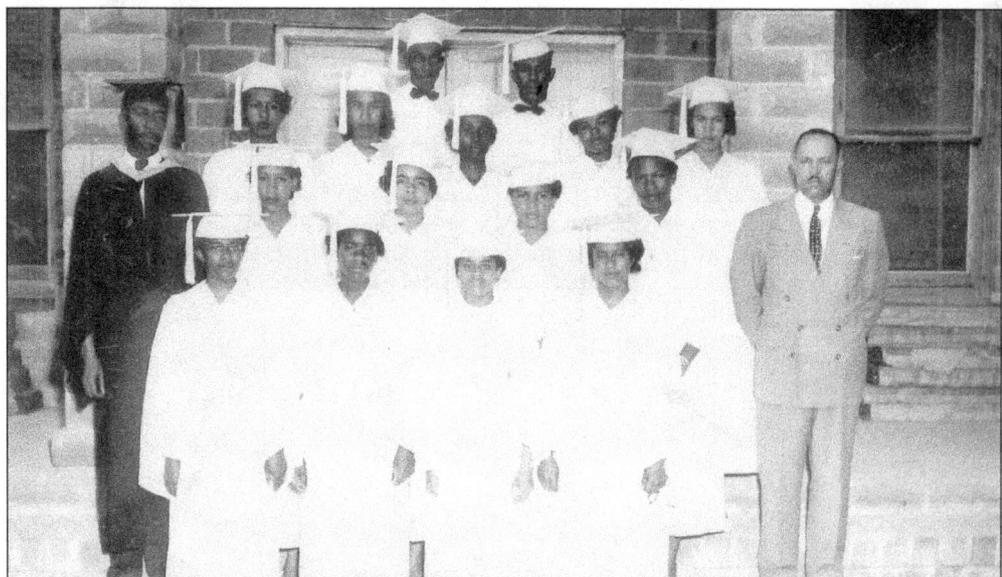

The Petersburg School graduation was held at the Presbyterian church in Pageland in 1955. Pictured from left to right are the following: (first row) Johnsie Threatt, Mary Ingram, Mary Adam, and Beulah Baker; (second row) Principal Alvin Arnold, Barbara Rivers, Katie Funderburk, Mary Brewer, Lucille Parker, and advisor Arthur Brewer; (third row) Flora Wadsworth, Annie Fraizer, Geneva Mack, Mary Funderburk, and Marjorie Frazier; (fourth row) Herman Miller and Dock Funderburk. (Courtesy of Flora Mae Arkorful.)

Lt. Luther Blakeney attended Coulter Memorial Academy and South Carolina State College in Orangeburg before becoming a pilot and weather forecaster. On June 18, 1943, he perished while flying over Lake Heron in Michigan during a training mission. (Courtesy of Luther Benson.)

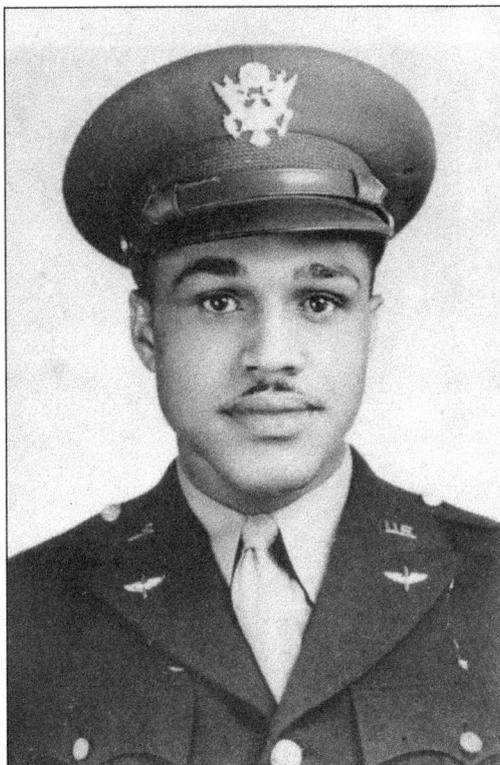

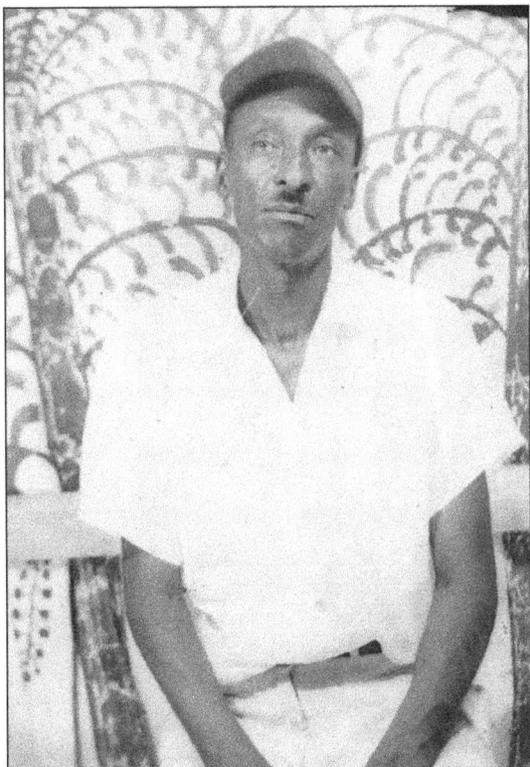

Harry Wadsworth married Kate Robinson, and the couple raised eight children. Active in the Second Presbyterian Church, Harry served as an elder and as a member of the succession, the governing board. He worked as a custodian at Petersburg High School before retiring in 1965. He also pitched for the local black baseball team and sang with the Clouds of Joy gospel quartet. (Courtesy of Flora Mae Arkorful.)

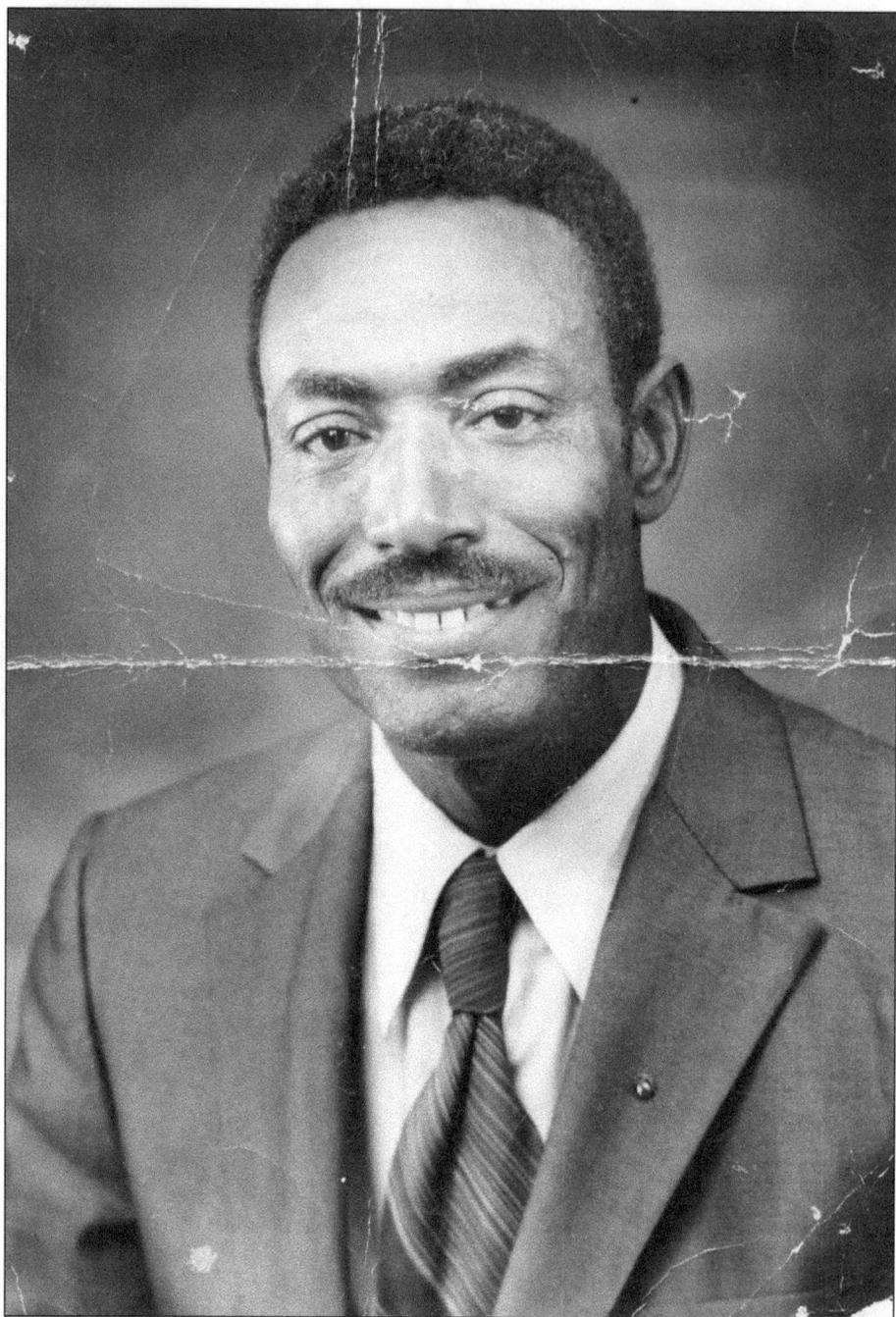

James D. McManus was a minister, civil rights activist, and entrepreneur in the Petersburg community. As president of the NAACP for nearly 20 years, he fought for justice and equality during desegregation and post-integration in the public schools. He also encouraged Africans Americans to get involved in the political process. McManus, who advocated economic independence, owned an enterprise that included a grocery store, bait and tackle store, credit union, and construction company. He married Jo McManus and fathered five children. (Courtesy of Glenda McManus Sanders-Robinson.)

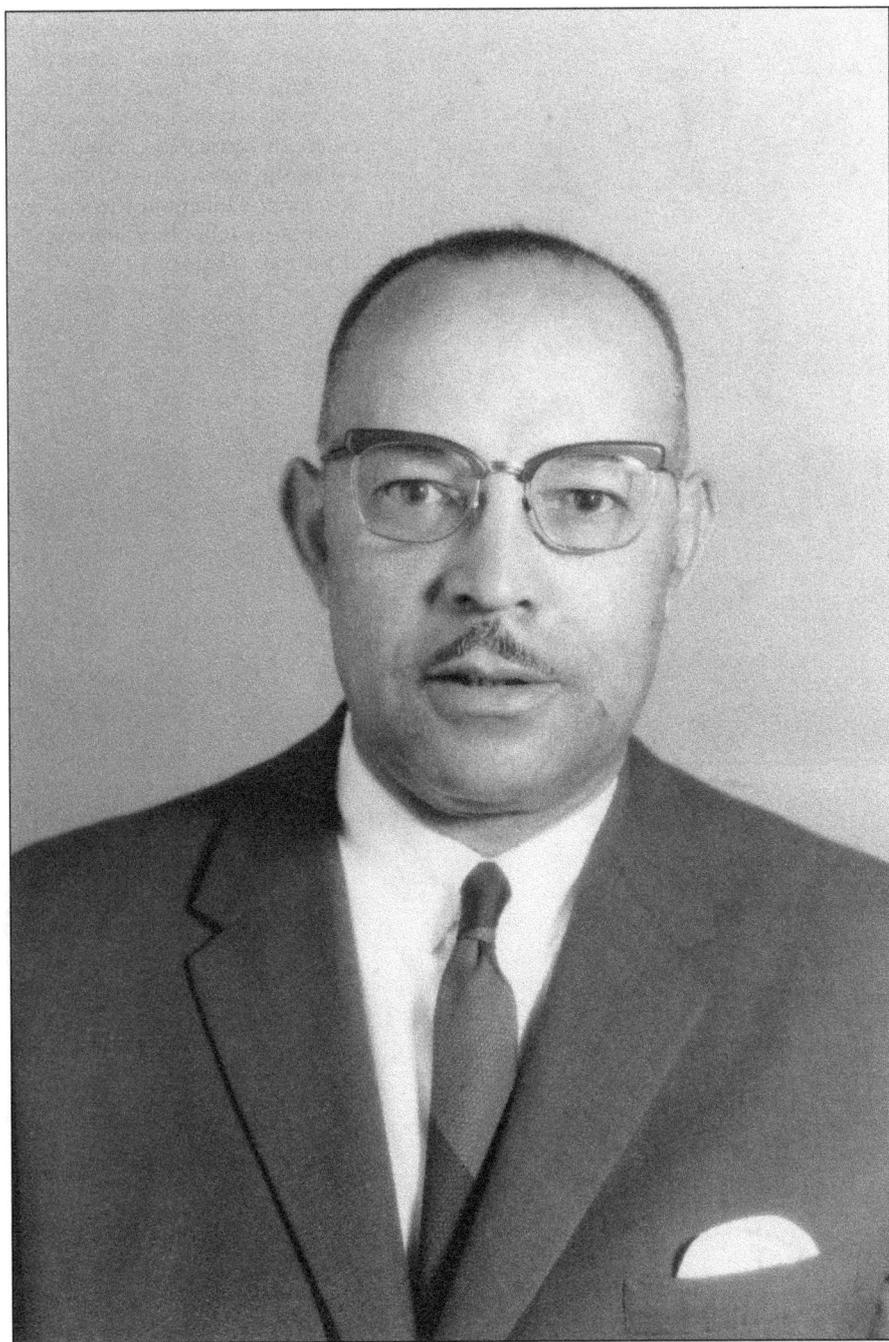

Arthur Van Brewer Sr. was an educator employed by the Chesterfield County school system for 30 years. In 1962, he founded the Chesterfield County Garment Corporation. Brewer served on the boards of several county institutions, including the Sandhill Telephone Company, the Lynches Rivers Co-Op, the Pee Dee Regional Councils of Government, the Chesterfield-Marlboro Economic Opportunity Council, the Chesterfield Board of Education, and the American Legion. He and his wife, Dorothy Saxon Brewer, had three children: Arthur V. Jr., Josef C., and Arthelia. (Courtesy of Dorothy S. Brewer.)

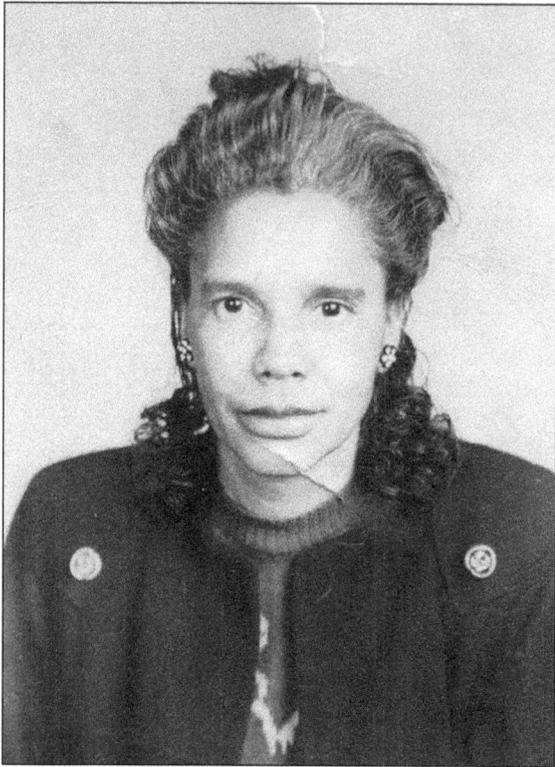

Avis Blakeney Robinson attended Coulter Academy and Brainerd Institute in Chester, South Carolina. She continued her education at Allen University in Columbia, where she received a bachelor of arts degree. She taught at the Pageland elementary schools. (Courtesy of Chrisandra Williams.)

A graduate of Morris College in Sumter, Annie M. Johnson raised her family in the Oro community and began her teaching career there as well. She later taught second grade at Petersburg High School. She was married to Wilbert Johnson Sr. (Courtesy of Wilbert Johnson Jr.)

Alvin Arnold graduated cum laude from Claflin College in 1941, receiving a bachelor of science degree. He then earned his master's in biology from South Carolina State College and a mortuary science degree from Eckels Mortuary School in Philadelphia. When Arnold was drafted into the armed forces, he attended Officer Candidate School at Fort Sill, Oklahoma, and became a second lieutenant before promotion to first lieutenant. He served as principal of the Pageland Centralized Colored School and then Petersburg High School before retiring from the Central High School staff in 1978. (Courtesy of Dorothy Arnold.)

Dorothy Arnold, the wife of Alvin, was a guidance counselor who worked for Petersburg, Pageland Elementary, and Pageland Junior High Schools. Dorothy was educated at the alma mater of her mother, Josephine S. Nix, Claflin College in Orangeburg. She is a member of the Oak Hill Baptist Church and has served in numerous capacities in the community. (Courtesy of Dorothy Arnold.)

After graduating from South Carolina State College, Paul Brewer Sr. taught agriculture and advised the 4-H Club at the Petersburg School. He often traveled with his students to 4-H fairs and Future Farmers of America programs so that they could compete in events pertaining to agriculture. Brewer's students also applied what they learned in class by giving back to the Petersburg community through various service projects. (Courtesy of Vanessa Brewer-Tyson.)

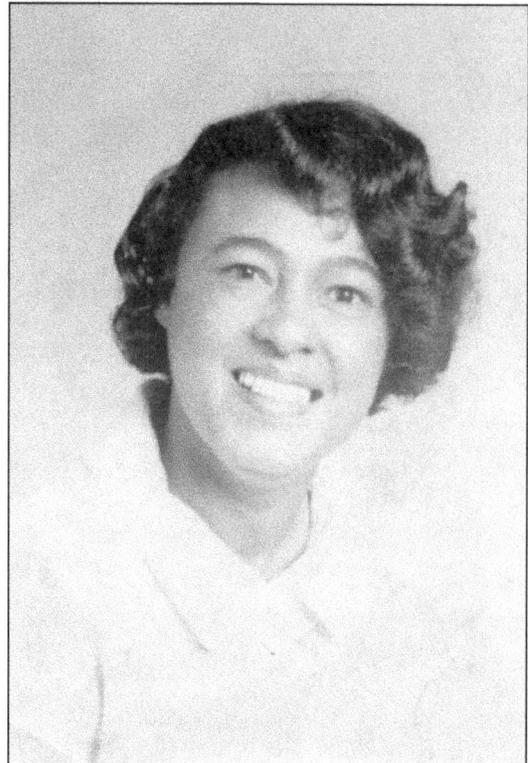

Effie Morrison Brewer graduated from South Carolina State College and went on to teach fifth grade and typing at the Shannon Colored School in Jefferson. She married Paul Brewer Sr. (Courtesy of Vanessa Brewer-Tyson.)

Horace W. Nichols Sr. attended the Laurinburg Institute and Fayetteville State Teachers College before receiving his master's from New York University. He served as a medic in the army and traveled on troop training. Nichols taught at the Rock Hill Colored School and Petersburg High School. He then became assistant principal of several junior high schools in Charlotte, North Carolina, and eventually retired from Albemarle Road Junior High School. He was an elder at the Second United Presbyterian Church. (Courtesy of Louise Nichols.)

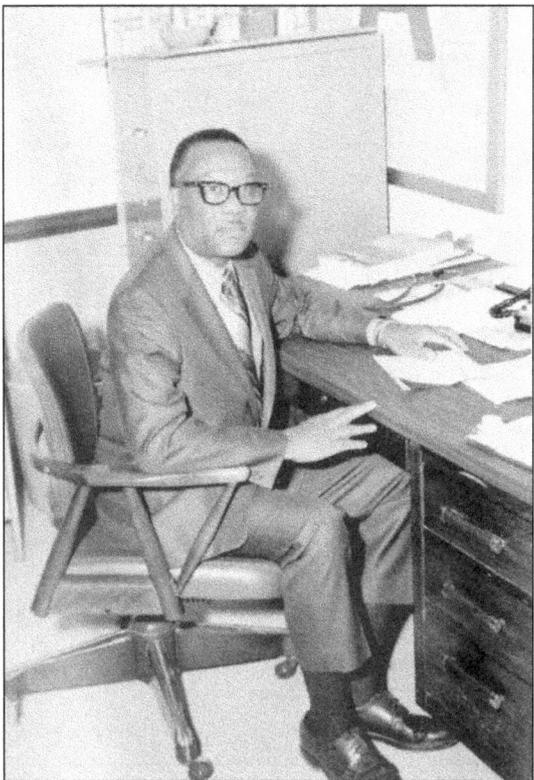

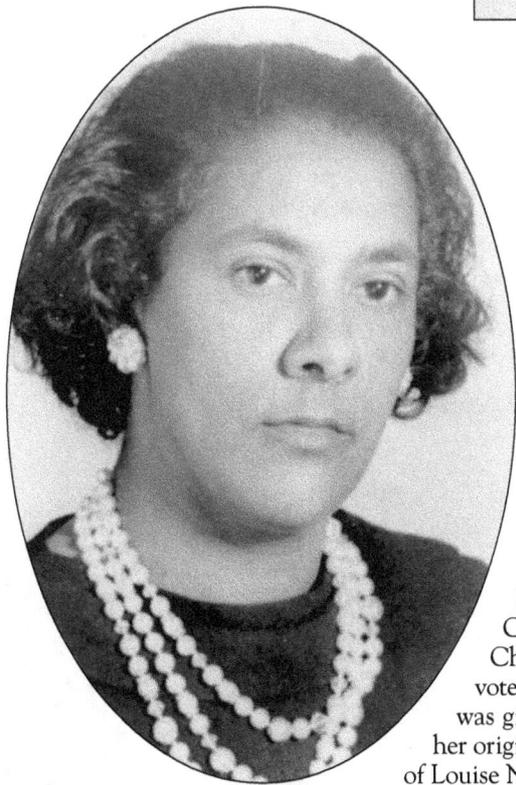

Louise Blakeney Nichols, the wife of Horace Nichols, received her education at Coulter Memorial Academy, Barber Scotia, and Fayetteville State Teachers College in North Carolina. In the early 1950s, she went to Chesterfield with a group of citizens to register to vote. The group was turned down, but in 1957, Louise was given a voter registration card. She still carries her original card when she goes to the polls. (Courtesy of Louise Nichols.)

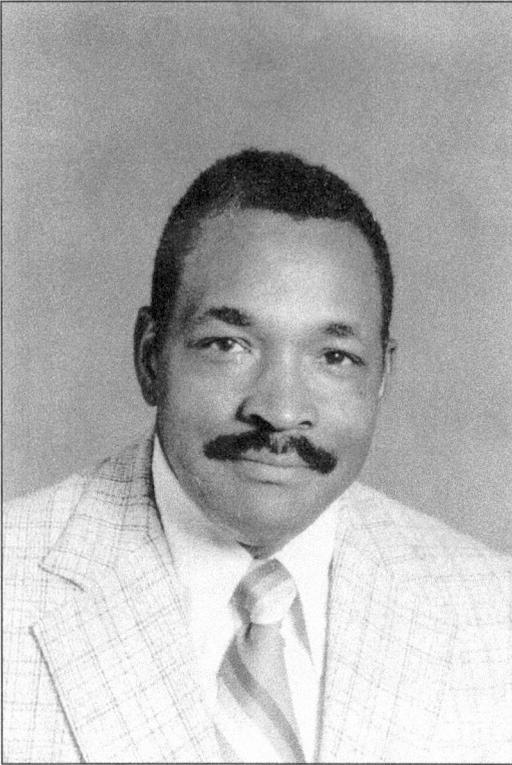

Rev. Colenzo Evans graduated from South Carolina State College with a bachelor's degree in science and agriculture. He went on to teach science at Gary High School and the Petersburg School. At the time of his retirement in 1983, Evans was serving as principal of McBee Elementary. After entering the ministry in 1965, he became the pastor of St. John Baptist Church in Sharon, South Carolina, and Nicey Grove Baptist Church in Wingate, North Carolina. He currently participates in the Masonic lodge, Booker T. Washington Consistory No. 225, and Al Bahr Temple No. 178 Prince Hall Shriners of Camden, South Carolina. (Courtesy of Pansy Evans.)

Pansy Threatt Evans received a bachelor's degree in library science from South Carolina State College and became a librarian at the Petersburg School, McBee Pine Forest School, and then Ruby Elementary School until her 1986 retirement. The wife of Rev. Colenzo Evans, she is a member of the Daughters of Isis, Prince Hall Affiliation. (Courtesy of Pansy Evans.)

Along with Alvin Arnold, Sebren Jordan, and Colenzo Evans, Joe Williams operated the first black dry cleaners, W. A. J. E. on Elm Street. He was active in several fraternal organizations, including Al Bahr Temple No. 178 in Camden and Booker T. Washington Consistory No. 225. Williams was also a 33rd Mason with the McCaskill Lodge No. 308 in Bethune. (Courtesy of Chrisandra Williams.)

Margaret Williams, the wife of Joe Williams, was a graduate of Claflin College. She taught third grade at the Petersburg School and retired with 41 years of service. She and Joe raised two children, Charles and Chrisandra. (Courtesy of Chrisandra Williams.)

Doreatha Threatt Jordan followed in the footsteps of her parents, Henry and Mary Threatt, and became an educator. Graduating from South Carolina State College, she began her career in 1951 and retired from teaching first grade at the Petersburg School in 1982. Doreatha married Sebren Jordan. (Courtesy of Doreatha Jordan.)

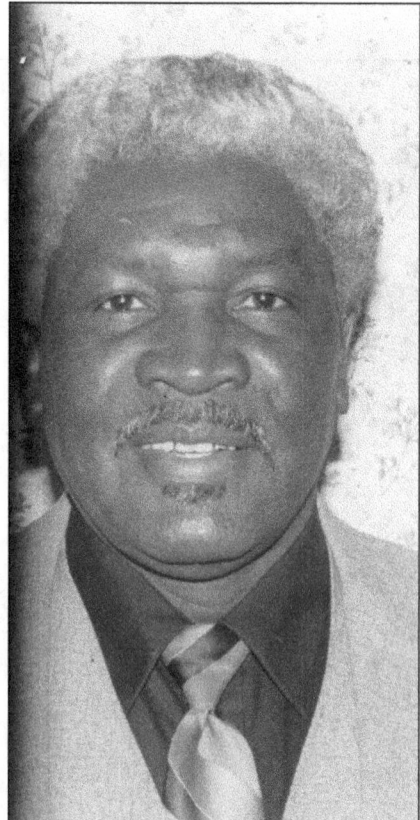

Sebren Jordan co-owned W. A. J. E. Dry Cleaners in addition to operating a barbershop in the Petersburg community. (Courtesy of Doreatha Jordan.)

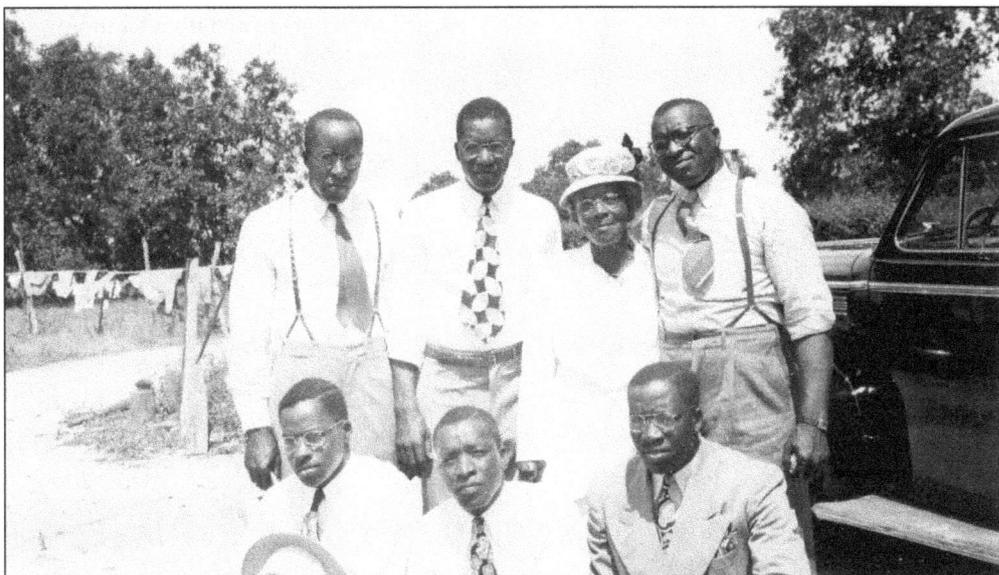

Zilpha Ann Dargan poses with her family in the 1940s after the death of her husband, James Dargan. Seen from left to right are the following: (first row) Kemp, Willie, and Pertie J.; (second row) Booker T., Harley, and Thomas. (Courtesy of Dr. William T. Dargan, Stories About Us Project.)

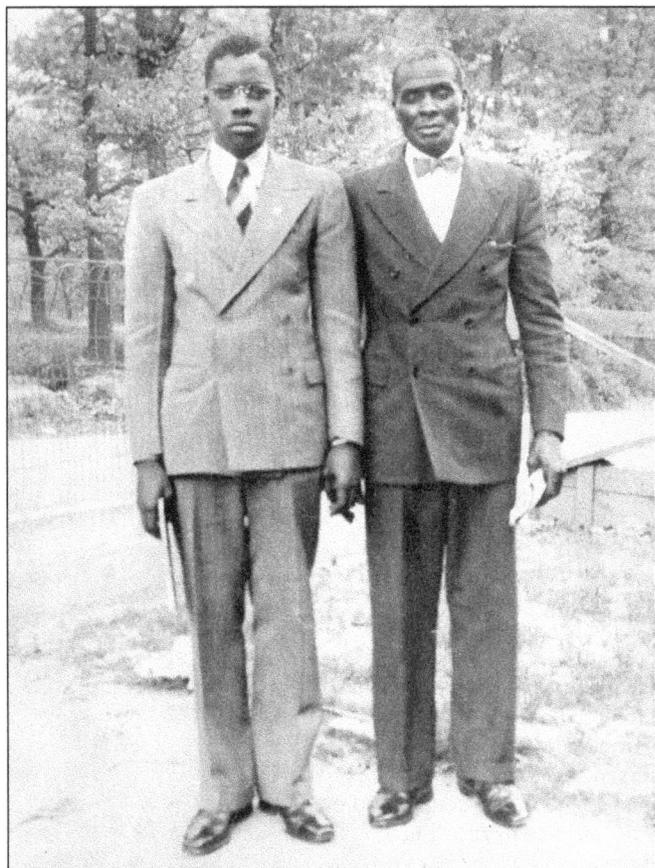

James Dargan moved to Pageland in the early 1900s and purchased land in the Black Creek community. He is shown here with his youngest son, Kemp. (Courtesy of Dr William T. Dargan, Stories About Us Project.)

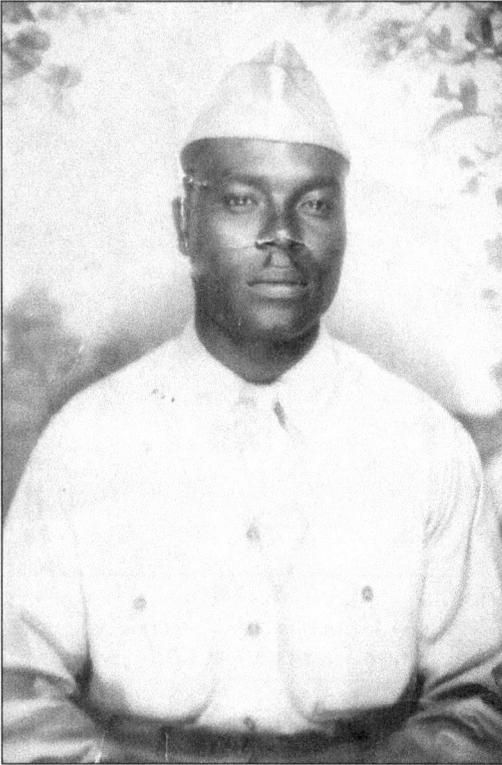

Parnell Miller graduated from Clinton College in Rock Hill, South Carolina, and taught at the White Plains Colored School in Jefferson. He was honorably discharged after serving in the U.S. Army during World War II. (Courtesy of Tippy Brown.)

Lucille Miller and her husband, Parnell, were the proprietors of Lucille's Place, located on Elm Street. The restaurant, famous for its hamburgers and ice cream sandwiches, served the community for more than four decades. The couple also owned a fish market next to Lucille's Place. (Courtesy of Tippy Brown.)

Many of the photographs in this book were inherited or collected. They tell stories. They help define our identity and link us to a rich and complex history. Here a worn Jule Fleming, born in 1855, stands with his youthful, debonair son Randolph in the 1900s. Jule was a businessman and a farmer who amassed many acres of land to pass to his children. Randolph did not continue this legacy like his father, a man who had been born into slavery. Some of the men and women in this book never had the opportunity to see the rewards of their struggles and determination in the generations that followed. Some never realized the everlasting effect their actions would have on our society. We should all be compelled to appreciate our ancestors, to celebrate their contributions—no matter how great or small—and to preserve the inheritance that was purchased with sweat, blood, tears, and love.

www.ingramcontent.com/pod-product-compliance
Lightning Source LLC
Chambersburg PA
CBHW080546110426
42813CB00006B/1225